1 MONTH OF
FREE
READING

at

www.ForgottenBooks.com

By purchasing this book you are eligible for one month membership to ForgottenBooks.com, giving you unlimited access to our entire collection of over 1,000,000 titles via our web site and mobile apps.

To claim your free month visit:

www.forgottenbooks.com/free872566

ISBN 978-0-266-59399-7
PIBN 10872566

This book is a reproduction of an important historical work. Forgotten Books uses state-of-the-art technology to digitally reconstruct the work, preserving the original format whilst repairing imperfections present in the aged copy. In rare cases, an imperfection in the original, such as a blemish or missing page, may be replicated in our edition. We do, however, repair the vast majority of imperfections successfully; any imperfections that remain are intentionally left to preserve the state of such historical works.

A GUIDE

TO

THE STUDY OF

BOOK-PLATES

(*EX-LIBRIS*)

BY

JOHN BYRNE LEICESTER WARREN

(LORD DE TABLEY)

Haurit aquam cribris qui vult sine discere libris

JOHN LANE: THE BODLEY HEAD
NEW YORK AND LONDON MDCCCC

Edinburgh: T. and A. CONSTABLE, Printers to Her Majesty

PREFACE TO THE FIRST EDITION.

IN 1837, now above forty years ago, the Reverend Daniel Parsons published an article on Book-plates in the *Third Annual Report*, 1837, *of the Oxford University Archæological and Heraldic Society*. And, at a later date, in 1851, Mr. Parsons announced his intention of writing a *History of Book-plates*.[1] This, unfortunately, he never lived to publish; but Mr. Parsons deserves a grateful commemoration in this preface as the first English writer on the subject of ex-libris.

And in all likelihood the present humbler attempt in the same direction would have shared the fate of Mr. Parson's *History*, had it not been for the continual encouragement and efficient assistance accorded to its writer by the Reverend Thomas William Carson, of Beaumont, Terenure Road, Dublin. It is difficult adequately to express the extent of my obligations to that gentleman during the progress of this work. Not only has he confided to my care, for the purposes of this essay, the most precious portion of his fine collection, but he has favoured me with many valued suggestions. In the two lists of English engravers he has especially assisted me, and supplied no inconsiderable portion of the names. His series of dated English book-plates, probably the best in the country, has greatly enriched my list. I might add the transmission of valuable books by post, the loan of pamphlets and reviews, advice on knotty points, help in the nomenclature of the

[1] *Notes and Queries*, 1st S. iii. 495.

different styles, and many other kindnesses too numerous to particularise. I can only once more render Mr. Carson my warmest thanks. To Henry Peckitt, Esq., of Carlton Husthwaite, one of our earliest and most extensive collectors, I am indebted for the loan of some rare French pamphlets, for the gift of some interesting ex-libris, and for much kind assistance and information. I must also record my gratitude to the Hon^ble Gerald Ponsonby for permitting me most pleasantly to inspect his very fine collection, and for aiding me in taking notes on many of his most interesting specimens. Except Mr. Carson, no one has contributed more to my list of dated English book-plates.

To Augustus Wollaston Franks, Esq., F.S.A., I owe the generous loan during a lengthened period of his small but choice collection. I am indebted to MM. John and Albert Scheible of Stuttgart for allowing me to refer to them various questions connected with German ex-libris, and for researches made on behalf of this essay. Also I must thank M. Meyer, the Secretary of the Museum at the Booksellers' Exchange in Leipsic, for many obliging facilities accorded in respect of the Lempertz collection now under his care. I also mention with gratitude M. Carl Schuckhardt of Frankfort, and Mr. W. Auvache of Museum Street, as two intelligent and industrious collectors, the fruits of whose labours are now incorporated in my own series. To Richard Garnett, Esq., and to W. Y. Fletcher, Esq., I owe the discovery of some highly interesting ex-libris in the National Library. I thank J. Martin, Esq., of the Inner Temple, for permitting me to take notes of his instructive collection, and J. Pearson, Esq., for supplying several of my illustrations and also contributing to my dated series.

In the various heraldic portions of this volume, I have freely had recourse to the standard English works upon

the subject, without deeming it necessary to append refer-
ences, or to state, except in a few cases, the sources whence
my information has been derived.

Since also heraldry and book-plates are so intimately
blended, and inasmuch as nine specimens out of ten are
more or less armorial, I have, in all my descriptions of
ex-libris, used the heraldic *right* and *left*, in opposition to
the *right* and *left* of Bartsch and other describers of en-
gravings. This plan may occasion a little awkwardness
to a reader consulting these pages solely from the artistic
point of view. Still I had no alternative. The confusion
would have been intense, had I described the armorial
portions of a book-plate on one system and its pictorial
accessories on another. While those ex-libris, which
present no trace of heraldry, are so few in number and
so exceptional that no great violence will be done in
conforming their descriptions to those of the majority.

The following abbreviations indicate the collections
of ex-libris, chiefly referred to in the present Essay.
(C.) Rev. T. W. Carson; (P.) Hon. Gerald Ponsonby;
(F.) A. W. Franks, Esq.; (L. B. Mus.) The Lempertz
Collection; (W.) the writer.

In closing this preface, I may perhaps be permitted
to offer one slight suggestion to booksellers. When a
volume in your catalogue contains an interesting or an
early-dated book-plate, it is well worth one more line of
type to notify the fact. Even the large book-auctioneers
might find this hint deserving of their serious attention.

LIST OF ILLUSTRATIONS.

A GUIDE TO THE
STUDY OF BOOK-PLATES.

HAVING selected a volume from one of those mysterious receptacles of drift literature, which stand at booksellers' doors with the intimation, *all in this box threepence*, on a dirty piece of card-board poised on a ragged fragment of stick, the bookhunter will presently at home inspect his new acquisition. The book is opened and displays, pasted inside the cover, a paper label. It reads, in a plain border, *William Downing, his book*, 1744. Now in England we call such a ticket as this, William Downing's book-plate, as abroad it would be called his *ex-libris*. In either case the meaning is, that this special volume was in 1744 William Downing's property and no other man's: that the book was *one from among his books*, an item of his library, a unit in his collection. The convenience of such a label of proprietorship, printed or engraved, led to its adoption soon after the appearance of printed books. Books have been lost, borrowed, or stolen ever since type began, and a mere manuscript name is inconspicuous and easily effaced.

Now, as to our English term of art *book-plate*, it is beyond question both clumsy and ambiguous. Yet the word has taken root and obtained a general recognition among bibliophiles. It is, therefore, too late to alter matters now.

A

But the chances are, if you enter a third-rate print shop, or a country bookseller's, and ask for *book-plates*, with no further periphrasis of explanation, that you will be handed *plates which have served to illustrate books.*

As to the word *book-plate* in its technical sense, that is, of exact equivalence to *ex-libris*, the dictionaries have been ransacked in vain, but in none of them does it seem to be recorded. We are unable to cite any earlier authority for its occurrence than 1791, in which year John Ireland published the first two volumes of his *Hogarth Illustrated.* In that work it is said, speaking of the early days of the great humourist, "the works of Callot were probably his first models, and shop-bills and *book-plates* his first performances."[1] Walpole comes very near to using the word, twenty years earlier, when he calls Hogarth's ex-libris[2] with the cipher, 'a plate he used for his books.' And, again, in his *Catalogue of Engravers*, ed. 1771, speaking of George Virtue's charming book-plate, this is entered as a 'plate to put in Lady Oxford's books.' But, no doubt, when the subject is ventilated, some earlier quotations for the word book-plate will turn up.[3]

On the other hand, the continental term, an *ex-libris*, is much more clear and serviceable. It is certainly also occasionally applied to the arms, etc., stamped outside on the binding of a volume instead of the paper, or more rarely vellum, label affixed to the cover within.[4] Yet this is only a slight divergence of meaning, and occasions but little ambiguity.

If all book-plates were as plain as William Downing's, there would be no great inducement to study a series so

[1] Introduction, p. xxii. Again, in vol. iii. (1798) p. 370, 'said to have been a *book-plate* for Lambert, the painter.'
[2] See *Anecdotes of Painting.* It is doubtful, if Hogarth had himself any band in this his so-called book-plate.
[3] See page 103, foot-note.
[4] Some folk paste their *ex-libris* on the back of the title-page ; some on the inside cover at the end of the volume

monotonous. But the owners of libraries soon began to improve upon a mere typographical statement of their name. Heraldry was at once employed as a ready and ornamental mode of declaring the proprietorship of a volume. Indeed, many of the oldest book-plates bear a coat of arms without name or further inscription. The owner then considering, that, among his own immediate circle and neighbourhood, such an heraldic imprint of his right to the book was enough. Indeed, in those days more of his retainers would recognise his figured coat of arms than read his printed name. Thus from their earliest origin book-plates became heraldic, and they have in the majority of instances so continued to the present time.

Upon their heraldry was soon engrafted a mass of extraneous ornamentation, usually, however, supposed in some degree to be connected with the central escutcheon. The mantling might be foliated into an infinity of shapes, the shield itself framed or encased in a variety of fashions. This framework itself might be ornamented florally, architecturally, with branch, fruit, cornucopiæ, arabesque, or what-not. The theory of heraldic supporters was expanded into caryatides, cherubs, term figures, male and female allegories, gods and goddesses feigned to be in charge of the shield. Thus there will be found an infinite divergence and variety in any well-selected collection of ex-libris.

These specimens range from simple name-tickets—often of high interest when reading, for example, *Samuel Parr*; *William Hazlitt*; *Thomas Babington Macaulay*—to highly elaborate engraved pictures. Such are the book-plates of Anna Damer, the sculptress, designed by Agnes Berry, the friend of Horace Walpole, and a fine anonymous composition, engraved by Barnes & Co., Coventry St., of a member of the family of La Tour d'Auvergne.[1]

[1] Both dated 1793.

Again, there is every diversity in the social grade of the persons to whom the book-plates belong ; though, doubtless, in the earlier days of their adoption ex-libris were mainly owned by nobles and ecclesiastics. Yet in the eighteenth century the series travels from the mathematical master at Christ's Hospital, who inscribes his name across the figure of a proposition in Euclid, to the superb military trophy which flanks the royal arms of France on the ex-libris of Lewis the XVth.

The main reasons for which a book-plate becomes interesting may be thus succinctly stated. It bears an early date, or infers an early date from its workmanship. It records as owner some well-known person in the past. It is beautiful as a work of art. These may be respectively called the antiquarian, the historical, and the artistic aspects of an ex-libris. To these leading categories two much smaller ones may be appended. Some plates possess interest for their heraldry alone, some for their topography. Such as those of *W. Williams of Antigua*, and the *Mexican Convent of St. Francis*. The mere eccentricities, the plagiarised designs, quaint mottoes, and other minor points of book-plate curiosity, will only be noticed incidentally, or as illustrating some of the more important aspects of our subject.

In France alone has the history of the book-plate from its origin to the present time been adequately investigated. France usually takes the lead in Bibliography, and in all subjects akin thereto. For the ex-librist is but a humbler class of bibliophile, whose slender resources admonish an abstention from the costlier luxuries of First Editions. In France, the rage for collecting ex-libris has expanded to a full maturity, in Britain such collectors are as yet a puny folk, little more esteemed than the juvenile hoarder of

postage stamps. In France, the book-plate has a recognised commercial value, the true index of a respectable social recognition. M. A. Poulet-Malassis' valuable handbook [1] has much contributed to this result. This brilliant and exhaustive treatise on the book-plates of his own country has reached a second edition. Its success is perfectly well deserved. With the outer stamps on French books M. Guigard in his excellent *Armorial du Bibliophile* [2] has supplied us with the fullest information.

In England various detached papers have been already published, to which references will be found during the course of the present work. [3] But nothing approaching to a book on the subject has been attempted as yet.

It is naturally with English book-plates that the present work is mainly concerned ; but, as the ex-libris of Germany, Spain, Italy, and Flanders are as little known as those of this country, we have not scrupled to seek for illustrations and comparisons from these foreign examples, and to devote some of our chapters to their especial study. It is much to be desired that some collector in each of these countries would publish the result of his researches.

With French book-plates we have much less concern. We shall assume that M. Poulet-Malassis' valuable essay is, as it ought to be, in all our readers' hands. With such a large *terra incognita* before us as Europe, excepting France, supplies, we shall trespass little on his carefully mapped

[1] Les ex-libris Français depuis leur origine jusqu'à nos jours. Nouvelle édition, ornée de vingt-quatre planches, Paris : Rouquette, 1875, 4to (with a separate album volume of plates).

[2] Johannis Guigard : Armorial du Bibliophile avec Illustrations dans le Texte. Tomes I. & II. Paris, Bachelin-Deflorenne, 1870-1873, 4to.

[3] By far the most important of these is the communication headed ' My Collection of Book-plates,' by G. W. D., in *Notes and Queries* for Jan. 3, 1880, which has appeared since this sentence was written. It is at once able and entertaining.

out domain. His work well merits an English translation; but in the present essay we have too much to notice in the book-plate history of other countries to find much space to quote his interesting pages. Some four of his French ex-libris will be added to our dated foreign list; and a few French engravers noticed, who have apparently come to light since the publication of his second edition. And, although illustrations from French specimens will be freely used as explaining our general theories on the subject of book-plates, yet into the *history* of French ex-libris, as a class apart, we shall not enter in this essay.

We must also premise, that as a rule no notice will be taken, and no account given, of purely modern *ex-libris*, either English or foreign. It is difficult, and indeed scarcely necessary, to draw a hard and fast line between old and modern book-plates. Speaking generally, an *ex-libris* subsequent in date and workmanship to 1830 may be considered a modern one. In a few cases, for formulæ of ownership, eccentricities, and apposite illustration of older specimens, such modern book-plates may be resorted to ; but, for the most part, they will be entirely excluded from these pages.

As we hinted briefly above, a large proportion of English book-plates of all periods are purely heraldic. Others blend natural objects with heraldic insignia. Some, and these not the least interesting, are wholly and entirely innocent of all heraldic device.

Now to blazon in detail the heraldic portions of every armorial book-plate noticed in this treatise must add considerably, and perhaps needlessly, to its bulk. And yet, without the blazoning, each description will be in a measure incomplete. We cannot pretend to have observed a rigid consistency in all cases, but our rule has been to blazon usually each anonymous or really important ex-libris.

Other book-plates, whose main significance consists in their inscription or design, will have their heraldry (if any) omitted. Either, we submit, will be quite enough to identify the book-plate for all purposes of after-reference. In some cases, we have omitted to give the heraldry, not from choice, but of necessity, having only had time, in the survey of another person's collection, to note the inscription.

After the more important examples a reference will often be added of the collection in which the book-plate occurs. This rather lengthens the description, but it is generally of practical use. There will be also placed, after most of the quoted ex-libris, an approximate date added in a parenthesis. The writer has found this so valuable in his own memoranda, and so serviceable for the purpose of his own researches, that he retains such roughly estimated dates for the guidance also of his readers.

As to the general subject, he proposes to treat of book-plates after somewhat the following scheme. First, the essence of an ex-libris is that it expresses proprietorship of the volume to which it is attached; that it announces the fact of the book's possession by some individual, or body corporate, named thereon. Consequently, the next chapter will be employed in showing from actual instances, the many various phrases by which book-ownership can be asserted and set on record.

We now get into the thick of our subject. The several chapters on the leading fashions in ex-libris decoration are among the most important in this essay. The book-plates of the last century present a mere chaos to the collector, until he is able at a glance to see to which style and period any given example must go.

The historical aspect of the ex-libris will then claim our attention in the catalogue of dated English book-plates, from the Restoration to the accession of George the First.

This list may, we fear, prove lengthy, and its descriptions somewhat dry and technical. It is, however, intended more for reference than for continuous reading.

Another view of a book-label may now be taken. The ex-libris is a precaution against the loss or theft of a volume. We shall, therefore, devote a chapter to recording the various mottoes, texts, and verselets directed against borrowers. Those in praise of books and study will receive a separate section.

A list will then be attempted of Foreign Engravers·of ex-libris, in which the French names, already exhaustively treated by M. Poulet-Malassis will be omitted.

The next general group will be the book-plates of places, a curious and motley assemblage. Legacy ex-libris and College Prizes will follow. The headings of the other chapters will sufficiently indicate their contents.

After this much of general preface, we proceed to the details of our subject.

PHRASES OF BOOK POSSESSION.

This book belongs to John Hughes[1] (1810). That is perhaps the simplest and most downright statement of a fact, which admits of being retold in many terms more ornate and polite. John Hughes speaks home; there is no *sibi et amicis* nonsense about John. He is a man of whom the borrower will do well to beware. But other folks have many more ways of saying on book-plates that a volume is their own. A string of actual instances will be given, as actual instances realise.

To commence, in Latin the mere genitive will express John Hughes's longer phrase of proprietorship. *LIBER Bilibaldi Pirckheimer. Sibi et Amicis.* P. (1500),[2] Frontispiece. This may be called the father of book-plates, the first Shakespeare quarto of the ex-libris collector. *Academiæ Cantabrigiensis Liber* (1720).

To the typical formula *ex-libris* should perhaps be given a precedence of consideration, as it has stamped itself upon the subject-matter of this treatise.

We have as yet met with no earlier instance of its occurrence on a dated English book-plate than this—*Ex libris Bibliothecæ Domesticæ Richardi Towneley de Towneley in Agro Lancastrensi Armigeri. Anno Ætatis: 73, Domini: 1702.*

[1] Inscriptions given in italics are copied from the book-plate, and quoted *exactly* as they occur.

[2] In this, and all subsequent cases, a date enclosed in a parenthesis means that the date is approximate, and that it does *not* occur on the ex-libris itself.

On the Continent, however, the phrase occurs much earlier. For instance—*Ex libris M. Christophori Raymundi Schifflini Augustani verb. Div. Min.* (M. C. R. Schiffling of Augsburg, Minister of the Divine word). The arms are a little ship (Schifflein) repeated, as is usual in foreign heraldry, on a larger scale in the crest. The mantling is gracefully foliated. The whole is enclosed in an oval medallion, above which *P S. xxvii: Dominus Lux mea et Salus Mea;* and again below the escutcheon *Anhelat Portum.* All round is a fine and graceful border of renaissance art, consisting of intertwisted branch and leaf-work, amid which two Blake-like fairy forms of boys issue to the waist from flower calices and crown the design with overheld arching palm-sprays. The ex-libris is probably earlier, if anything, than 1610. The arms are, of course, at that period untinctured. The book-plate is one of great beauty.

Another instance—*Ex Libris S. S: C: G: B: L: B:* (*Liber Baro*) *S.S.* 1661. *Arms*—Quarterly, first and fourth, Ar (?) a pale counter-compony; second and third, or (?) a beaver erect. (The tinctures all very doubtful.) *Motto— Deo et Cæsari.* The shield is coarsely framed, and surmounted by a coronet. An olive branch flanks it at each side; thick and dumpy festoons of fruit are placed below.[1]

Our next dated occurrence of the typical phrase brings us again back to Britain, and reads on Bishop Sterne's bookplate—*Ex libris Joh. Stearne, S.T.P. Epi. Clogherensis:* 1717, in a circular band round the episcopal cartouche. At each corner outside the inscription is some rather fine leafwork, which completes the square of the plate, whose general aspect is older than its inscribed date. Likely enough, Bishop Sterne founded his book-plate on an earlier one of some predecessor of his in the see of Clogher. This Bishop's

[1] The ex-libris is German, and, artistically speaking, a poor specimen; but the date and formula inscribed make it noteworthy.

name recurs here and again in Swift's Journal to Stella. Sterne was Dean of St. Patrick's, and intimate with his more celebrated successor in that deanery. Swift calls Sterne the hospitable owner of good bits, *good books*, good buildings; and even goes so far as to tell Halifax in 1709, 'that only the Bishop (Sterne) and one or two more rendered Ireland tolerable to him.'[1] However, about 1717, the date of this plate, a rupture seems to have occurred between the two friends.

For want of space the type phrase is sometimes found abbreviated, as—*ex libr. Cored. Neob A°.* 1732, a bold piece of Teutonic heraldry, in which the escutcheon appears on the breast of an Eagle displayed. The slightly varied but perhaps more classically correct *e libris* is found in Germany rather early. *E libris Fr. Dom. Haeberlin Ulmani.* The design consists of Caryatids and Amorini disposed about an outer proscenium, which shows a library interior, scene-like, beyond (1700). The English instances are, as usual, later than the German.

It will be sufficient to quote two examples—*E libris Hen. Aston*, an armorial plate (1740) and *E lib. Tho. Jowling, A.M. Rect. de Alcester*, with this inscription merely surrounded by an oak wreath (1740).

Ex bibliotheca or *E bibliotheca* is a formula of great continental prevalence and considerable antiquity. It occurs very early on a dated book-plate of Charles Albosius,[2] a Citizen of Autun, near Chalons—*Ex bibliotheca Caroli Albosii E. Eduensis. Ex labore quies*, 1574 (dated).[3] The ex-libris is merely typographical, and bears no kind of design.

[1] Life of Jonathan Swift by John Forster, London, Murray, 1875, Roy. 8vo, p. 190.

[2] Poulet Malassis, p. 4.

[3] That is bearing an *engraved or printed* date. Ex-libris with dates upon them added in manuscript are not considered dated ones. This distinction is important.

The Electoral Library of Bavaria, whose book-plates are remarkable for their size as well as their artistic excellence, will furnish us with another early dated example of this formula—*Ex bibliotheca Sereniss*^ᵐ *Utriusque Bavariæ Ducum* 1618 (dated). Winged Caryatids supporting the electoral ermine-faced crown with one hand, fruit festoons hanging from their other hand. Between them, richly framed, the Bavarian arms. Quarterly, 1 and 4, Paly bendy sinister of eight; 2 and 3, a lion rampant, crowned, double-tailed, langued and armed. Around the escutcheon hangs the collar of the Golden Fleece. Below, on an arabesqued platform, with censers at each corner, is engraved the above inscription. 7 × 5½ in. Twenty years later, a new plate was engraved for the same library, on which the formula was thus varied—*Ex Electorali bibliotheca Sereniss. Utriusq. Bavariæ Ducum* on an indented bracket on which the escutcheon rests. Arms (as before) in an oval frame surrounded by the Golden Fleece. The links of the collar are prominently rendered. To right and left, two inverted cornucopiæ of fruit. Above, the electoral crown is supported by four cherubs grouped on the upper portion of the escutcheon frame. Two in front with their hands resting on the frame, and two behind upholding the crown. 10 × 7 in. (1640). Taking this in every respect, I know of few finer ex-libris.

In England I cannot find anything to record until days that are comparatively late.[1] For instance, *E BIBLIO-THECA Baronis de Baltimore*, A.D. 1751, occurs on the circular ex-libris of that nobleman, so dated and inscribed. The design is merely the crest, two flags issuing from a ducal crown, and above a Baron's coronet. A modern French instance may just come in to show the phrase in an abbreviated form. *Ex bibl. Merard de St. Just* (1820).

This rarer modification also occurs—*Ex catalogo biblio-*

[1] Buckwath (1735).

thecæ Cavmartin (1750),[1] to which we may append two other rather pompous phrases of possession,—*Unus ex collectione librorum Domini Johannis Georgii Eimbckenii* (1720) and *Ex musæo Christiani de Nettelbla Holmia Sueci* (Stockholm, 1750); or *Ex museo D. Claudii Ruffier in Lugdunensi Præfecturâ Franciæ Questoris* (1690) C. and *Ex musæo E. P. Le Tors de Chessimont* (1740) C. *Pertinet ad Bibliothecam B. Woodcroft.* This from a modern ex-libris, but for want of an older instance of this further variety of expression, we here introduce it.

Indeed, the changes can be rung upon the word *bibliotheca* to a considerable extent.

Taken alone, it occurs very frequently, as in *Bibliotheca Palatina* (1730), *Bibliotheca Velseriana* (1700),[2] or in its genitive with *liber* understood, *Bibliothecæ M. H. Theodori Baron.* (1720), or *Pro bibliotheca*, on the anonymous heraldic book-plate of an Italian Prince (1820), which is rare and unusual. Or, *ad bibliothecam Jo. Jac. Reinhardi. Ord. Class. num.* (1695). *Ad bibliothecam Fratrum L. L. B. B. de Vogelius* (1720). (C.). Sometimes this same variety of the formula occurs disjoined from the rest of the inscription; as thus, *Franciscus Præpositus S. Salvatoris Pollingæ, A°.* 1744; after which there is added on a separate bracket at the base of the design—*Ad bibliothecam Ibidem;* meaning that the volume in question belongs to the library *in that place,* namely S. Salvator, and not to the said Francis, its *præpositus.*

The modified property of a monastic in his books is also thus modestly expressed—*Ad usum F. Johannis Baptistæ*

[1] *Ex catalogo bibliothecæ Argenson.* Armorial; the Field-Marshal's batons crossed behind the escutcheon (1730). *Inscriptus catalogo librorum Josephi Xaupi, &c.,* 1730 (dated).

[2] Or abbreviated, *Biblioth. D.D. de Freval* (F.). A wild Louis-Quinze plate, on which the unicorn supporters have taken fright, and are literally kicking over the escutcheon; or, again, *Ex Biblioth. Regia Berolinensi* (Siennicki).

Ininger Ord. Erem. S. Augustini (1750). The next triplet of examples adopts the curious expression 'private library.' *A. Gray's private library* (1820). *Bibliotheca privata Antonii Ignatii, etc., S.R.I. Principis, Præpositi Elvacensis, Comitis Fugger, etc.* (1820). And last but not least curious— *Ex libris bibliothecæ domesticæ Ricardi Towneley in Agro Lancastriene Armigeri, anno ætatis 73, domini* 1702.[1] Note the eccentric record on his book-plate of the owner's age. *Insigne librorum*, which we quote from M. P. Malassis, without having observed an actual instance of its occurrence, is a most unusual phrase, but means simply the book-mark. *Symbolum bibliothecæ Johannis Bernardi Nack, civis et mercatoris Francofurti. Jnv. Dr. Osterlander. Del. et sc. St. Hilaire*, 1759. This seems a remarkable phrase, but probably it is not a formula of book-possession; meaning in this case merely the sign of the bookshop of B. Nack, inasmuch as that bookshop is depicted beneath under very fanciful conditions (Plate 16, p. 219).

Comparavit Monasterio S. Viti cis Rotham ibidem professus P. Quirinus Hohenädl (1730). *Ex supellectile libraria Bened. Guil. Zahnü*, in a plain, coarsely engraved, shellwork frame (1780); that is to say, part of the book-furniture, or the library effects of B. G. Zahnü (C)—a curious expression, of which we have only seen this single instance.

Horace Walpole, acceding late in life to the Earldom of Orford, expressed his proprietorship in his books by an ex-libris reading,—*Sigillum Horatii Comitis de Orford* (1791–1797), and a convent in Dalmatia does the same, *Sigillum Convent. Fontis Bæatæ Virginis in Zaara.* Possibly the volumes of their respective collections were thereby supposed to be sealed as their own.

[1] And a fourth—*Ex libris Bibliothecæ Personalis P.F. Hilarionis Piskowski Ord. Præd.* (ordinis prædicatorum) (1750) *Siennicki.* Engraved plate 12.

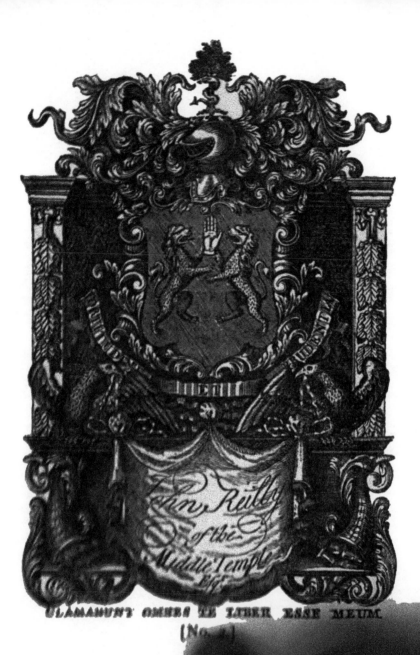

John Reilly
of the
Middle Temple

CLAMABUNT OMNES TE LIBER ESSE MEUM.

(No. 14)

The last Latin assertion of ownership to be given is, strange to say, a poetical one :—

Clamabunt omnes te, liber, esse meum.[1]

This very neat adaptation from Martial occurs on three book-plates, which we have seen, and doubtless on others. It is earliest found on the fine ex-libris of *John Reilly, of the Middle Temple, Esq.* (1690—1700); then, at least fifty years later, on the very similar book-plates of *Theophilus Desbrisay* and *John Huson, Esq., Counsellor-at-Law.* Both are unsigned, but evidently by the same hand (1745). The elaborate angular lined framework, with wooden flourishes, ends on each plate in a tent-like awning above ; while on each side a martial half-length female, helmeted, is introduced into the ornamentation.

After this long string of Latin formulæ, those which we have been able to collect in the modern languages will seem scant and meagre. Our French instances are—*A Mr. De Lorme, Gentil Homme, ordinaire du Roy* (1750), *Bibliothèque particulière de son Eminence Mgr. le Cardinal Maury.*[2] *Bibliothèque de Pastoret. Bibliothèque de Rosny,* which is slightly altered thus, *De la Bibliothèque de M. Le Chev. Dampoigne.*—*Du Cabinet de Missire Barthelemy Gabriel Rolland, conseiller en Parlement, President à la première des Requêtes du Palais,* 1761,[3] which last is rather more appropriate to the numismatist than the bibliophile. And the similar *Cabinet littéraire ex libris Celliev* (1760), giving us an interior view of the cabinet aforesaid, its book-shelves, central table, and checkered pavement ; the whole in a circular wreath of leaves and berries.

[1] Martial, *Epig.* xii. 3. I am indebted to Mr. Carson for this reference.

[2] John Siffrein, Cardinal Maury, born 1746, died 1817.

[3] on an anon. French armorial ex-libris (1750). The scroll is *Du Cabinet de,* but, oddly enough, no name follows.

B

In these two analogous instances which follow, the volumes assume the poetical licence of speech to declare their master.

Je suis à Jean Tommins (1750) on an English book-plate of a Frenchman, designed by Cipriani and engraved by Ford; and *J'appartiens à Lucien Wiener* (modern).

These next are less dithyrambic,—*Ce livre est du Monastère de la Visitation de Sainte Marie de Clermont* (1830, Emblems of the Passion and plain border), and another, very similar, *Ce livre fait partie de la Bibliothèque de M. le Comte de Fortia d'Urban, demeurant à Paris, Chaussée-d'Antin, rue de la Rochefoucault,* No. 12, No. 366 (1810, no design, merely typographical).

In Italian we give simply—*Bibliotheca del Conte Luigi Massimil* (1720), *Bibliotheca Terzi* (1780), *Della Libreria Bellisomi* (1820), *Di S.A.R. il Duca di Lucca* (1770), *del Conte D'Aglie* (1750).

In German the crop is nearly as bare—*Zu den Büchern H. Züngli* (1800), *Lucanische Bibliothec* (1720), *Aus der Büchersammlung N. Friedrichs von Mulinen* (1805), *Volckertische Liberai* (1750), *Aus dem Orthische Büchervorrade* (1730), *Lesebucher von J. C. Müller* (1770).

In English, the yield is worst of all—*Hooton Library* (1810) printed in red. *A. Gray's Private Library* (1820). *This book belongs to John Hughes* (1810), *William Downing, his book,* 1744 (dated). Two of these instances have been already given above, for convenience of comment and contrast.

This concludes our catalogue of the phrases of book ownership. The great excess of Latin formulæ over those in any modern language cannot fail to strike the reader. The paucity of English book-plates even with Latin phrases will be also very apparent. In France and Germany such statements of proprietorship were during the last century extremely prevalent. In England and on English book-plates they are quite exceptional.

LEADING STYLES OF ENGLISH BOOK-PLATES.

THE JACOBEAN STYLE.

THE artistic style of English ex-libris decoration, which we propose to distinguish as Jacobean, is first found (so far as our present materials carry us) accompanied by a date on certain college book-plates of A.D. 1700. Like ornaments recur in the next year on the ex-libris of *Dame Anna Margaretta Mason, relict of Sir Richard Mason, Kt., late Clerke Comtroler* (sic) *of the Green Cloath to King Charles and King James the Second,* 1701. Now it sounds natural enough to stamp as Jacobean the book-plate of a lady, whose husband served the last James, yet this style of Jacobean decoration continued to appear on book-plates until about 1745, long after the name ceased to be strictly applicable. Still, as the art of the Mason book-plate in 1701 is practically the same with that of Francis Winnington's ex-libris in 1732, we presume it will be allowable to call the last, no less than the first, Jacobean, although designed during the reign of George the Second. To affix any fresh name to the Winnington plate would be to assume a solution of continuity between the art of the two specimens which does not exist. In this account, therefore, of the leading styles of English book-plates, we shall commence by discussing the Jacobean, claiming to ourselves some latitude to extend the term to book-plates dating well into the middle of the eighteenth century.

Nor will it be necessary to remind the reader that, during

the prevalence of this and all the succeeding styles about to be discussed, the series of purely heraldic, that is to say, of unornamented armorial book-plates, continued unbroken. While in all the styles of decoration a nucleus of heraldry was preserved, as the centre and the reason of the varied and extraneous ornament. The escutcheon, indeed, was the excuse for the festoon, the cherub, or the framework.

Mr. Carson's collection contains two fine specimens of Jacobean book-plates, but on these the work is so ornate and exceptional that they will assist the student but little in recognising the leading characteristics of this style; and, therefore, they will not be so particularly dwelt upon as some smaller and far less beautiful examples, which explain this vogue better in its normal and average appearance on ex-libris. The first (p. 16) dates about 1700, and is of *John Reilly of the Middle Temple, Esqr.* Below runs—*Clamabunt omnes te liber esse meum. The arms*—vert, two lions combatant or, supporting a dexter hand ar. *Crest*—a tree, round its stem a serpent, all ppr. *Motto*—Fortitudine et Prudentia. The escutcheon is raised on an elaborate and richly carved Jacobean sideboard. The mantling is preserved, curiously foliated above. The central portion of the sideboard nearest to the shield is in lower relief and bears a diapered pattern. Two columnar-like shafts project in higher relief on either side; on each is carved a heavy perpendicular leaf festoon. Below the escutcheon, right and left, on the ledge of the sideboard, are two eagles with expanded wings and ribbons in their beaks. Below these again, on each side, cornucopiæ inverted and apparently pouring out books. Across the lower face of the sideboard is spread a fringed cloth, which bears the inscription, gathered at the top into three ribbon-tied bunches. $5\frac{1}{4} \times 3\frac{1}{2}$ in. (Pl. 2.)

The next plate is later but nearly as fine. It is anonymous. *The arms*—ar., three wolves' heads couped sa. *Crest*

—a crescent or, flames issuant therefrom. The shield appears in an oval, plain medallion, which hangs in an outer frame, composed of flourished limbs of stone-work. Two angels with trumpets set to their lips, undraped to their waists, recline above the shield, their lower limbs inserted into two large cornucopiæ. Between them, a flaming torch. From their inner hands depend heavy leaf festoons. Below, two smaller standing angels hold, right and left, an opened cloth ready for a name. An outer border of leaf-worked cornice completes the design. In the right corner is the signature —*Ja Sartor fecit Londini.* 6 × 3¾ in. (Plate 5, p. 58.)

It is not till Jacobean ex-libris begin to thicken about 1725, that a sufficient number can be brought together upon which it would be safe to generalise. Our coming observations are, therefore, based more on these later and commoner book-plates, which every collection will supply, than upon a few choicer and earlier specimens, of which few are as yet known to have survived.

Speaking, therefore, of the *ruck* of ex-libris of the first years of Queen Anne, we may with hardly any qualification assert, that on the book-plates of that period the escutcheon is set in no kind of frame and does not rest upon a bracket. The little extraneous ornamentation, which the coat of arms receives, is derived from expanding and convoluting the mantling from the helmet into leaf-work more or less elaborate.

But in the beginning of the century occur dated ex-libris of certain colleges, who placed above their escutcheon neither helmet nor crest, and who, consequently, had no mantling wherewith to decorate the bare flanks of the shield. To supply this void in decoration, a distinct frame was placed round their escutcheons, and this framework was ornamented with ribbons, palm-branches, or festoons. The prominent or high relief portions of this frame were not set close to the edges of the escutcheon, but between it

and them an interval of flat patterned surface nearly always intervened, in which, as upon a wall, the actual shield was imbedded. This we shall call the *lining* of the armorial frame, and we shall find this lining is usually imbricated into a pattern of fish-scales, one upon another, or diapered into lattice-work.[1] The scale-covered or latticed interval of lining is the characteristic of the style, which we propose to call Jacobean, and which on English book-plates preceded the better-known Chippendale fashion of decoration.

Now the earlier book-plates of Anne have merely the Jacobean frame; but another step in the external decoration was to add a bracket, distinct from the frame, upon which the shield in its frame was supposed to rest. This bracket naturally imitated the decorative art and surface arrangement of the shield frame.

The Jacobean style was most prevalent on our book-plates about 1730; and we have accordingly engraved (see plate 6) a not very beautiful, but extremely characteristic specimen of this distinct decorative fashion.

The book-plate of *Francis Winnington* (p. 73) *of Lincoln's Inn, Esq.*, 1732, bears *imprimis* a definite date. It gives, moreover, the shield set in a distinct frame, and that resting on a distinct bracket. It gives the scale pattern on the first and the lattice or diapered pattern on the second, each so differential of this style. It shows clearly the interval of lower surface so patterned, which is always placed next to and immediately around the escutcheon. It preserves, above, the old mantling, distinct and unmixed with the limbs of the framework.

The escallop shell in the centre of the bracket must be noted. It is the normal and perpetually recurring orna-

[1] More rarely simple horizontal lines replace the cross-barred pattern; and on the latest and roughest specimens in Jacobean style the lining simulates the bricks upon a wall (masoned).

ment of the Jacobean escutcheon frame. But the more usual arrangement is that the scallop should be placed in the centre of the frame above; while in the centre of the bracket below, as a kind of pendant to the scallop, appears a satyr or demon's head, or the head of a canephorus. On the top ledges of the frame are often placed as ornaments, eagles, baskets of fruit, apples, festoons; while, either as quasi-supporters on the ledges of the bracket, right and left, or on the side ledges of the escutcheon, if the bracket be amalgamated with the frame, are lions, cherubs, male and female term-figures, busts of fairies with butterfly wings, angels with trumpets, etc. Recurring to the scallop shell, we shall see that it was afterwards transmitted on to the Chippendale frame; but it became a shelly border on these book-plates rather than one distinct shell.

Such, therefore, is the Jacobean ex-libris, and such its ornamentation. Ample specimens in this vogue have survived, and it is readily recognisable. We have taken the Winnington plate for our type of the style, and the reader will do well to study it with some attention. As compared with the woodwork preserved in churches of Charles the Second's reign, as compared with the mouldings on monuments of the same period, a practical identity of decoration cannot fail to strike the antiquary.

Some illustrative ex-libris in this fashion will be now given and commented upon.

The ex-libris of *Charles Barlow, Esq., of Emanuel Colledge (sic) Cambridge,* 173(0)[1] (dated) gives us the Jacobean style in its most exaggerated phase of decorative exuberance. Both diaper and scale pattern are here, as well as the normal scallop shell. The framework groans under other

[1] This is one of those tantalising three-quarter dates, so unsatisfactory to the collector. The three first numerals are engraved, the last is left blank to be filled up in manuscript.

accumulated decorations. Eagles, dumpy Amorini reading, a wreathed head, a thick festoon, a basket of flowers, and what not, are all piled pell-mell. The outer border of ornaments which skirts the margins of the plate is very unusual.

Sir George Cooke, of the Inner Temple, London, Prothonotary of the Court of Common Pleas, Westminster, 1727 (dated). Another Jacobean book-plate. The mantling still preserved and separate. The scale-work on the inner lining of the frame prominently developed. The outer limbs and curves rather lighter than usual. No bracket beneath.

Sir Thomas Hare, Baronet, of Stow Hall, in Norfolk, 1734 (dated). The Jacobean frame still in characteristic angularity. This example gives the latticed or diapered lining extremely well. The head of a canephorus replaces the normal scallop shell below. Busts of fairies, butterfly-winged, are placed on the lateral ledges. No separate bracket. *The Most Noble John Duke of Bedford,* 1736 (dated). The mantling is retained separate. The scale-lined frame reappears, elongated below laterally for the motto scroll to rest on. No bracket. *Saml. Goodford of ye Inner Temple, Esq.,* 1737 (dated). No mantling to helmet. Scaled lining. A prominent bracket, its inner portion scaled, its outer diapered. A shaggy fawn's head in centre. Couchant lions on each outer ledge. *John Robinson, M.D.,* 1742 (dated). Mantling preserved separate. Lattice-work lining to frame. *Thomas Frewen, of Brickwall, in the County of Sussex, Esq.,* 17(38). The last two numerals in MS. Mantling as before. The scale-work lining. No bracket.

These specimens rank first in our description of Jacobean plates, not for possessing any exceptional excellence, but from the important fact of their bearing dates.

Second only in importance to the dated examples of

any given style are such book-plates as are signed by engravers.

The following artists' names occur on ex-libris which are clearly Jacobean. James Sartor, one of the earliest designers in this style, has been already referred to. Next comes a name of acknowledged reputation. *Honourable Henrietta Knight. Thos. Worlidge fecit.* This shows a large surface of scale-covered lining. The scallop-shell occurs above, slightly altered into an indefinite fan-shaped ornament. A demon or satyr's head is placed below, with a ring in the mouth, much in the door-knocker style. Festoons hang from the lower frame limbs. Bracket and frame combined (1735).

Paulet St. John, Esq., F. Gardner S. The diapered lining becomes here extensively prominent. Censers of flame are placed on the uppermost frame ledges. Below, a separate niche is excavated in the diaper ground, which bears an independent brick-like pattern, and the head of a canephorus. On the lateral ledges, right and left, a huntsman, booted and spurred, flourishing a whip, a bugle-horn swung round him. Bracket and frame combined. A striking but roughly engraved plate, probably of provincial work (1740).

John Earl of Hyndford. B. Scott f. Short mantling floats above. No frame to the escutcheon. The supporters supplying the side ornamentation. The usual diapered bracket is placed below (1725). *Fillingham. Cole, sculp.* Eagles and an urn on the upper frame ledges, lattice-lined bracket as before (1730).

Bickam, Jun., who signs a plate in 1730, and *W. R.*, must also count as engravers of Jacobean ex-libris, but the style is not distinctly developed in their works, so we shall not here describe them.

Prominent unsigned and undated Jacobean specimens are—*Lucius Henry Hibbins, of Grays Inne* (*sic*) *Esqe.* Very

ornate and characteristic. The lattice lining appears in compartments on a second horizontally hatched surface. The frame does not rest upon the bracket, which appears below detached. Apples on the upper ledge (1735). *Thomas Payler.* The frame is scaled only. The bracket both scaled and latticed: Cherubs on its lateral ledges. Female head in its centre (1730). *John Wynne, A.M., Rector of Caerydruidion.* Scaled frame. Angels with trumpets on its upper ledges. Satyr's head below. No bracket (1740).

Hester Brodrepp (1735) is a valuable example. The upper half of the frame lining is scale-work, the lower half diaper pattern. Cornucopiæ at each side.

John Ash (1735). An extremely good specimen. The scale work as usual. The limbs of the frame are curiously inter-locked, with a devil's head above, a maiden's below. (F.)

John Huson (1745) places his arms under a pavilion sup-ported by two female undraped, plumed, and helmeted term-figures. The bracket is diapered with another plumed female head in its centre. *Theophilus Desbrisay* has adopted Huson's design, replacing the bracket head by a trophy of arms. These two plates are probably among the very latest to which the term Jacobean can be applied.

The fine but rather wild plate of Sir Paul Methuen, Minister of Queen Anne and George the First, may come in here as a Jacobean book-plate. But we do not note the ex-libris as a good example of the style, but merely give it for its historical interest. Indeed, the work is quite exceptional.

Sir Paul Methuen. Arms—Ar., three Wolves' heads erased, ppr., surrounded by the Bath. *Crest*—A Wolf's head couped, ppr. *Supporters*—Two fiery lynxes reguard., ppr., collared and chained or. *Motto*—Virtus invidiæ scopus. Mantling very blown-about and stormy, ending off into actual tassels on single-line flourishes. The 'fiery' lynxes

and the escutcheon rest on a fine open lattice-work bracket. The scallop shell in its centre. This bracket is upheld below by two seated, full-grown angels, male and female, much smaller than the lynxes, whose outer hands support the bracket ledge and inner hands grasp a trumpet.

Sir Paul Methuen died in 1757. The plate dates about 1720.

A few more specimens before we conclude. *John Putland, Esqr.* The frame lining plain-barred horizontally. Below, a satyr's head. On upper ledges Eagles with wings expanded on fruit-baskets (1725). *Edward Wake.* Brickwork lining, a winged term-figure of a boy and girl, right and left, holding a festoon. Scallop shell degenerating into a fan below (1735). *The Honourable Heneage Legge, Esqr.* Diapered linings. Festoons hung across. Scallop shell above. The bracket plain-ruled vertically (1740). *Robert Keith of Craig, Esqr.* Diaper lined with two oblong apertures cut, right and left, through the lining. This is very unusual. Satyr's head below (1745). *William Robinson Lytton, Esqr.* Scaled lining to shield frame; brickwork lining to bracket. On the former, a scallop shell; on the latter, a satyr's head. Eagles on the upper ledges; Lions, right and left, on the bracket. A fine plate but coarsely engraved (1740). And this may conclude our selected specimens.

Our reader will now have gained a good general idea of what a Jacobean ex-libris is like. It is a formal, and, no doubt, conventional style of decoration. It is more remarkable perhaps for its solidity than for its gracefulness. Yet few will deny that these book-plates have a very distinct character of their own, and, if not actually lovely, they are seldom in bad taste.

THE CHIPPENDALE STYLE.

We now come to the Chippendale style, which is the leading artistic fashion on English ex-libris after 1750. It superseded the Jacobean ornamentation, and a vast number of book-plates were designed under its influence. Contrasted with a Jacobean book-plate, these leading points of difference will be observed. The mark and stamp of a Chippendale ex-libris is a frilling or border of open shell-work, set close up to the rounded outer margin of the escutcheon, and, with breaks, more or less enclosing it. This seems to be a modification of the scallop-shell so normal at the base either of frame or bracket on a Jacobean plate. It is, in fact, a border imitating the pectinated curves and grooves on the margins of the scallop shell. Outside this, succeed various furniture-like limbs and flourishes, eminently resembling the triumphs of that ornate upholstery, which Chippendale[1] about this time brought into vogue. The design is completed externally by a profusion of free flowers ; that is to say flowers in natural sprays and branches, and preserving the natural habit of their growth, and not imprisoned in heavy conventional festoons as on the Jacobean book-plates. I cannot, for instance, recall on these last a single instance of such a rose branch as occurs at the side of the Cupid on Richard Caryer's *ex-libris*[2] (see plate), though such sprays will recur again and again upon the great bulk of Chippendale book-plates, of which

[1] Chippendale (T.) Gentleman and Cabinet-Maker's Director, being a large collection of the most elegant and useful Designs of Household Furniture, in the most fashionable taste, with 160 plates of elegant designed Furniture. Fol. 1754.

[2] This plate is, except the heraldry, identical with one inscribed *Joseph Pocklington, Newark, Nottinghamshire*, 1761 (dated). But the Caryer plate is, I believe, the original of the two.

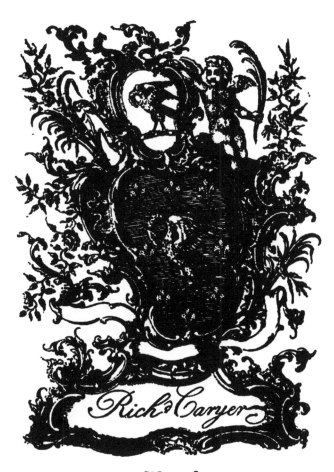

[No. 3.]

they constitute a leading characteristic. Speaking gener-
ally, the Chippendale ornamentation is freer, less stiff,
and more rounded than the Jacobean. The two sides of
the design are seldom symmetrical on a Chippendale plate,
but almost always so on a Jacobean. The outline of the
escutcheon itself in the Chippendale style is often broken
into by the incurving of the shell-work or of the upholstery
border ; the shield is sometimes oblique, often pear-shaped,
seldom a complete oval. On the Jacobean ex-libris the
shield is always of a regular figure. To sum up shortly,
the Chippendale plate is ornamented with shell-work,
upholstery, and free flowers.

One of the earliest dated ex-libris, which can claim the
name of Chippendale, is that of *East Apthorp, A.M., Cam-
bridge* 1741 (dated). Indeed · this is almost a transitional
plate, for, though the shell-pattern and free flowers stamp
it as Chippendale, yet the indications of a horizontally
hatched Jacobean lining to the frame are also present.

The next dated plate in this fashion is of *Charles
Delafaye, Esq., of Wichbury, Wilts,* 1743. *Bath. I. Skinner
Sculp*. The shell-border and untied flowers are both
present, though but timidly and tentatively developed, as
compared with the Caryer plate, one of the finest examples
of Chippendale at its best. *Benjamin Hatley Foote,* 1743
(dated). This is a very decided Chippendale plate with
the style far more developed than on the one by Skinner.
Isaac Mendes, 1746 (dated), by Levi, but not characteristic.
James Brackstone, Citizen of London, 1751 (dated), is a
singularly pure example of the style, giving its fully
developed characteristics. So is the ex-libris of *Sir
Thomas Gerard, Bart.,* 1750 (dated).

*Charles O'Connor of Belanagare in the County of Roscom-
mon, Esq.,* 1753 (dated). Not well engraved but decidedly
middle Chippendale. *Philip Thicknesse, Esqr., Land Guard*

Fort, 1753, dated, and characteristic. *John Ord, Lincoln's Inn*, 1761 (dated), gives about the limit of the pure Chippendale plate, for signs of decadence are here observable. It has not been necessary to describe these book-plates separately, as almost the same descriptive words would apply to one and all of them. Of all we may say, that the shield is flanked with shell-work, outside which various carved limbs, as of wood, are added. Flowers decorate the exterior frame. Above the escutcheon is the crest. The helmet is usually omitted, and mantlings are quite exceptional. The shield rests on an oblong bracket of similar work to the frame. This bears the owner's name. That is the normal Chippendale book-plate.

The dated book-plates in this fashion have been after our custom taken first. We shall now subjoin a list of undated ex-libris executed in the middle or purest period of the Chippendale vogue. Indeed, one is compelled to break up this great group into three epochs. The early Chippendale; before the full characteristics of the mode were developed. Such are the plates by Mountaine and Skinner. The middle or pure Chippendale, which comprises the *ruck* of examples in every collection. The late or deteriorated Chippendale, which will be presently treated of. Such divisions are inevitable. A plate by Skinner or by Delegal are both Chippendale, yet how unlike!

Now all these ensuing plates are good instances of pure middle Chippendale. Their floral decoration is neither too timidly developed nor too profusely overdone.

John Belfour (1750); observe the vanishing rudiment of a bracket. *Charles Corbett, of Lincoln's Inn*, 17— (half dated). *Fred.Cornwallis* (Archbishop of Canterbury)(1768). *John De Chair*, engraved by *J. Kirk, St. Paul's Church Yard*, a fine example (1750). *Morgan Graves, Esq.*, with more symmetry than usual in the flowers. *John Gore, Esq.* (1755), the shell-pattern in perfection. *James Irving, Esq.*, has

unusually large-headed flowers (1750). *Robert Long,* who gives the type scallop shell below and the shell-pattern around the shield. *Chas. Pinfold, LL.D., Governor of Barbados,* an excellent specimen of the style (1750). *Theodore Broadhead,* a choice example, but the decoration just a turn too varied (1760). The list might be easily quadrupled, but these are enough.

The essence of the grace of a Chippendale plate was its freedom and artistic moderation. Consequently, when the fashion had become generally diffused, it began to be vulgarised in the hands of weak designers, who essayed to pile the flowers upon the frame beyond all measure and limit; and who endeavoured by a crowded decoration to mask the real weakness and poverty of their powers of design. In this, the decadence of Chippendalism, other adjuncts of ornament were sought. The combinations of the shell-work and simple flowers were retained, but regarded as inadequate. Then took place a kind of reactionary movement, as it were, to one portion of Jacobean ornament. Cherubs, fiery dragons, books, balustrades, trees, sheep, fruit-baskets, miniature nymphs in kilted petticoats, began to appear among the springing flowers upon the ledges of the frame, until at length one wild plate gives us, amid the furniture curves and blossoms, distinct and detached agricultural vignettes.

This marvellous production may be truly regarded as Chippendale run wild and *in extremis.* The book-plate reads C. Eve. It is a poor, crowded, smudgy affair. On different stages of the frame appear, for instance, Cupids reaping fields of growing barley, medleys of agricultural implements ; the general arrangement of the design is execrable.

Francis Blake Delaval, Esq. This is better engraved than the last, but quite departs from the normal arrangement of the accessories in a Chippendale book-plate. An

upper story, so to speak, is added to the normal design. Shells teeming with fruit, flowers in pots, and an upper ornamental valanced cornice, apart from the escutcheons (for there are two), impends in the air, like a canopy, above name, shields, and flower-sprays. *Richard Wright, M.D., etc.* This is another two-storied plate, with books, and balustrades leading nowhither. *Rev. John Watson* has a Cupid, with one foot on another balustrade, reaching down some of the flower-branches. The ex-libris of *J. Hardy* and *James Clitheroe*, each perch a stormy, fire-breathing, Chinese dragon on their frame ledge. *Richd. Jenkins, Salop,* has groups of Cupids, two reading and two measuring with compasses a globe. *John Williams* gives a charming little maiden, with a love-lock and kilted robes, quite realistic. *John Halifax*, a sheep under a hawthorn, and a Cupid directing a box. *Thomas Salwey, of Richard's Castle, Salop.* A pretty plate, but the furniture decoration overdone. *Sir Joseph Mawby* has literally piles of blossom, five deep.

We have not dated these examples separately. They will all be found to range from 1765 to 1780. They are collectively cited as examples of the Chippendale style, past its best and already in its decadence.

The engravers of Chippendale book-plates are legion, but among the names, which we find signing plates in the early or undeveloped Chippendale style, are *R. Mountaine*, a very prolific engraver (instance the ex-libris of *John Hoadly, LL.D.*, the Dramatist, of *Thos. Worsley*, and a plate inscribed *Pringle*).[1] These three plates all date about 1750. Mountaine has another semi-oriental style, in which he seems to have no imitators, and which did not survive this artist on English book-plates. *I. Skinner, of Bath*, has been already mentioned. Another engraver, who

[1] There is a variety of this plate, with a graceful outer border of vine leaves and tendrils round its exterior margins.

signs *W. H.*, engraves a plate of *E. Jones, Fellow of King's
Coll., Camb.*, precisely in Mountaine's early Chippendale
style, and with that engraver's touch. Also another ex-
libris of *Henry Russell*, to which the same observations
apply. We believe this to be one *William Hibbart*, who
signs at length, and dates in 1750, a book-plate of the Earl
of Clanricarde; but enthusiastic collectors ascribe the *Jones*
plate and another reading *Jolliffe* to William Hogarth!

Among engravers of pure or middle Chippendale plates
are *J. Kirk* on the *De Chair* ex-libris mentioned above.
Mordecai on *E. H. Sandys* (1750). *J. Wills*, engraving an
anonymous ex-libris, with initials *J. A. C.* And the follow-
ing names of engravers, all of whose book-plates in this
style may be dated from 1750 to 1760. *W. Austin, B. Cole,
T. B. Green, Billinge, Levi, Robinson, Robson, Stent, Mat.
Skinner, W. H. Toms,* 1752 *dated, H. Hawes, N. Hurd,
M. M., W. Stephens.*

The following artists engraved late or deteriorated
Chippendale plates:—E. Burtenshaw, Dover; Delegal,
New Bond Street; W. Henshaw, J. Mynde, G. Terry, and
several others.

This may end our survey of the Chippendale book-plate.
As a style we may regard it as original and thoroughly
national. It broke up the stiff formalities and heavy angular
limbs of the Jacobean frame, and replaced them with grace
and freedom. It gave us flowers as they grow, for festoons
of stony leaves, and embossed blossoms which never could
have grown,—things as like real flowers as heraldic mon-
sters are to living animals,—leaves and calyces which no
botanist ever could identify,—berried laurels, with impos-
sible tendrils, palm branches jointed like telescopes. The
fault of the Chippendale style was this, that, graceful as it
was, it had not enough backbone, and in weak hands soon
degenerated into mere prettiness.

ALLEGORIC BOOK-PLATES.

The allegoric book-plate, as we know it in England, seems rather an occasional fashion indulged in by the fanciful or the dilettante in art than a continuous national style. Historically considered, it may have been evolved from such examples of the Jacobean ex-libris, as present to us their frames most heavily adorned with angels, term-figures, amorini or satyrs' heads. Indeed, the Jacobean mode was continually cropping out into mythological or-namentation. The plainer plates perhaps merely gave a head, but still that was the head of a satyr or canephorus. Nothing about this mode was realistic. To the Chippendale ex-libris these allegoric plates have little affinity. They continued, it is true, intermittently right through the thick of the Chippendale vogue. This last went, as we know, for ornament mainly to shells and flowers ; and, beyond an occasional Cupid perched on a frame-limb, we shall not trace any allegoric admixture or tendency on the book-plates of the best and purest Chippendale periods, that is to say, in its early and its middle stage. In the decadence of that style, it is true, some reaction took place in the old mytho-logical direction ; but this seems merely to have been a convulsive attempt to bolster up a decoration, of which the public had begun to tire, by piling the Chippendale frame in all directions, with whatever came to hand.

Still, whether we take the allegoric plates of the period of Hogarth, Pine, and George Vertue, or consider the later group of mythological engravers, such as Bartolozzi and his scholar Sherwin, Henshaw, and the like—it must be conceded that in England during the eighteenth century allegoric book-plates were never a numerous class. In

France, however, during the same period such ex-libris were, on the contrary, profusely abundant.

Now, as we began by indicating, it is not difficult to affiliate the Allegoric mode upon the Jacobean. Indeed, the one seems to fade into the other by degrees, which are almost imperceptible.

Take, for instance, the Sartor plate: in this, we have only to depict or to imagine its twin trumpeting angels, not as pieces of dead carving in wood or stone, but as animated beings, and we get an allegory ready-made.

Indeed, on Bartolozzi's book-plate, executed for Sir Robert Cunliffe, the hypothetical transformation has actually taken place. There are two angels, who also blow trumpets, and they are unquestionably portrayed as live ones. But, inasmuch as live angels do not usually sit on ledges of sideboards, the engraver has with some judgment placed beneath them clouds instead. Closer still, in Lady Oxford's plate, we shall remain in actual doubt whether certain cupids are furniture work or celestial visitants.

Our business now is merely to consider how and when allegory reached the British book-plate. Since, of course, before this style permeated to the ex-libris, we may reasonably conclude that the vogue had taken a certain hold upon some section of the community. Indeed, about the year 1730, acres of ceiling frescoes were being done by the yard, and allegory began to sprawl in all its dizzy contortions and aërial foreshortenings on many of the palaces and public buildings of the period. Sir James Thornhill had just received forty shillings a yard for the cupola of St. Paul's and Greenwich hospital, and twenty-five shillings a yard for the staircase of the Southsea House and Blenheim, besides embellishing the Princess's apartment at Hampton Court[1] at

[1] Graphic Illustrations of Hogarth by Samuel Ireland. London 1794, 4to, p. 87.

a rate not recorded. Vanderbank, Laguerre, and a dozen others had been daubing away in all directions with much public applause and great private emolument.

That allegory should, therefore, reach even the English book-plates, was inevitable. But we must not expect their allegory to rival the wild riot and exaggeration of French contemporary specimens. The character of a nation is reflected even in its ex-libris. The vogue was here at best an exotic growth. It shot up amazingly for a time. A foreign court and ladies like the Duchess of Kendal fostered it. The more phlegmatic Englishman under the two first Georges, in emulation of his superiors, tried also to indulge in this pseudo-classical masquerading; but he went into the new mode in a timid faint-hearted kind of way; and perhaps half suspected that he was doing something ridiculous, when he ordered his engraver to confide his family escutcheon to the care of Minerva and to the Delian Phœbus himself.

But worthy George the First probably troubled himself very little, one way or the other, how engraver John Pine, whose features remain immortal as the fat friar in 'Calais gate,'[1] chose to commemorate his royal munificence to the University of Cambridge in presenting them with various tomes, which his Hanoverian majesty would never have opened himself. Pine, however, was equal to the occasion, allegory was in fashion, and he produced the following book-plate.

Munificentia Regia, 1715.—The design represents a vast structure, rather like an ormolu chimney-piece clock; of which the arms of the University of Cambridge[2] in a plain solid frame represent the face. Behind this towers

[1] J. Ireland. Hogarth Illustr. 1. 292. Hogarth also did John Pine's head in the Rembrandt style.

[2] See plate 4, engraved from the second size of this ex-libris, which does not give Pine's name in full.

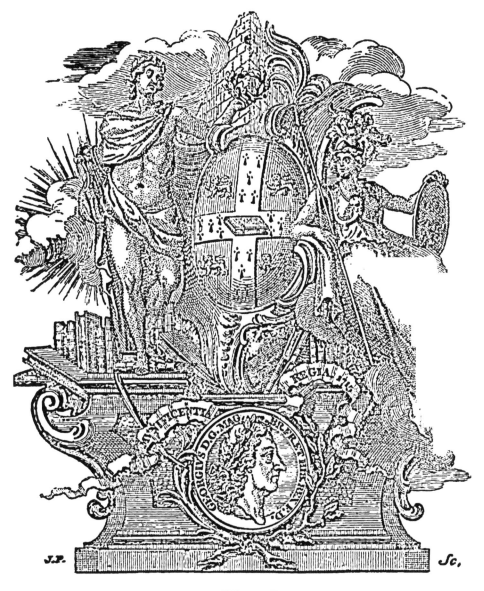

[No. 4.]

up a vast pyramid ; on which the brick-work is distinctly marked. As dexter supporter, stands Phœbus Apollo in person, reaching out a wreath. A clouded sun rays out behind him. At his feet are deposited samples of the book collection, of late so munificently bestowed. As sinister supporter, sits Minerva with helm, spear, and Gorgon-headed shield. Her feet are wrapt in cloud. In the centre of the bracket, beneath these gods, is inserted a medallion portrait of royal George, reading round its exergue *Georgius D.G.,* MAG. BR. FR. ET HIB. REX. F.D. This is flanked by a laurel and a palm branch. Across the base is *J. Pine sc.* There are four sizes of this plate ; on the three smallest Pine merely signs *J. P. sc.* (Large size, Mr. Pearson, smaller sizes, W.) A very pompous piece of work, as our readers will agree.

John Pine subsequently engraved, about 1740, a much quieter sample of allegory, from a design by Gravelot. But it is one thing to commemorate a simple Doctor of Divinity, and another to record the munificence of kings.

J. Burton, D.D. Gravelot inv. J. Pine sculp. Design— Library shelves half draped by the conventional curtain. In front, two amorini as supporters to a shield in a plain sparsely curved frame as in the last book-plate ; Arms—az., a fess erm. betw. three talbots' heads erased ar. The dexter cupid holds an open folio, and looks up across the shield at the sinister supporter ; who is given in profile, kneeling on cornice of the shell-work name-bracket, which completes the vignette below. This design reversed is appropriated subsequently by *Wadham Wyndham, Esqr.*

The charming book-plate of Henrietta Cavendish Holles, Countess of Oxford, is peculiarly valuable as showing the precise point of transition between the Jacobean and the allegoric style ; and well illustrates, moreover, how easily the living allegoric figure sprung from the dead carved

image of the Jacobean frame. The book-plate gives us, so to speak, an allegory within an allegory. There is the picture of Minerva as school-mistress to a college of Amorini. Then there comes the frame. Two youthful heads which appear at its sides among the carvings are clearly wooden ornaments. But how about the Mercury and Archimedes at the top? Are these carved upholsteries, or waifs and truants of Minerva's school within? That the point should admit of any doubt shows how short the step was from the Jacobean to the Allegorical book-plate. This ex-libris is later than Pine's, and therefore we have given his allegories precedence ; but this plate is, of course, more valuable in both an historical and artistic aspect.

We should explain that Henrietta, Countess of Oxford, was the only daughter and sole heiress of John Holles, last Duke of Newcastle of the Holles Family ; and that she was wife of Edward, second Earl of Oxford, who was the only son of Robert Harley, first Earl and the famous minister of Queen Anne. Earl Edward became the continuator and completer of that famous collection, commenced by his father, which is now best known by having furnished materials for the *Harleian Miscellany.* This ex-libris,[1] as is recorded thereon in Lady Oxford's handwriting, was placed in a gift book from her husband. It is unsigned, but I have stumbled upon its description in a list of George Vertue's Works in Horace Walpole's *Catalogue of Engravers,*[2] who there describes it as a ' plate to put in Lady Oxford's books.' Vertue spent a good deal of his time with Lord Oxford, in whom he found a congenial Mæcenas.[3] The Peer used to take the engraver with him on tours about England to sketch the various objects of

[1] p. 89.
[2] A Catalogue of Engravers, who have been born or resided in England, digested by Horace Walpole, Earl of Orford, from the MSS. of Mr. George Vertue. London, 8vo, 1794, p. 229.
[3] The phrase is Walpole's.

interest in their route. His patron's death in 1741 seems to have been a severe loss, in every sense, to George Vertue. The frontispiece to the Auction Book of the Harleian Collection was also George Vertue's work.

After this preface let the ex-libris speak for itself:— *Henrietta Cavendish Holles* (Countess of) *Oxford and Morti-mer.* *Given me by* (my Lord, 1730). The last two words and date are filled in in manuscript. Design—a library interior, with bookshelves to the ceiling; in the centre an arched doorway, with Corinthian columns on each side and the usual curtain and bell-rope draped above. Through the archway we are shown a charming vista of landscape outside. We see a straggling country house in a park or pasture, in-tersected by a river, crossed by a three-arched bridge. Over the pasture are dotted little spruce round-topped trees, like those in a child's toy-box. The river winds from a line of distant hills. In the foreground stands Minerva, sandalled and helmeted, but unarmed, and with her skirts tucked up. She is superintending a school of six industrious Cupids. The most prominent of these is painting in oils, with an easel before him, and a palette on his thumb. To his progress the attention of the goddess is chiefly directed. Another cupid plays the harp, two more sit on the frame of the design, weaving festoons; another, also on the frame, near a celestial globe, is copying a satyr playing on a flute under a tree; which picture cupid the sixth holds up for him. The whole design is set in a richly ornamented Jaco-bean frame, with the usual leafy curves and limbs, mingled with two youthful heads as lateral ornaments; and, below, palms and festoons apparently of jewels. On the frame above are seated, right and left, two more cupids as suppor-ters to a medallion bearing the countess's monogram, above which is an urn, and below heavy bunches of fruit. The right cupid is masked in the flowing robes of a philosopher,

one hand holds a plummet, the other an upright writing slab. The left cupid is attired as Mercury, with petasus and caduceus complete. These cupids on the frame are quite as large as those in the picture; and therefore we doubt whether they are supposed to be carved wooden ornaments, or living and moving allegoric existences. The plate is $5\frac{1}{2} \times 3\frac{1}{2}$ in. It is possible that the ex-libris represents an interior of the Brampton library, and the view may be one in the Brampton Park. But Welbeck, which she possessed in her own right, seems to have been especially Lady Oxford's favourite place, so that the reference may be to Welbeck. Hither she retired after her Lord's death, and in its galleries assembled the portraits of her ancestors to a prodigious number (see plate 7).[1]

Passing onwards from the allegories of the Harley family, we are next arrested by a much coarser piece of work, dating about 1750. This is the plate.—*John Duick.* Apollo, with a broad ray effect round his head, playing the lyre to the nine muses, who are grouped around him; the musical ones also assist in the concert with various instruments. Below are clouds, above them appear the abrupt cliffs of Helicon, with Pegasus launching himself into air therefrom; the fountain, Hippocrene, tapped by his galloping hoofs, descends the cliffside in a cascade. Not well engraved. We incline to think Mr. John Duick must have been a Dutchman naturalised in England; and he may have imported to this country a somewhat foreign taste in the subject of his ex-libris.

Among the designers of ex-libris in the allegorical style, a mention must be made of William Hogarth. In this fashion is the plate 'done for the books of John Holland, herald painter,' which he executed. Design—Minerva seated, among four Cupids, with a shield bearing—az., a lion ramp. guar. betw. eight fleur-de-lis ar. The supporter-

[1] Walpole, *Ib.* 195. I nearly quote his words.

like female figures right and left of George Lambert's arms on Hogarth's other most authentic book-plate, are also tinged with allegory. The decorations of the *Arms of the Duchess of Kendal,* of his own, and his sisters' shopcard, etc., are clearly Jacobean. These were probably all done before 1725. But the framing of the separate designs in *Industry and Idleness,* published in 1747, seems to be undeveloped and tentative Chippendale. So that, to some extent, Hogarth worked in each of our leading styles.

Our next example is about the most strained bit of English book-plate allegory which has come under our notice, and here also perhaps the foreign extraction of the owner may, as in the case of John Duick, have tinged his ex-libris with an unusual violence of motive. The subject, as it is, might certainly be taken from a ceiling fresco in Mr. Tulkinghorn's chambers, in Lincoln's Inn Fields. Four over-plump and under-winged cherubs (amazingly foreshortened) soar aloft, triumphantly bearing in mid air the Vansittart coat of arms. On a spear-headed banner, for the information of men and angels, is unfurled the worthy owner's name, occupation, and address — *Robert Vansittart, of London, Merchant.* His motto likewise ascends on a napkin—*Fata viam invenient.* This is pretty well!

In far better taste, and very finely engraved, is the ex-libris of the celebrated Currer Library. It represents a hooded sibyl, who, posed in an attitude of study, is poring over an open tome, at the base of a pyramid. Her right hand is laid against her cheek, supported by a light wand ; her left hand leans carelessly upon the volume in her lap. Her tunic is composed of a light barred oriental fabric. A caduceus lies at her feet, and the Currer escutcheon rests against the caduceus, but modestly shrouds from view some of its charges in the large heavy wreath of berried laurel

which surrounds the design in an oval. Outside the vignette, across the base of the plate, is written—*E libris Johîs. Currer de Kildwick Arm.* The book-plate is unsigned.[1] 6 × 4½ in.

In this Yorkshire ex-libris the allegory is managed with good tact and success. Another example, also from Yorkshire, may be contrasted, of which the very opposite can be asserted. Anything more clumsy or unreal it is difficult to imagine. Still, the plate is a curiosity, and should be noticed. Suppose Mr. Gascoigne's two sisters to be masquerading in the Parlington library. Certainly the forms depicted are more like two Yorkshire damsels of average looks than the denizens of Parnassus. The plate reads above, on a beam of the architecture—*T. Gascoigne, Parlington* (Co. York). It represents the interior of a spacious and comfortable library. (Such interiors, tho' common abroad, are rare on English book-plates.) Columns support the roof; a niched statue of Minerva appears on the wall. At a table in the foreground a muse is seated writing. She is sandalled, draped in a tunic, and wears a wreath of blossoms. The caduceus is here again neighboured with the Gascoigne arms on the carpet. The escutcheon bears—ar. on a pale sa., a conger's head couped of the first, etc. Over the shoulder of the muse appears another deity with lyre and laurel-wreath, whom we provisionally must take for Apollo. He is singing or dictating to the muse at the table. It is altogether a wondrous piece of make-belief. The plate is signed by *Hughes, Bond St.* (1780). Mr. Carson.

Of very different calibre are the allegories of Bartolozzi, to which we now pass. The first is the book-plate of *Sir Robert H. Cunliffe, Bart.*, in which the Cunliffe escutcheon appears in mid air, upon a bank of clouds. Over its upper

[1] *R. H. Alexander Bennet* afterwards borrowed and spoilt the same design.

portion is draped the usual 'property' curtain. Two cherubs are in charge of this sky-borne heraldry. The left one is seated, and has some trouble with the curtain. Our old friend, the caduceus, occupies his other hand. The dexter cherub stands bolt upright, and leans against the shield. To his lips is set a long trumpet; but, in case of accidents, a second reserve trumpet rests upon his shoulder. The engraving is of a charming delicacy. It is signed *F. Bartolozzi fec.* 5 × 5 in. The design is probably Cipriani's, for *Jean Tommins'* book-plate, which is the same in everything but the heraldry, is inscribed *Cipriani delt. J. Ford, sculpt.* It is a third time more coarsely reproduced by *Yates* for *Thomas Anson, Esqr. of Shugborough*, Lord Lichfield's progenitor. Some more works of Bartolozzi may follow. The next specimen was probably designed for George the Third, at the commencement of his reign, by the 'Engraver to his Majesty.'[1] The scene is mid air. We have no clouds, but still the conventional drapery. The royal arms, as borne by George the Third before the Union, are upheld by three flying cherubs from below. Another cherub, flying to the right, poises aloft, with both hands, the kingly crown. A third cherub, above him, in the attitude of a tumbler pigeon, has got into an entanglement with the heavy fringed curtain, which they have so needlessly taken up with them. On the left side, leaning back upon the top of the escutcheon, is Fame, broad-winged and somewhat of the Dutch type of beauty, the usual long trumpet is set to her lips and her cheeks are puffed out for a sonorous blast. Her whole weight is swung back upon the shield, regardless of the three already over-weighted small cherubs beneath it. The entire group is quite one for a ceiling fresco, and may be compared with the Vansittart plate. It is signed *F. Bartolozzi inv. sculp.* 7⅛ × 8½ in.

[1] See the Menezes plate at p. 48, where Bartolozzi so describes himself.

The next plate is still highly allegoric, and by the same charming engraver, but in quite another mood. The scene represents a square-built and picturesquely ruinous altar of stone. Greensward surrounds its base, and wild herbs and rose stems are intermingled ; the altar (or perhaps the monument) is placed on a promontory above the sea, and a distant coast line (Spain?) and ships are seen afar. On the altar itself, is a censer fuming, and two votive wreaths. In the foreground, a lovely female genius, winged and half undraped, is kneeling with mallet and chisel. A cupid, nestled against her, points to a name, which she has newly cut upon the altar-face. *D. Isabel de Menezes.* The plate is signed *F. Vieira Portoensis invt. F. Bartolozzi, R.A., Engraver to his Majesty. Ætatis* 71, *an.* 1798. 2¾ × 4 in.

This is rather too sombre a design for an ex-libris, and may be the memorial card of some Spanish lady, who died in England. It is often difficult to say dogmatically among such engravings of Bartolozzi, which are and which are not book-plates. Moreover, in his day, it was the fashion for people of taste to have illustrated visiting cards, which doubtless did duty also as ex-libris. The next example was likely enough employed by its owner in both capacities. It belonged to Henrietta Frances, Countess of Bessborough, wife to John, the third Earl.

Design—A Roman interior. Venus seated on a chair of classical ornamentation. Behind her a vase of flowers. She is holding in one hand a burning censer, in the other a dove. Two cupids, one floating in air, the other just soaring from the pavement, wave above her a long scarf inscribed *H. F. Bessborough.* The plate is signed thus— *C. B. Cipriani inv. F. Bartolozzi sculp.* 1796, *R.A.,* and again *Published Decr.* 30, 1796, *by F. Bartolozzi.* Mr. Ponsonby's Collection.

Now this protective formula of publication is most unusual

on a book-plate ; for this reason, that the piracy of private ex-libris designs was too insignificant and unremunerative to require such a safeguard. The publisher's name first began to be placed on engravings in 1735, in accordance with an Act of Parliament, chiefly passed at Hogarth's [1] instigation, to secure the copyright in such prints to their designer. In 1796 the illustrations to books all bore this formula. For instance, the Frontispiece to Vol. III. of the *Lady's Pocket Magazine*, 1796, is a wild piece of allegory —*Europe Protecting Britannia from the Demons of Discord*, and this reads *Published by Harrison & Co., Feb.* 1, 1796. Likely enough, Lady Bessborough's plate first did service in some such serial ; and was afterwards converted by a name inscription across the scarf to her more special private use. Still, Bartolozzi's work was then, as now, so popular, that he may have found it worth his while to place even his book-plates and visiting-cards under the protection of the Act. [2] Our catalogue of allegoric ex-libris may conclude with a batch of less important examples very succinctly described.

Charles Hoare and *Joshua Scrope* have one design. Winged cherubs hoist their respective arms to the top of a very tall bookcase. The last plate is signed *C. & A. Paas,* 53, *Holborn. Wm. Mitford of Pitt's Hill*, a cherub among clouds with an escutcheon, engraved by Sherwin. *Thomas Birch* is really quaint. Minerva seated has charge of the shield ; to whom enter a cherub flying in

[1] 8 George II. Chap. 38. The Act vested an exclusive right in their works in designers and engravers, and restrained the multiplication of copies without their consent. On the 'gratitude' print, published by Hogarth on the passing of the Act, he states it to have been 'obtained by his endeavours and almost at his sole expence.' *Nicholl's Biographical Anecdotes*, 2nd Ed., 1782, p. 34.

[2] I have seen *Miss Callender's* card by Bartolozzi appropriated.

with the missing crest.[1] *Verney Lovett. Trin. Coll. Cant.*,
is in the dotted style, struck off in red, by *W. Henshaw.*
A genius, laurel-wreathed, reclining on a cloud bank, with
widely outspread wings, simpers complacently over the
Lovett insignia. *W. F. Gason, Clare Hall, Camb.*, is also
signed by *W. Henshaw.* Minerva stands in a landscape,
with trees behind her. Before her is an altar, which
bears the Gason arms. In the air a flying cherub,
trumpeting, and waving a scroll with the Gason name
and address, as given above. In execution very inferior
to the last.

The reader will by this time have gained a fair idea of
this curious vogue of representing things as they are *not.*
We recommend him to study the French book-plates of
the seventeenth century, if he wishes to see combinations
yet more fantastic. The century of the vignette was the
heyday of the ex-libris.[2] And a leading authority[3]
explains that the whole *personnel* of Olympus, clouds,
powers, thunderbolts, cherubins, glories, suns, were in
France at that epoch pressed into book-plate requisition.
We have nothing on our side the channel to match with
this, but even in sober England the allegoric vogue ran
its day, and, among the various styles of English ex-libris,
it cannot be denied a notice.

[1] Compare above the description of John Holland's book-plate by
Hogarth.

[2] 'Le xviii siècle, "le siècle de la vignette" comme l'on dit Mm. de
Goncourt est par excellence, le bon temps des ex libris.' *M. Tourneux
l'Amateur d'autographes.* Nos. 214—215, p. 61 (Avril 1872.)

[3] P. Poulet-Malassis, p. 28.

THE LANDSCAPE ON ENGLISH
BOOK-PLATES.

GILBERT WAKEFIELD, who passed his life in a good deal of controversial hot water, had engraved about 1780 a pretty wood scene, in which a thirsty stag is drinking at a river, with this motto in Greek, *Truth and Freedom*. There was no kind of heraldry about the plate, which made it at that period all the more exceptional. A certain amount of allegory the design doubtless contains ; but the important point is this,—we have before us one of the earliest purely landscape book-plates in our national series. Let this example, therefore, introduce our chapter on a new phase of book-plate art.

Now, no names are more intimately associated with the vignette landscape than those of the Brothers Bewick ; and this chapter might, if we chose, be illustrated solely by book-plates of their workmanship. Very charming are their ex-libris vignettes. They show us ruins, rocks, deep foliage, or time-corroded holes, flowing river, distant spire and mountain. They give actual Tyne-side scenes, views of Newcastle, St. Nicholas's Tower, Jarrow Church. Unluckily, the armorial shield is far too often present, intruding itself into fishing scenes and similar incongruous situations. But for this the orderer of the book-plate rather than the engraver was to blame. Of course, the Bewicks applied the landscape vignette to many other pictorial

purposes beside the ex-libris. But a goodly number of *bonâ-fide* book-plates in this style of their engraving survive; so numerous, indeed, are these examples, that we intend, space permitting, to revert to them specially hereafter.

The earliest dated Bewick book-plate is that of *T. Bell*, 1797, a date which shows that the Bewicks followed rather than originated a taste and style already popular, which they afterwards brought to such perfection. It is from the works of their less-known predecessors and contemporaries that the examples in this chapter will be taken.

Now of the landscape book-plate. This was rather the lineal descendant of the Chippendale than of the Jacobean style. The last expanded into allegory by giving life to its decorative images and busts. The Chippendale decoration developed into landscape by adding to the free flowers of the frame the fields and lands whence such blossoms had come. But the change did not take place abruptly, or *per saltum*. Take, to prove this, three transitional or composite book-plates, on which landscape is associated with the earlier fashions, Allegory and Chippendale, which it soon supplanted altogether.

In the *Tanrego, Pyott, and Burrow* book-plates the fusion of styles and arrangement of the vignette are precisely similar. The foreground of the design is blocked by a gigantic coat of arms framed in the later Chippendale fashion. There is a bracket below, and distinct from the frame; on this is the name, and on its ledge various implements. Behind the shield-frame, left and right, appears a distinct background of landscape; but the sky interval, between the top of the frame and the upper border of the plate, is common to both landscapes, and divided by no line of partition. Middle distance there is none, as the bracket rises high enough to conceal that portion of the design from view.

The first plate belongs to a school. It reads—*Tanrego in the County of Sligo*, 17[86],[1] dated. Scholastic implements crowd the upper portion of the bracket. In its lower left corner a diminutive Minerva is seated. Her helm is plumed, her owl is at her side. She is pointing upwards at the motto of the school, *Minerva Duce*, which swings on a scroll among all the paraphernalia of learning. The goddess sits just under the school telescope, which considerably exceeds her in length. In the background, to the right, a Greek temple rises from the sea on a wooded promontory; perhaps Sunium is meant. To the left are pyramids and the desert. In the heaven above, a sun with ray effect and a fragment of the zodiacal belt. Signed, *J. Taylor sculpt.*

Take next a book-plate of the Pyott family. *Pietatis Amator. Ed. Bramston sculp.* Arranged as the *Tanrego* ex-libris. Right background gives a sea view. Vessels are riding at anchor off a small fort, over which a flag flies. A very violent ray effect on the horizon. The left background depicts a land view. There are columns and a ruined arch. An obelisk with a horse-trough. Two shepherds in colloquy, with crooks.

Last comes the plate of *Edwd. Burrow*, which, though unsigned, must be also by Bramston. The general style and disposition as before. Right background, a sea fort, and a ship at anchor before it. Left background, another sea view. A ship, much larger than the first, and a fishing town on the horizon. A most awkward effect is produced by the inequality of the horizon line in each distinct vignette. In these three book-plates the landscape is clearly subsidiary to the Chippendale decoration. These vignette background views are merely added to finish off the flowers and flourishes of the frame. Note the date of the *Tanrego*, 1786 : for, as we take it, we shall get few later Chippendale specimens.

[1] The figures in brackets are in MS.

In the next book-plate—we select typical instances—a step onwards is made. The landscape has here become the most important ingredient in the design. Chippendalism has disappeared, and we hear no more of it during the present chapter. Allegory will still linger, but it will be subordinate. We have thus reached a class of book-plates in direct continuity with those of the Bewicks. In fact, we shall now enumerate some eight typical landscape ex-libris, selecting purposely those signed by engravers. And we may regard their designers, without much violence to probability, as the predecessors of Thomas Bewick, though perhaps one or two of the names ought more strictly speaking to be called his contemporaries.

We begin with *Peter Muilman, King Street, London, and Kirby Hall, Castle Hedingham, Essex. Terry sculp., Paternoster Row.* Design—a wooded lawn with ruins. In the foreground two cupids, one raising the Muilman escutcheon, which rests upon the sward, the other bears aloft the family wreath and crest. A pretty bordering of shrubs and turf occupies the base of the design. 5 × 3½ in. Take also this plate, *Wm. Bennet, Henshaw sc.*—A shield swung upon a branch of a broken oak. A cupid wreathing the arms in festoon. Sward, bushes, and rock in foreground. Nicely designed. The next is more elaborate, but far inferior. Anon. *Vero Nihil Verius.* Minerva (very large), with her owl, seated on a rocky bank. Vistas of pasture fields and hedgerows in the background. The perspective faulty. In right corner *Wells del. sculp.* After the above examples the trace of allegory disappears. Here is a batch of analogous landscape book-plates. *James Sheppard, Wells sculp.* An armorial shield suspended by a ribbon on an oak bole. Iris leaves and a pond adjoining ; hedgerows, a town, and low hilly slopes beyond. *T. W. Greene, Lichfield. Pye sculp., Birm*(ingham).—The shield, oval-shaped, is rather thornily

deposited in a bramble bush on a promontory against an oak, broken off short, as usual. Opposite grows a thistle, very carefully rendered. An arm of the river winds in, across which are discerned the three spires and one tower of Lichfield.

William Bentham, Lincoln's Inn. An escutcheon swung by a strap round the bole of a giant oak. On the strap, *Virtus invicta gloriosa.* In the background a lake and a dome-roofed pavilion with a portico. *W. Sherwin sculp.* This cannot date after 1780. It is therefore before Bewick; and though the touch is very different, the arrangement of the details are quite in his manner.

Johannes Symmons Arm. F. Sansom del. et sculp.—This is a curious plate. A beech-tree, stunted but complete, occupies the central foreground. Against its bole rests the Symmons shield very insecurely. To the right it is flanked by a tall flowering plant of exotic growth, in a garden-pot, with leaves like the india-rubber. To left rises a holyhock in full bloom. A woody lawn appears behind with massed holes and foliage beyond. *James Lahy. Ovenden, Butcher Row, sct.*—The usual broken oak, with shield, eagle-crest, wind-floated motto scroll, and plumed helm. A background of mountain lines very slightly indicated. Printed in red. And take last an example in which both allegory and heraldry are omitted, and we have a landscape book-plate pure and simple. *Joseph Priestley. Allen sct., Birming".*—Design—a mountain spring trickling into a basin below, with flags, plantain, and ferns growing around it. A charming vignette. *James Yates,* who edited the Doctor's collected works, afterwards used the same book-plate. At Birmingham many of Priestley's writings were published.

At this point we should arrive at the consideration of the ex-libris of the Bewicks; but we shall treat of these in a chapter apart, space permitting. We may, however,

here instance several ex-libris by artists more or less im-
mediately connected with the great Newcastle engravers.

The first is engraved on copper by Ralph Beilby, Thomas
Bewick's partner. *J. Brand, A.B., F.S.A., Coll. Linc. Oxon.*
An extensive Gothic ruin, with shafts and broken archways.
Turf and shrubs, and tufts of sedges, spread around. An
oak-tree, broken, of course, in the foreground. Against
which is an altar-like slab with the inscription. Behind,
across foliage, the steeple of St. Nicholas's Church, so
commonly recurrent on Bewick ex-libris. Signed in left
corner *R.B.* Mr. Hugo states[1] that Bewick borrowed
the idea of the Adamson book-plate from this design.[2]

Quite of the Bewick school is the next example by *J.
Bailey.* There is, however, an over-elaboration, of which
Thomas Bewick was seldom guilty. *Geo. Allan, Darling-
ton, engraved by J. Bailey.*—The foreground is occupied by
a Roman inscribed altar, near which are piled charters,
deeds, bows, arrows, horns, an armorial shield. These are
all strewn upon the grass. In the middle distance rises a
ruined cathedral. A modern spired church and a village
appear behind. *Thos. Crawhall, Allenheads, No.*—Carved
on a rock-face, a spring behind. Varied foliage above. A
field view to left, in the distance. Quite in Bewick's manner.
The plate is unsigned. *H. Stamford & Libe* (sic) 179(0),
the conclusion of the date is masked by the foliage. This
is placed on an antique altar, bearing a sculptured urn. A
dead tree and boulder in foreground. Woodland behind, and
boughs above. Bewick designed a plate for H. Stamford,
but the description will not fit this one. It does not seem
by him; but is boldly and rather well engraved. Both this
and the last are on copper. Let us take another curious

[1] Bewick Collector, p. 306.
[2] Ralph Beilby executed another book-plate for *Thos. Wentworth,
Bretton Hall, Yorkshire,* 1789, dated.

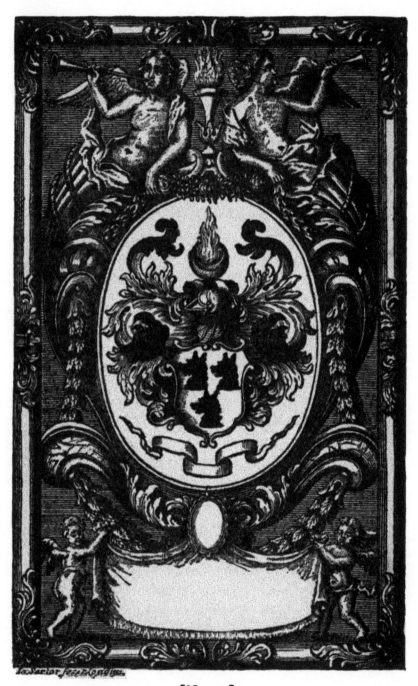

[No. 5.]

instance in a thin wire-drawn style of engraving. *Philip Taylor.* Design—Two lean unnatural trees, right and left, occupy the foreground, the exact pendents of each other. Woven from the branches of one to those of the other is a scroll, reading, *Scientiâ beati sumus.* A long flat prospect of pasture behind. To extreme right a windmill. To extreme left a cottage, with smoke from the chimney. A quaint little plate of about 1790, with a distinct manner— though not a good one—of its own.

We may conclude this rapid survey of the English land-scape book-plates by just noticing a few post-Bewickian examples in this vogue, confining ourselves chiefly to signed ex-libris. *Michael Smith Esq., W. Esdall del*. et sculp*. The broken oak, escutcheon, globe, caduceus, cor-nucopia, etc., in foreground. *W. B. Chorley, Liverpool* on a ruined brick wall. Foliage above. Inscribed slab in the grass. Gothic ruin behind. A Bewick imitation, signed, *Bonner sc.* The next is more servilely copied still. *I. H. Fryer. Lambert sc.* on a rock slab, foliage and the broken tree above. A river-side scene and water-mill beyond. But our last specimen is a lovely vignette of great delicacy, quite free from the Bewick influence, and with no heraldic adjunct. *James Hews Bransby, Breve et irreparabile tempus,* signed *J. Scott.* The foreground gives us the furrows of a newly turned up field. Among these, a sower is scattering seed from his bag. Further off, a ploughboy is driving his team, the horses being, for contrast, black and white. A cottage in a tuft of trees, and the escarpment of a down, seen shadowed against a stormy sky, complete an exqui-site picture, well worthy to close our selected series of landscape ex-libris.

It may be convenient to present to the reader at a glance the names of some engravers of the landscape book-plates. Earliest come W. Sherwin, Ed. Bramston, J. Taylor, and

Terry. Except Sherwin, there is an admixture of allegory or Chippendalism in the designs of the other three. Then follow Henshaw and Wells, still combining landscape with allegory. These last are landscape designers, merely preserving the heraldic element. Pye, Birmingham; Ovenden, Butcher Row; F. Sansom; Allen, Birmingham. The last omits the heraldry. In connection with the Bewicks come R. Beilby and J. Bailey. After the Bewicks, W. Esdall, Bonner, Audinet, Lambert, J. Scott. The ruck of these book-plates date from 1780 to 1810.

We have thus traced the succession and order in which five distinct decorative fashions arose, and are illustrated by the English book-plate. We have selected, for want of space, only a few typical examples of each leading vogue. We have shown that, with very few exceptions, heraldry was always present in combination with each and all of the five. It combined well with the Jacobean or Chippendale fashions. It combined but poorly with allegory, and with landscape worst of all. The Jacobean book-plates are not beautiful; but they have a *cachet* of their own, and are seldom vulgar. The Chippendale ex-libris are often extremely graceful, and as a decorative fashion, this may be considered both original and successful. With respect to allegory, we can only regard it here as an exotic growth, fostered by foreign influences; but the landscape bookplate is thoroughly and nationally our own. How great is Thomas Bewick when unweighted by the cumbrous heraldry of his patron for the time being!—how charming are his episodes of woodland and gliding stream! And even in the presence of Bewick, Wakefield's drinking stag, Priestley's fountain spring, and Bransby's sowing scene are worthy to be commemorated. Moral teaching, doubtless, was intended in all three, and this quiet allegory of nature *was* here an endemic growth. While the Mercuries and

Minervas, the sprawling angels and cheek-puffed Fames, represented merely a spurious courtly sentimentalism, that might be typified by Chesterfield masquerading in the mantle and vine leaves of Theocritus.

ENGLISH DATED BOOK-PLATES.

SEVENTEENTH CENTURY.

IT will be observed that throughout this essay great prominence is given to book-plates which bear dates.[1] It is submitted, that an ex-libris so inscribed with the year of its engraving becomes by that addition thrice as valuable to the historian, to the antiquary, to the collector. Added to this, it is at present very imperfectly known what materials really survive for a history of our earlier English book-plates. It has therefore been deemed best to endeavour to commence a record of our dated English book-plates in the first instance ; and to make the surer ground, which such a list will supply, a starting-point for tracing upwards and assigning to their respective periods our more antique and undated book-plates hereafter. That some few of these last are indeed older than the Restoration is highly probable ; but, as I have hitherto met with none that are *certainly* older, and *certainly* book-plates, their age will not here be insisted upon.

The general antiquary will be surprised to learn that we have as yet no English book-plate with a date to record earlier than the Restoration. We have full confidence that earlier specimens will come to light, when the inner covers of the libraries of our old country houses shall have been properly searched. There will be a Lamport yet in store

[1] That is to say *engraved* dates, not manuscript ones.

for the ex-librist of the future. Meantime, we must arrange such imperfect records as we possess.

Our first specimen will prove that even engraved dates are in a few cases themselves misleading. In this, and the following instances, the inscriptional portion of the plate is copied first in italics, and is given letter for letter ; old spellings and archaisms being sedulously preserved. In such book-plates as I have had no opportunity of inspecting, or which I could only see hurriedly, the descriptions are given, of course, shortly and often imperfectly. Some half-dozen components of the ensuing list, entered as my own, were acquired so late that I had only space to work in their inscriptions without their heraldry.

The reader must be warned not to expect rigid heraldic accuracy in these ex-libris. Their engravers seem to have been on these points often careless enough. Frequent mistakes occur in rendering the tinctures, and in some minor armorial niceties. It may be pleaded in extenuation, that the space upon a book-plate is often too limited to admit of the engraver setting forth a coat of arms with all the details, which accompany its description in an heraldic work ; especially those relating to the crest, and (when they are present) to the supporters. No doubt, many of the owners of these book-plates had not knowledge enough themselves to exercise any supervision of the design, which was tendered to them, of their own arms.

FUST—*Sr. Francis Fust of Hill Court in the County of Gloucester, Baronet. Created* 21st *August* 1662. *The* 14 *year of King Charles* 2d.[1] *No.* (left blank for the book). *Arms*—Ar. on a chevron betw. three woodbills, paleways, sa. as many mullets pierced of the first. Quartering

[1] In this case, as in others when I have access to the *ex-libris*, the inscriptional part is copied exactly. ' 14 year' and ' 2d ' are thus reproduced.

Boynton, Mannock, Spring, Bancroft, Bedingfield, and numerous others.

Crest—A horse in full speed, ar. *Mottoes* above the crest —Swift and True ; and below the arms—Terrena per vices sunt aliena. Above the right side of the shield is written *Mariages* (sic) *in the male line,* of which the quarterings are given and the names over-inscribed to the number of twenty. Above the left side of shield is read *Mariages in the female line,* which follow in like manner to the number of twenty also. Above the shield are two brackets, left and right, against which the mantling is outspread ; these are lattice-worked within and have outer slightly ornamented frames, bearing dishes of fruit and sun-flowers. Above the fruit hang square festoons of flowers. The motto and inscription scrolls are richly foliated. $6\frac{3}{4} \times 3\frac{3}{4}$ in. W.

After some debate, it has been deemed best to notice this remarkable book-plate under its ostensible date, but it was really engraved long after. The inscription is ambiguous and would seem to infer that Sir Francis Fust was the first Baronet, and that *he* had been created one in 1662. Now the facts are these. Sir *Edward* Fust it was, who soon after the Restoration, was raised to that dignity. Of Sir Francis Fust we hear nothing till times far more recent. This Sir Francis, on September 28, 1724, married Fanny, daughter of Nicholas Tooker, Merchant of Bristol. On a smaller undated book-plate, which exists, this same Sir Francis only gives his own marriage ; and on the ex-libris under notice the last coat, except Fust, which is repeated, on the side of the ' Mariages in the Male Line,' will be found to be Tooker, therefore our apparent book-plate of 1662 must be postdated to 1724.[1]

[1] These incongruities are detected by the Rev. D. Parsons, *Notes & Queries,* 5th, S. V. 65. See also Burke's *Extinct Baronetcies,* 1841, p. 211.

The next is a very simple and business-like book-plate in the writer's collection :—

HILL— *No. xxviii.*
D. & C. Place. Shelf 1.
FRANCISCI HIL
ET AMICORUM
ANNO DOMINI 1668
Pretium
27 Augt. 1668.

The MS. portions of this ex-libris are printed in Italics. The rest in small capitals. The original is composed of movable types; hence, this early book-plate is not an *engraved* but a purely typographical specimen. In the first statement of the date, the 16 is printed, the 68 being filled in in MS. In the second statement, the date is purely manuscript. It cannot be too often repeated, that dates in manuscript on ex-libris are not here considered, as entitling a book-plate to rank in our dated series. It is merely the 16 in type that enables me to record the book-plate of Francis Hill as one bearing a date in the seventeenth century.

NICHOLSON.—*Gilbert Nicholson, of Balrath in the County of Meath, Esqr.,* 1669.

Arms—Erm. on a pale sa. three martlets arg. *Crest*—A tiger sejant bezantée,[1] the neck transpierced by a javelin, all ppr. *Motto*—Pro Republica. Mr. Carson.

The mantling is very voluminous, curling upwards as well as downwards. The shield itself is set in an inner foliated frame; this is very rarely the case. Two unusual rose-like twists occur under the helmet, which are portions of this frame. There is a motto scroll, but no bracket for the inscription, which is simply written across the base of the plate without any scroll, bracket, or border to contain it.[2]

[1] These may be plates, their tincture is dubious.

[2] There is another copy of this ex-libris identical in all but small details, but clearly from a distinct copper plate.

CLAYTON.—*Sr. Robert Clayton, of the City of London, Knight, Alderman & Mayor thereof, Ao.* 1679. *Arms*— Ar., a cross sa. betw. four pellets. *Crest*—On a mural crown a leopard's gamb erect, ar. grasping a pellet. *Motto*—(none). Fine rounded foliated mantling to the base of the escutcheon on each side. The inscription on a plain scroll below the arms. No intermediate motto scroll. W., and Mr. Peckett's collection.

Here, as in some parallel cases, the date of Sir Robert's office is recorded as the main fact in his life, but the plate was probably not engraved till some years after. Sir Robert was the wealthiest city merchant of his time, and only second to the earlier Gresham in civic import- ance. He had a magnificent house in the Old Jewry, and a wonderful villa at Marden in Surrey. He represented the City for 30 years in Parliament, and was a munificent benefactor to Christ's Hospital and other London Institu- tions. He got into political trouble by opposing James the 2nd, and he is mentioned in Dryden's *Absalom and Achitophel* (Part II.) under the name of Ishban,

' Who'd een turn loyal to be made a peer.'

On the arrival of William of Orange, he rode out to Henley to present the city address. There is an amaz- ingly pompous tomb of Sir Robert and his wife at the Church of St. Mary at Bletchingly. This he seems very prudently to have put up for himself in his own lifetime. He sleeps under a lofty canopy in his robes as Lord Mayor. Lady Clayton stands beside him with a motto *Quando ullum inveniet parem.* Weeping Cherubs complete the group.

Inasmuch as a gap of nineteen years will here ensue before our next dated book-plate, we are forced to consider these four preceding examples as ' outliers' in the English series. But from 1698 the reader will be presented with a continuous series of dated book-plates, year by year, until the conclusion of Queen Anne's reign in 1714.

There is a strong family likeness between the ex-libris, which follow, of the conclusion of William's reign and the first half of Anne's. They might indeed be the work almost of one single engraver. So easily recognisable is the style of this period that many undated book-plates may in full confidence be ascribed thereto. But with these, of course, we have at present no concern.

The heraldic arrangement is usually this—A plain escutcheon, surmounted by a helmet;[1] on this the wreath and crest. From the helmet is outspread to each side, upwards, usually to a level with the top of the crest, and downwards to a line with the base of the shield, a voluminously rolled and foliated mantling. Below the shield comes a narrow scroll for the motto (in some book-plates empty); and, last of all, a separate, much broader bracket for the inscription, with usually waved or indented edges.

In their arrangement the coming book-plates are so closely analogous that it may be useful to direct the reader's attention to some minor points of contrast between them. A knowledge of heraldic art at this period may prove useful in dating earlier specimens. The margin of the escutcheon is indented. (Percival, 1702.) It is nearly always plain.

The escutcheon has a separate inner frame of its own, distinct from the mantling. (Nicholson, Kent, 1713.) This is very unusual.

The motto scroll appears, but is left empty. (Bennett, Buckby, Foley, Lovelace, Hanmer, Parker, Ward.)

The motto scroll is absent altogether. (Cook, 1701, Englefield, Gwyn.) The usual indented name-bracket is changed into a fringed cloth. (Buckby, Eyre, Leicester, Parker, Roxburghe, Turnour.)

[1] Varied, of course, for Knight, or Baronet, and Peer. If a coronet appears, it rests immediately on the shield, and the helmet issues out of it. The helmet continues on the book-plates of peers till about 1780.

The motto scroll bears the date. (Northey, Harington.) This usually occurs after the name on the name-bracket. The name-bracket has its lateral margins foliated, not indented or plain. (Byerley, Ketelby, James Bertie, Holbech, Newdegate).

The mantlings show a distinct inner, hatched sable lining. (Bennet, Butler, Cooke, Eyre, Nicholas, Page, Fielding.)

The mantlings show only their outer sides. (Hanmer, Gwyn, etc. etc.)

These ex-libris are anomalous and do not conform to the normal arrangement. (Knatchbull, Lynch, Strafford, Kent, 1712.) The two last have Jacobean brackets.

The dated college book-plates are also quite apart in their arrangement and ornamentation. Scale-work frames, with hawk-bells in festoons, ribbons, tufts of palm, scallop shells, cherub's heads, etc., are here prevalent. The crest and mantling being absent, their void has to be supplied by some other decoration. They are nearly all in the Jacobean style.

The *continuous* series of English dated book-plates commences with Simon Scroope, of Danby.

SCROOPE.—*Simon Scroope, of Danby super Yore, in Com. Ebor, Esq.*, 1698. (The 28 quarterings, beginning with Scroope, and ending therewith, follow, enumerated on the same scroll.) *Arms*—Quarterly, first, az. a bend or. (and 27 other quarterings). *Crest*—Out of a ducal coronet gu. (?) a plume of feathers ar. *Supporters*—Two Cornish Choughs sa. *Motto*—*Devant si je puis.* Mantling only to the base of helmet. Inscription scroll slightly foliated. Above it a motto scroll plain. Mr. Peckett's collection. About 9½ × 7½ inches. A fine book-plate.

ENGLEFIELD.—*Sir Charles Englefield, of Englefield, in the County of Berks., Baronet,* 1698. *Arms*—Barry of six

gu. and ar. on a chief or, a lion pass. az. *Crest*—An eagle disp. per pale az. and gu. W. No motto or motto scroll.

CAVENDISH.—*Cavendo Tutus* as motto of the Cavendish Family. No other inscription except the date, 1698. *Arms* —Sa. three stags' heads cabossed, ar. ; impaling, erm. a fess engr. gu. betw. three fire-balls inflamed sa. *Crest*—a snake nowed, ppr. *Motto*—(as above). Mr. Ponsonby.

RABY.—*The Right Honourable Thomas Wentworth Baron of Raby, and Colonell of his Maiesties owne Royall Reg^{mt}. of Dragoons,* 1698.

Arms—Sa. a chev. betw. three leopards' faces or. *Crest* —A griffin pass. ar. *Supporters*—Dexter, a griffin ar. ; sinister, a lion or. *Motto*—En Dieu est tout. W., Mr. Carson, and Mr. Martin.

The mantling very voluminous. See the book-plate of the same person as Earl of Strafford under the year 1712.

GWYN.—*Francis Gwyn, of Lansanor, in the County of Glamorgan, And of Ford-Abby, in the County of Devon, Esq'.* 1698.

Arms—Quarterly, first, per pale az. and gu. three lions ramp. ar. (and eleven other quarterings). *Crest*—A lion ramp. ar. (motto and motto scroll none). W. $5\frac{1}{2} \times 4\frac{1}{2}$ in.

Very elaborate, intricately foliated, intervolved mantling, in style like Nicholson of Balrath's plate. The lowest point of the mantling on each side ends in a tassel. Name scroll indented. On a smaller plate ($3\frac{1}{2} \times 3$ in.), the above inscription is repeated. The arms are also simpler. No tassels to the mantling. Name scroll as above. W.

SYDENHAM.—*Sir Philip Sydenham Bart. of Brympton, in Somerset and M.A. of the University of Cambridge. Æta. suæ* 23, 1699. *Arms*—Ar. three rams pass. sa. *Motto*—Medio tutissimus. Mantling widespread, stiffly foliated. Mr. Martin.

SYDENHAM.—*Sir Philip Sydenham, etc.,* 1699. Arms

and inscription as above, but the design is quite different, consisting of a square pile of books in three tiers (compare Wm. Hewer); the scroll in the centre does duty as armorial shield. The motto is written on the upper margin, and the inscription is placed upon an uprolled portion of this scroll at its base. Mr. Martin.

HEWER.—*Wm. Hewer, of Clapham, in the County of Surry* (sic), *Esq*̅., 1699.

Not heraldic. Design—a square pile of books, built up in three tiers; at the top, deeds and charters. Across the centre of the pile an unfolded scroll hangs with Wm. Hewer's monogram; below, also upon a scroll, is the date. W.

This is the William Hewer of Samuel Pepys, the diarist.

This specimen concludes our dated book-plates of the seventeenth century. They belong to eleven individuals, but several of these have left more than one book-plate. All, except Wm. Hewer, Sydenham, and Francis Hill, adopt heraldic designs. The number of dated English ex-libris in this century is very small.[1]

[1] Since the above went to press, I have added in this century AUBREY—*S*ʳ *John Aubrey of Lantrithyd in the County of Glamorgan Baronet and of Boarestall in the County of Bucks*, 1698. W. BROWN-LOWE—*Sir William Brownlowe of Belton in the County of Lincoln, Baronet*, 1698. Mr. Peckett.

DATED BOOK-PLATES OF THE EIGHTEENTH CENTURY.

DATED ex-libris begin now to thicken upon us. Indeed, the number existing of the years 1702 and 1703 is very remarkable. It seems convenient to begin a new chapter with the commencement of a new century, but there is no perceptible difference in the art of the specimens, that follow, from those already enumerated.

We commence with some College book-plates. It is curious that these should be absent as yet from our earlier list.

<p align="center">1700.[1]</p>

TRINITY HALL, CAMBRIDGE.—*Collegium sive Aula S. St. Trinitatis in Academiâ Cantabrigiensi*, 1700. *Arms*—Sa. a crescent erm. within a bordure engr. of the last; (no crest, tho' the Hall has one) escutcheon set in the Jacobean scale-patterned frame decked round with ribbons, festoons, etc. Inscription on an indented bracket (Franks).

PEMBROKE HALL, CAMBRIDGE.—*Collegium sive Aula Mariæ de Valentiâ communiter nuncupata Pembroke Hall, in Academiâ Cantabrigiensi*, 1700. C. *Arms*—Barry of sixteen ar. and az. over all five martlets in pale gu.; impaling, vair, two pallets gu. on a chief or, a label of three points throughout az. (the arms of Valence and Chastillion). In a finely worked Jacobean scale-lined frame with festoons, branches, ribbons, etc., very similar to the last.

[1] The ' 1700 ' book-plates should be in the preceding chapter.

ANONYMOUS. — Dated 1700 — no other inscription. *Arms*—Quarterly of six ; first, barry of eight gu. and ar. ; second, az. semée of fleur-de-lis ar., in chief a label ; third, az. a cross crosslet cantoned with four crosses or (and three other quarterings). *Crest*—An eagle, wings expanded, issuing from a ducal crown, or. Finely mantled to base of escutcheon. C.

ROGERS.—*William Rogers of Dowdeswell in the County of Glocester, Esq^r., 1700. C.*

Arms—Ar. a mullet sa. ; on a chief gu. a fleur-de-lis per pale, or and sa. *Crest*—A fleur-de-lis, per pale, or and sa. *Motto*—(none). A fine large book-plate.

1701.

COOKE.—*John Cooke of the Inner Temple, London, Esq., Cheife Prothonotary of the Court of Comon Please, (sic) Westminster, 1701. W.*

Arms—Paly of six, gu. and sa. three eagles displayed arg.; over all, on an escutcheon of pretence, the arms of Warren. *Crest*—A swan, per pale, gu. and sa. wings expanded, ducally crowned, or. (Motto and motto scroll absent.)

CORPUS COLLEGE, CAMBRIDGE.—*Collegium Corporis Christi et B. Virginis Mariæ in Universitate Cantabrigiensi, 1701. C.*

Arms—Quarterly, first and fourth, gu. a pelican in her piety ppr., second and third, az. three fleur-de-lis ar. No motto. Encased in a tasteful Jacobean scale-covered frame, with festoons, branches, etc. Part of the inscription is in cursive hand, part in capitals.

COKE.—*Cary (sic) Coke, Wife of Edward Coke of Norfolk, Esq^r., 1701.* P., & N. & Q. 6th S. 1. 198.

MASON.—*Dame Anna Margaretta Mason Relict of Sir Richard Mason K^t., late Clerke Comtroler (sic) of the Green Cloath (sic) to King Charles and King James the Second, 1701.*

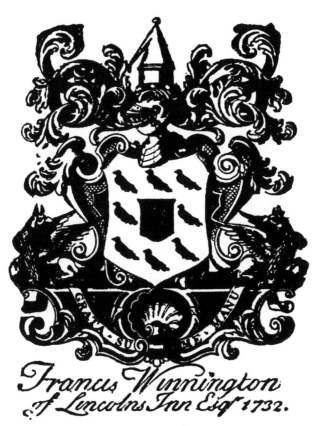

Francis Winnington
of Lincolns Inn Esqr 1732.

[No. 6.]

Arms—Ar. a lion ramp. az.; impaling sa. a lion ramp. betw. eight cross crosslets ar. (no motto) W. and Mr. Pearson. Arms in a Jacobean scale-covered frame, identical with that of Lincoln's College, 1703 (to which refer). It is interesting to read the names of Charles and James the Second occurring on an ex-libris.

ESSEX.—*The Rt. Hon^{ble}. Algernon Capell, Earl of Essex, Viscount Maldon, and Baron Capell of Hadham,* 1701., W.

Arms—Gu. a lion ramp. between three crosses crosslet fitchée or. *Crest*—A demi lion ramp. or, holding in its paws a cross crosslet fitchée gu. *Supporters*—Two lions or, ducally crowned gu. *Motto*—Fide et Fortitudine. Mantling with spaces between its foliations, which is unusual.

1702.

PERCIVAL.—*S^r John Percivale, Baronet, of Burton in the County of Cork in Ireland,* 1702. W. *Arms*—Ar. on a chief indented gu. three crosses pattée of the field. *Crest* —A thistle erect, leaved ppr. *Motto*—Sub cruce canto. A bustling politician of those times, who, as he rose in the world, engraved a new dated ex-libris in 1715 to commemorate his elevation to the Peerage in that year, on which he figures as *John, Lord Percival, Baron of Burton in the County of Cork.* W. We have a third *ex-libris* dated in 1736 of himself as Earl of Egmont. He died in 1748. His son John, 2nd Earl, was the author of 'Faction Displayed.'

HALIFAX.—*The Right Hon^{ble}. Charles Lord Halifax,* 1702. W. two sizes. *Arms*—Quarterly, first and fourth, ar. three lozenges conjoined, in fesse gu. within a bordure sa.; second and third, or, an eagle displ. vert, beaked and membered gu. *Crest*—A griffin's head couped, wings expanded sa. charged on the neck with a portcullis, ppr. *Supporters*—Two griffins, gutty de sang, each charged on the shoulder with a portcullis.

A prominent politician of Queen Anne's reign, and a minor poet. In frequent contact with Dean Swift, to whom he seems to have made large promises, which ended in smoke.

KENT.—*The Right Hon^{ble}. Anthony Earle of Kent*, 1702. W. *Arms*—Barry of six, ar. and az., in chief three torteaux, es. *Crest*—On a chapeau az., turned up, erm., a wyvern ar. wings elevated. *Supporters*—Two wyverns ar. *Motto*—Foy est Tout. W. Slightly cut mantling.

KETELBY.—*Abel Ketelbey of ye Middle Temple, Esq^r.*, 1702. W. Name-bracket laterally foliated.

TREVOR.—*The Right Hon^{ble}. Sir Thomas Trevor, Knight, Lord Chief Justice of Her Majesties Court of Comon Pleas and one of Her Majesties Most Hon^{ble}. Privy Council*, 1702. W. No motto or scroll for the motto.

DERBY.—*The Right Hon^{ble}. James Earl of Derby, Lord of Man and ye Isles*, 1702. *Arms*—Ar. on a bend az. three bucks' heads cabossed, or. *Crest*—An eagle, wings endorsed, or, feeding on an infant in its cradle, ppr., swaddled az. banded of the first. *Supporters*—Dexter, a griffin or.; sinister, a buck, also or; both ducally collared and chained az.: the buck attired of the first. *Motto—Sans changer.* (6½ × 8½ in.) W.

Fine foliated mantling and plain motto scroll.

HERVEY.—*The Right Hon^{ble}. John Lord Hervey, Created Baron of Ickworth in Com. Suff. March the* 23^d, 1702. W.

Arms—Quarterly, first, gu. on a bend ar. three trefoils, slipped vert. (and other quarterings). *Crest*—A leopard pass. sa. bezantée, ducally gorged and chained or, holding in the dexter paw a trefoil slipped vert. *Supporters*—Two leopards sa. bezantée, ducally gorged and chained or. *Motto*—Je n'oublierai jamais.

Plain mantling and name-scroll. Note that here the date refers to the creation, but the book-plate was probably

engraved shortly after. This is the father to Pope's Lord Hervey.

KNATCHBULL.—*Thomas Knatchbull, Esq'., third son of Sir Thomas Knatchbull, of Mershamhatch, in the County of Kent, Baronet.* 1702. W.

Arms—Quarterly, first, az. three crosses crosslet fitchée, betw. two bendlets or. (and three others). *Crest*—On a chapeau az. turned up erm. a leopard statant ar. spotted sa. (motto and its scroll wanting). The old foliated mantling replaced by the more modern mantle, its upper corners tied up and tasselled below. Name bracket indented.

TEMPEST.—*Sir George Tempest, Baronet, of Tonge, Co. York,* 1702. Wilson, Birmingham, Cat. 47, p. 2.

LITTLETON.—*S'. Thomas Littleton, Baronet, Treasurer of Her Majesties Navy,* 1702. P. and W.

Arms—Quarterly, first and fourth, ar. a chev. betw. three escallops sa.; second and third, barry of eight, or and gu. *Crest*—A Moor's head in profile, couped at the shoulders, ppr. wreathed about the temples ar. and sa. *Motto*—Ung Dieu et ung Roy.

FOX.—*Charles Fox of the Parish of St. Martin in the Fields, Esq.,* 1702. P.

Arms—Erm. on a chev. az. three foxes' heads erased or, on a canton of the second a fleur-de-lis of the third. *Crest*—On a chapeau az. turned up erm. a fox sejant or. *Motto*—(none).

BENGOUGH.—*James Bengough of the Inner Temple, London, Gent.,* 1702. P. *Arms*—Per fesse engr. ar. and sa. in chief three lions' heads erased, and in base three crosses patée counter-changed. *Crest*—A lion's head erased sa. (P.) Mantling to base of shield. *Motto*—(none).

TOWNELEY.— *Ex libris Bibliothecæ Domesticæ Richardi Towneley de Towneley in Agro Lancastrensi Armigeri Anno Ætatis: 73 Domini: 1702.* P. and W.

Arms—Ar. a fesse sa. three mullets in chief of the second. *Crest*—On a perch or, a hawk close ppr. beaked and belled of the first. *Motto*—Tenez le vray.

Fine voluminous mantling reaching to level with the base of the shield. The name scroll (which is rare) slightly foliated like the mantling at its sides. A remarkable book-plate. The phrase *ex libris* is rare at this date.

HOLBECH.—*Mr. Ambrose Holbech of Mollington in the County of Warwick*, 1702, W.

Arms—Vert, six escallops ar. differenced by a crescent of the second. *Crest*—A maunch vert, charged with escallop shells, ar.

The 'Mr.' on an armorial book-plate is unusual. He, who bears arms, is usually styled at this period *Armiger* or *Esquire*. The lateral sides of the name-bracket are foliated.

NEW COLLEGE, OXFORD.—*Collegium Novum: Oxon*, 1702, C. *Arms*—Ar. two chevrons sa. betw. three roses gu. seeded, or, barbed vert, impaled with the arms of the See of Winchester, encircled with the garter, and ensigned with an episcopal mitre. *Motto*—Manners makyth man With elaborate highly floreated mantling. The College was founded in 1379 by William Wyckham, Bishop of Winchester.

BERTIE.—*The Hon^{ble}. James Bertie, Esq^r., of Stanwell in Co^m. Middx., second son to James late Earle of Abingdon*, 1702. Pearson.

Arms—Quarterly, first, ar. three battering rams bar-ways in pale, ppr. headed and garnished az., a crescent for difference (and three other quarterings). *Crest*—A man's head affrontée couped at the shoulders ppr. ducally crowned or, charged on the chest with a fret, az. *Motto* —Virtus ariete fortior.

Mantling voluminous and intricately cut. Cross-hatched inner lining shewn. Inscription scroll laterally foliated.

BERTIE.—*The Hon^ble. Robert Bertie of the Middle Temple, Esq^r.* 1702. (Hutt.) Younger brother to the last. James Bertie's son became ultimately Lord Abingdon.

BYERLEY.—*Robert Byerley of Gouldesbrough in the West Rideing (sic) of ye County of Yorke, Esq^r.,* 1702. W.

Arms—Or, a cross crosslet gu.; over all, an escutcheon, quarterly, first, az. a manche ar., within a bordure crusily[1] or (and three other quarterings). *Crest*—Two lions' gambs or, holding a cross crosslet gu. *Motto*—Foyall et Loyall.

Mantling elaborate. Lining vertically hatched (gules) and kept very distinct from the outer portions. Lateral edges of the name-scroll foliated.

1703.

DENBIGH.—*The Right Hon^ble. Basil Fielding Earl of Denbigh* 1703. W. *Arms*—Ar. on a fesse az. three lozenges or. *Crest*—An eagle displayed ar. *Supporters*—Two bucks ppr. attired and unguled or. *Motto*—Honor virtutis præmium.

Short mantling with cross-hatched lining. The family name is now spelt *Feilding*.

LYNCH.—*Philippus Lynch Medij Templi Socius,* 1703. W. *Arms*—Ar. a chev. gu. betw. three trefoils slipped az. *Crest*—A fox pass. ppr. *Motto*—De lupo.

Very unlike the rest of the series. The escutcheon is oval. The inscription in Latin is exceptional. There appears a Jacobean frame round the arms, of which the limbs are confused with and mixed up among the mantling.

NORTHAMPTON.—*The Right Hon^ble. George Earl of Northampton, Baron Compton,* 1703. P.

Arms—Sa. a lion pass. guard. or, betw. three helmets ar. *Crest*—On a mount vert a beacon or, enflamed on the top ppr. on the beacon a label inscribed *Nisi Dominus*. *Sup-*

[1] These charges are uncertain.

porters—Two dragons, with wings expanded, erm. ducally gorged and chained or. *Motto*—Ji ne cherche qui ung. (*sic*).

CREWE.—*Nathaniel Crewe, Lord Bishop of Durham and Baron Crewe of Stene*, 1703. Franks.

Arms—Az. a cross betw. four lions ramp. or (for Durham); impaling az. a lion ramp. ar. (for Crewe). *Crest* —Out of ducal coronet or, a lion's gamb erect ar. *Supporters*—Dexter, a lion ar.; collared gu.; thereon three roses, or.; sinister, a griffin sa. *Motto*—(none). Baron's coronet, but no mitre. Crozier and sword in saltire behind arms. With light graceful mantling.

LINCOLN COLLEGE.—*Collegium Lincolniense in Universitate Oxon*, 1703. C.

Arms—The escutcheon divided paleways into three parts, the centre ar. thereon the arms of the See of Lincoln, ensigned with a mitre, all ppr. On the dexter side, barry of six ar. and az., in chief three lozenges gu: Sinister side, vert, three stags trippant, two and one ar, attired or (motto and crest none). The shield set in a pretty Jacobean frame lined with scale-work, and flourished into angles, adorned outside with ribbons and festoons. A few ornaments like mantling curves at top.

POLEY.—*Henry Poley of Badley in Com. Suffolk Esq*., 1703. (Mr. Martin.) *Arms*—Or, a lion ramp. sa. *Crest* —A lion ramp., as in the arms, collared and chained or. *Motto*—Fortior est qui se.

EYRE.—*Robert Eyre of Lincoln's Inn, Esq*., 1703. W.

Arms—Ar. on a chev. sa. three quatrefoils of the field. *Crest*—A leg erect, in armour, per pale, ar. and sa., couped at the thigh. *Motto*—Sola virtus invicta.

Mantling with cross-hatched (sable) lining. A fringed cloth bears the name.

GUILDFORD.—*The Right Hon^ble. Francis North Baron of Guildford*, 1703. W.

Arms—Az. a lion pass. or, betw. three fleur-de-lis ar. differenced with a crescent ar. *Crest*—A dragon's head erased sa., scaled, ducally gorged or. *Supporters*—Two dogs ar. *Motto*—Animo et Fide.

Mantling loose with spaces between its folds.

NORTH.—*The Right Hon^{ble} William Lord North of Carthlage and Baron Grey of Polleston,* 1703. C. *Arms*—Quarterly, first and fourth, az. a lion pass. betw. three fleur-de-lis ar. ; second and third, gu. a lion ramp. ducally crowned, within a bordure ar. *Supporters*—Two dragons sa. ducally gorged and chained or. *Crest*—A dragon's head, erased, sa. scaled, ducally gorged and chained or. *Motto*—(none). Mantling slight.

PENN.—*William Penn Esq^r Proprietor of Pensylvania,* 1703. Mr. Carson.

Arms—Ar. on a fesse sa. three plates. *Crest*—A demi-lion ramp. ar., gorged with a collar sa. charged with three plates. *Motto*—Dum clavum teneam.

An ex-libris of high interest.

SELBY.—*James Selby Sergeant at Law.* 1703. (Hutt.)

FOX.—*S^r Stephen Fox of ye Parish of S^t Martin in the Fields Knight,* 1703. P. and C.

Arms—Erm. on a chev. az. three foxes' heads erased or, on a canton of the second a fleur-de-lis of the third. *Crest*—On a chapeau az. turned up erm. a fox sejant or. *Motto*—(none).

Intricate rounded mantling to the escutcheon base.

NORTHEY.—*S^r Edw. Northey Knight her Majestyes Attorney Generall,* 1703. C.

Arms—Or, on a fesse az. betw. three panthers statant gu. semée of estoiles ar. two lilies of the last, with a rose in the centre, gold stem, vert. *Crest*—A cockatrice, flames issuant from the mouth ppr. *Motto*—Steady. Rich

circular rolled mantling. The date is divided, right and left, on the motto scroll, an unusual position.

QUEENSBERRY.—*Duke of Queensberry*, 1703. (Mag. Notes and Queries, 5th S. viii., 397.)

BURY.—*The Hon^ble S^r Thomas Bury Knight, one of the Barons of her Ma^ties Court of Exchequer*, 1703. (Mr. Martin.) *Arms*—Erm. on a bend engr. az. plain cotised gu. three fleur-de-lis or. *Crest*—A demi-dragon arg. wings, ears, and claws sa.

NICHOLAS.—*Edward Nicholas Esq^r of Gillingham in the County of Dorset*, 1703. W.

Arms—Quarterly, first and fourth, ar. on a cross gu. a crown or; second and third, ar. a fess betw. three ravens sa.; over all, an escutcheon az., a chev. betw. three wolves' heads erased or. *Crest*—A lion statant or; semée of estoiles az. *Motto*—(none). Hatched lining to the mantling. Motto scroll empty.

ROXBURGHE.—*The Right Honble John Earl of Roxburghe Lord Ker Cesfoord and Cavertoun*, 1703. W.

Arms—Quarterly, first and fourth, vert. on a chev. bet. three unicorns' heads erased ar. armed and maned or, as many mullets sa. for *Ker*; second and third, gu. three mascles or, for *Weapont. Crest*—A unicorn's head erased ar. armed and maned or. *Supporters*—Two savages, wreathed about the head and waist with oak leaves, each holding with the exterior hand a club resting upon the shoulder, all ppr. *Motto*—Pro Christo et Patria dulce periculum.

BROMLEY.—*William Bromley of Baginton in ye County of Warwick, Esq^r.*, 1703. W.

Arms—Quarterly, per fesse indented gu. and or, an escutcheon ar. charged with a griffin segreant vert. *Crest*—Out of a ducal coronet or, a demi-lion ar. supporting a banner gu. charged with a lion pass. gold, staff of the last. *Motto*—Vexillo virtutis vinco.

Stiff, circular, outspread mantling with distinct sable inner lining. The plate is smaller than the average: 2½ × 2 in.

BRODRICK.—*St John Brodrick of the Middle Temple Esqr*, 1703. F.

Arms—Ar. on a chief vert two spears' heads erect of the first, the points embrued gu. *Crest*—Out of a ducal coronet or, a spear ar. embrued gu. *Motto*—A cuspide corona. Circular voluminous mantling to base of shield with cross-hatched, sable, lining.

THOMOND.—*The Right Honble Henry Earl of Thomond, Lord OBrien, Baron of I Brickan*, 1703. W. and C.

Arms—Quarterly, first and fourth, three lions pass. guar. in pale, per pale, or and ar. ; second, ar. three piles meeting in a point, issuing from the chief, gu. ; third, or a pheon az. *Crest*—An arm embowed, brandishing a sword, ar. pomel and hilt or. *Supporters*—Two lions guar. per fesse or and az.[1] *Motto*—Vigueur de dessus.

BEDFORD.—*The most Noble Wriothesley Duke of Bedford, Knight of ye Most Noble Order of the Garter*, 1703. W.

Arms—Ar. a lion ramp. gu. ; on a chief sa. three escallops of the first. *Crest*—A goat passant ar. armed or. *Supporters*—Dexter, a lion ; sinister, an antelope ; both gu., the latter ducally gorged, lined, armed, and hoofed gold. *Motto*—Che sara sara.

SOMERSET.—*The Right Honble Lord Charles Somerset, Second Son to ye late Marquess of Worcester*, 1703. P.

Arms—Quarterly, France and England, within a bordure componée ar. and az. *Crest*—A portcullis or, nailed az., with chains pendent thereto gold. *Motto*—Mutare vel timere sperno.

[1] On this book-plate some niceties of tincture are omitted, which in this and in a few other cases I deem it best to supply.

BUCKBY.—*Richard Buckby of Lincolns Inn Esq^r*, 1703. W.

Arms—Sa. a chev. betw. three stags' heads cabossed or. *Crest*—A stag's head erased or.

RICHMOND.—*Thomas Richmond alias Webb of Rod-bourne Cheney in the County of Wilts Esq^r*, 1703. W.

FORTESCUE.—*John Fortescue of the Middle Temple Esq^r*, 1703. W. Name bracket altered to a cloth.

FOLEY.—*Richard Foley Esq^r Second Prothonotary of Her Majesties Court of Comon Pleas*, 1703. W. Motto scroll empty.

BENNET.—*John Bennet Esq^r Judge of the Marshalls Court*, 1703. W.

PAGE.—*Francis Page of the Inner Temple Esq^r*, 1703. W. Name bracket altered to fringed cloth.

BUTLER.—*Richard Butler of Lincoln's Inn Esq^r*, 1703. W.

Arms—Az. a bend between six cups covered or, differenced with a mullet gu. *Crest*—A unicorn saliant ar. armed or. Motto none, and its scroll empty. Sable inner lining to the mantling.

1704

SKIPWITH.—*S^r Fulwar Skipwith of Newbold Hall in the County of Warwick Baronet*, 1704. C.

Arms—Quarterly, first, ar. three bars gu.; in chief a greyhound courant sa. collared or (and other quarterings). *Crest*—A turnstile ppr. *Motto*—Sans Dieu je ne puis.

DAWES.—*Sir William Dawes Baronet*, 1704. C.

Arms—Ar. on a bend az. cotised gu. three swans or, betw. six battle-axes sa. *Crest*—A halbert erect or, on the point a flying dragon without legs, tail nowed sa. bezantée, vulned gu. *Motto*—(none).

DUDLEY.—*Sir William Dudley Baronet of Clapton,*
1704. Mag. Notes and Queries, 5th S. viii., 397.

WARD.—*John Ward of Capesthorne Cõm. Cestr. and of
the Inner Temple Esq*ʳ, 1704. W. *Arms*—Quarterly, first
and fourth, az. a cross pattée or; second and third, ar. a
chev. betw. three martlets sa. Motto scroll empty; mant-
ling slightly foliated. Name scroll represented by a
fringed cloth. No crest, but an isolated curl of the mant-
ling fold is placed so as to fill its void.

WEYMOUTH.—*The Right Hon*ᵇˡᵉ *Thomas Lord Viscount
Weymouth, Baron Thynne of Warminster,* 1704. W.

Arms—Quarterly, first and fourth, barry of ten, or and
sa.; second and third, ar. a lion ramp. gu. *Crest*—A rein-
deer statant, or. *Supporters*—Dexter, a reindeer or,
gorged with a plain collar sa.; sinister, a lion, tail nowed,
gu. *Motto*—J'ai bonne cause.

WINCHELSEA.—*The Right Hon*ᵇˡᵉ· *Charles Earle of Win-
chelsea, Viscount Maidstone, Baron Fitz-Herbert of East-
well,* 1704. P. W. *Arms*—Quarterly, first and fourth, ar.
a chev. bet. three griffins pass. wings endorsed sa.; second
and third, gu. three lions ramp. or. *Crest*—A pegasus,
courant ar. winged, maned and hoofed or, ducally
gorged of the last. *Supporters*—Dexter, a Pegasus ar.
wings, mane, and hoofs or, ducally gorged of the last;
sinister, a griffin, wings endorsed sa., ducally gorged or.
Motto—Adversis major, par secundis. Mantling loose
and short.

PARKER.—*Thomas Parker of the Inner Temple Esq*ʳ,
1704. W. *Arms*—Quarterly, first and fourth, gu. a chev.
betw. three leopards' heads or; a crescent for difference.
Second and third, az. two bars betw. three mullets ar., two in
chief and one in fesse. *Crest*—A leopard's head guard. erased
at the neck or, ducally gorged gu. Motto scroll empty.
Mantling rather simply cut, a fringed cloth bears the name.

LEICESTER.—*The Right Hon^ble Philip Sydney Earle of Leicester, Viscount Lisle and Baron Sydney of Penshurst,* 1704. C. *Arms*—Or, a pheon az. *Crest*—A bear sejant ar. muzzled sa. collared and chained or, supporting a ragged staff, also ar. *Supporters*—Dexter, a lion or, ducally crowned, chained and collared : sinister, a lion guard. ar. ducally crowned or. *Motto*—Quo fata vocant. Inscription on a fringed cloth. Mantling with very black lining.

LOVELACE.—*The Right Honble John Lord Lovelace Baron of Hurley in Com̃. Berks,* 1704. *Arms*—Gu. on a chief indented sa. three martlets ar. *Crest*—On a staff raguly, vert, an eagle displayed ar. *Supporters*—Two pegasi ar. Motto scroll empty, mantling simple. W. The staff raguly is hardly visible.

1705.

TURNOUR.—*S^r Edward Turnour of Hollingbury in the County of Essex Knight,* 1705. Pearson. *Arms*—Ermines, on a cross quarter-pierced ar. four fers-de-moline sa. *Crest* —A lion pass. guar. ar. holding in the dexter paw a fer-de-moline sa.

Elaborate strawberry-leaved mantling. Motto scroll empty. The inscription bracket changed to a fringed cloth.

MONTAGU.—*George Montagu Esq^r,* 1705. W. *Arms*— Quarterly, first and fourth, ar. three lozenges conjoined, in fesse gu. within a bordure sa.; Second and third, or, an eagle displayed vert., beaked and membered gu. *Crest*— A griffin's head couped, wings expanded or, gorged with a collar ar. charged with three lozenges gu.

NORTH.—*The Honble Charles North Esq^r,* 1705. W.

1706.

HARINGTON.—*Gostlet Harington of Marshfield in the Coun: of Glocester Gent:* 1706. W. *Arms*—Quarterly, first

and fourth, sa. a fret ar.; second and third, gu. a chev. engrailed erm. betw. three pheons ar. *Crest*—A lion's head erased or.

No motto, but the date is placed by itself on the motto scroll. Curious mantling cut like strawberry leaves. An odd smudgy look about the shadows; inscription in a very large round hand. The helmet is covered with stars.

<p align="center">1707.</p>

HALDANE.—*The Hon^{ble} John Haldane of Gleneagles,* 1707. C. and P. *Arms*—Quarterly, first and fourth, sa. a saltire rayonnant (wrongly drawn in book-plate) ar.; second, az. a saltire cantoned with four roses ar.; third, az. a bend chequy gu. and ar. *Crest*—An eagle's head couped or. *Motto*—Suffer, suffer.

Mantling only to helmet-base.

JONES.—*Richard Jones Esq^r,* 1707. *Arms*—Per pale az. and gu. three lions ramp. ar., a crescent for diff.; on an escutcheon, over all, gu. three lions pass. ar. *Crest*—A griffin's head erased ducally crowned ar. Pearson.

Motto and motto scroll absent; plain circular mantling, no lining visible.

SHELBURNE.—*The Right Hon^{ble} Henry Lord Baron Shelburne in ye Kingdom of Ireland,* 1707. C. *Arms*—Erm. on a bend az. a magnetic needle pointing at the pole-star or; impaling, per bend crenelle gu. and ar. *Crest*—A bee-hive or, fretty az. bees ppr. *Supporters*—Dexter, a pegasus erm. bridled, crined, winged, and unguled or, charged on the shoulder with a fleur-de-lis az.; sinister, a lion per bend crenelle gu. and ar. *Motto*—Ut apes geometriam.

GRAY.—*S^r James Gray Baronet,* 1707. W. *Arms*—Gu. a lion ramp. ar. within a bordure engr. of the last

Crest—A dexter hand couped at the wrist, holding·a chaplet, all ppr. *Motto*—Decus et.tutamen.

HANMER.—*S͗ Thomas Hanmer of Hanmer in Com̄: Flint Baronet*, 1707. W., two sizes. *Arms*—Ar. two lions pass. guard. az. armed and langued gu. (numerous other quarterings). *Crest*—On a chapeau az. (given here gu.), turned up ermine, a lion sejant guard. ar. 6 × 5⅜ in.

Sir Thomas was Speaker of the House of Commons, and also a man of letters, and edited Shakespeare. He married secondly an heiress named Elizabeth Folkes, whose book-plates in her maiden name we also have. The motto is here absent and its scroll empty.

1708.

CAMPBELL.—*The Honourable Archibald Campbell Esq͗*, 1708. W. Two sizes. *Arms*—Quarterly, first and fourth, gyronny of eight or and sa.; second and third, ar. a lymphad, her sails furled and oars in action, all sa., flag and pennants flying gu. *Crest*—A boar's head erased ppr. *Supporters*—Two lions guard. gu. *Motto*—Ne obliviscaris.

THOMPSON.—*William Thompson of Humbleton in Yorkshire Esq͗*, 1708. W. *Arms*—Per fesse ar. and sa. a fesse embattled betw. three falcons, belled, all counter-changed. *Crest*—An arm embowed, grasping the truncheon of a tilting spear, ppr. (Motto scroll empty.) Plain rough mantling.

ROTHES.—*The Right Honble John Earl of Rothes*, 1708. C. *Arms*—Quarterly, first and fourth, ar. on a bend az. three buckles or; second and third, or a lion rampant gu. *Crest*—A demi-griffin ppr. *Supporters*—Two griffins, per fesse, ar. and gu. *Motto*—Grip fast. Plain mantling and plain motto scroll.

1709.

NEWDIGATE.—*S͗ Richard Newdigate of Arbury in the County of Warwick Baronet*, 1709. W. *Arms*—Gu. three

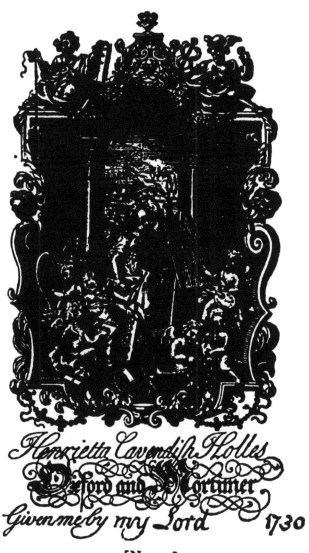

Henrietta Cavendish Holles
Oxford and Mortimer
Given me by my Lord 1730

[No. 7.]

lions' gambs erased ar. *Crest*—A fleur-de-lis ar. (Motto and its scroll absent.) Mantling unusual, finely cut with distinct spaces showing through its folds to the base of the shield. Name bracket foliated at its lateral edges. Two curious calligraphic flourishes in the third line of the inscription.

BUCKINGHAM.—*Owen Buckingham, Reding (sic) County of Berks Esq*^r, 1709. C. *Arms*—Erm. on a bend wavy az. betw. two lions ramp. gu. three bezants. *Crest*—On a chapeau az. turned up erm. a demi-swan, wings expanded ppr. membered or, gorged with a ducal coronet gu. These arms were granted in 1708, so that the book-plate was engraved hard upon the grant to commemorate it.

This plate has a shaded background, and is the only one in the series so ornamented. Its general work is also more modern than any of Queen Anne's book-plates which I have seen.

HEAD.—*S*^r *Francis Head Baronet*, 1709. C. *Arms*—Ar. a chev. ermines, bet. three unicorns' heads couped sa.; over all an escutcheon, quarterly, first and fourth, ermine, on a fesse sa. three roses gu.; second and third, az. as many stags trippant ppr. *Crest*—A unicorn's head, couped, ermines. *Motto*—Reginæ fidus, fidus et patriæ.

1710.

SOUTHESQUE.—*The Right Hon*^{ble} *James Earl of Southesque Lord Carnegy of Kinnaird and Leuchars*, 1710. C. Two sizes. *Arms*—Or, an eagle displayed az. beaked, membered, and armed gu. *Crest*—A dexter hand holding a thunderbolt winged or. *Supporters*—Two greyhounds, ar. collared or. *Motto*—Dread God.

KENT.—*Jemima Dutchess (sic) of Kent*, 1710. Two separate escutcheons placed side by side in a common frame-work. The dexter shield:—*Arms*—Barry of six ar. and az. in chief three torteaux. The sinister shield:—

Arms—Ar. a lion rampant gu. Compare this plate with that of the same lady in 1712. It will be found that both in the tinctures and charges there is some difference between the two.

1711.

FREWEN.—*Thomas Frewen of Lincoln's Inn in the County of Middlesex Esq*, 1711. W. *Arms*—Quarterly, first, erm. four bars az. a demi-lion ramp. ppr. issuant in chief; second, ar. a cross crosslet fitchée sa. (and two other quarterings). *Crest*—A demi-lion ramp. ar. langued and collared gu. bearing in its paws a galtrap az. *Motto*—Christo duce vincam.

1712.

GRACE.—*Michael Grace Esq*, 1712. C. *Arms*—Quarterly, first, gu. a lion ramp. ar.; second, gu. a saltire ar. betw. twelve crosses crosslet or; (and two other quarterings); impaling, or, on a cross gu. five mullets of the field. *Crest*—A demi-lion ramp. ar. *Supporters*—Dexter, a lion ppr.; sinister, a boar or. *Mottoes*—En grace affie. And—Concordant nomine facta.

The upper ledge of the name-bracket is corniced, the rest of it only engraved in outline.

EDWARDS.—*Coll: Jesu Oxon. legavit Jonathan Edwards, S. T. P. Principalis*, 1712. *Arms*—Az. three stags trippant ar. Elaborate angular scale-lined frame-work. Hawk-bell festoons, palm branches, a cherub's head, etc. Inscription on a cloth, not a bracket.

KENT.—*Jemima, Dutchefs (sic) of Kent*, 1712. Two separate shields. Dexter, *arms*—barry of six ar. and az., over all, an escutcheon, az. a lion ramp. gu., surrounded by the garter. Sinister—*arms*—as on the inescutcheon. The frame-work is more ornamented than in the Duchess's plate of 1710. A scallop shell appears above between the two shields; the frame has the usual scale-work. The bracket is foliated.

STRAFFORD.—*His Excellency the Right Honourable Thomas Earl of Strafford. Viscount Wentworth, of Wentworth Woodhouse, and of Stainborough. Baron of Raby. Newmarch, and Oversley ; Her Majesty's Ambassador Extraordinary, and Plenipotentiary to the States General of ye United Provinces, and also at the Congreſs of Utrecht ; Colonel of Her Majesty's own Royal Regiment of Dragoons ; Lieutenant General of all Her Forces ; First Lord of the Admiraltry (sic) of Great Britain and Ireland ; one of ye Lords of Her Majesty's most Honourable Privy Council ; and Knight of the most Noble Order of ye Garter.* 1712. W. 6½ inches by 4½.

This stately rodomontade of titles and offices has been copied at full, as a typical and rather early instance of a class of *ex-libris* which is commoner on the Continent than with us.

Arms—Sa. a chev. betw. three leopards' faces or, encircled with the garter. No *crest. Supporters*—Dexter, a griffin ar. ; sinister, a lion or. *Motto*—En Dieu et tout. Wholly without mantling.

BRUCE.—*The Right Hon^{ble} Charles Viscount Bruce of Ampthill (Son and Heir Apparent of Thomas Earl of Ailesbury) and Baron Bruce of Whorleton,* 1712. C. *Arms* —Quarterly, first, or, a saltire and chief gu. on a canton ar. a lion ramp. az. *Crest*—A lion statant az. (and eight other quarterings). *Supporters*—Two savages ppr. wreathed about the head and loins with laurel, vert. *Motto*—Fuimus.[1]

1713.

KENT.—*Henry Duke of Kent,* 1713. W. Two sizes. *Arms*—Barry of six, ar. and az. surrounded by the garter. *Supporters*—Two wyverns ar. No *crest. Motto*—Stat religione parentum. 5 × 4 in. A very fine *ex-libris*.

Mantling wholly absent. The escutcheon placed on a

[1] Lord Bruce was summoned to the Upper House in his father's lifetime.

highly ornamented Jacobean bracket. The name also in
an oblong Jacobean frame-work, appended below the
bracket. Contrast the simpler book-plate of Anthony,
Earl of Kent, eleven years earlier.[1]

ROWNEY.—*Tho. Rowney of the City of Oxford Esq*.
1713. C.

The book-plate of Thomas Rowney concludes our dated
series. In August 1714 Queen Anne died, and with the
accession of the House of Hanover a new epoch in our
national history begins. In art, in literature, in politics, a
great change came over England. The year 1714 seems,
therefore, on several accounts a convenient pausing place.

The series just enumerated is not, we submit, without in-
struction. We view every dated ex-libris as, to some ex-
tent, a definite historical record; nor is it uninteresting to
have some idea of what libraries existed in Britain in the
days of Pope, of Swift, of Marlborough. The list just
given will, no doubt, be doubled by future research; but,
as far as it goes, it is a faithful index of the book-lovers of
the period. As contrasted with foreign contemporaneous
book-plates, it is rather a plain and unostentatious series.
But, as a rule, though not highly decorated, all these ex-
libris are in good taste.

It is worth while inquiring, before we close this portion
of our subject, who were the book-collectors in Queen
Anne's reign. The series, which has just been given,
affords fair materials for a rough reply.

We record the ex-libris of 99 distinct individuals[2] and

[1] The Kent family is prolific in dated book-plates. We have seen
—Anthony, Earl of Kent, 1702 (two varieties); Jemima, Duchess of
Kent, 1710, and again in 1712; Henry, Duke of Kent, 1713 (two
sizes); Anthony, Earl of Harold (his heir apparent) 1717. Seven
dated book-plates in all.

[2] Two persons, Lord Raby and the Duchess of Kent, have book-
plates in two separate years.

colleges. Of these 24 are Peers of the realm; 13 are Baronets; 6 bear courtesy Titles or are Honourables; 6 are Knights (of whom three are lawyers); 35 are Esquires, and of these 15 are lawyers; 3 are anonymous or uncertain; 6 are Colleges; 3 are of Ladies; 1 'Mr.'; and 2 'gentlemen.'

There are plenty of Lawyers in the catalogue, but no medical men. No clergyman, except Bishop Crewe, and he is Baron Crewe as well as Bishop of Durham. No one, except Towneley, has the formula *ex libris.* Hewer's, Hill's, and Sydenham's are the only unarmorial book-plates.

The number of book-plates dated in 1701 is five; in 1702 the number is eighteen; in 1703 it is twenty-nine; in 1704 the number recedes again to nine. It is curious, why the years 1702 and 1703 should be so prolific of dated examples.

Every single year from 1698 to Queen Anne's death is represented by one or more dated book-plates.[1] This list has taken some years and a good deal of trouble to compile. It is intended more for reference than for continuous reading.

ADDITIONS WHILE PRINTING.

FITZWALTER.—*The Right Honble Charles Mildmay Lord Fitzwalter Egremont Burnell and Bottetoft,* 1701. (*Carson.*) HEDGES. —*The Right Honble S^r Charles Hedges Knight one of her Majesties Principal Secretaries of State,* 1702. (*W.*) PRICE.—*Honble Robert Price,* 1703. (*Salkeld.*) PYGOTT.—*Nathaniell Piggott of the Inner Temple, London, Esq.,* 1703. (*W.*) POLLOK.—*S^r Robert Pollok of that Ilk Baronet,* 1707. (*W.*)

[1] All the Colleges, Lynch, Hill, and Towneley have Latin inscriptions. Not a single book-plate is signed by an engraver.

MOTTOES DIRECTED AGAINST
BORROWERS.

NEXT to an umbrella, there is no item of personal property concerning the appropriation of which such lax ideas of morality are current as a book. If you neglect to restore a horse, a greatcoat, or a pocket-handkerchief, some social stigma will probably attach to you should the depredation become generally known. In the case of the book-borrowers there is no such Nemesis. They flourish like green bay-trees, and command universal respect. The broken sets, which they have caused, give them no twinge of remorse. The gaps, which they have left in innocent homes, break not their sleep at night. Their tables groan with a holocaust of odd volumes, filled with any one's ex-libris but their own.

This is a dismal picture, but our forefathers seem to have suffered from the ravages of this insect—we cannot call it—man. Book-larceny seems to have reared its front of brass at a sufficiently early period. The ex-libris is the mature act of book-preservation, and to engrave thereon some fulmination against the borrower, is a virtuous and commendable proceeding.

Such mottoes form a rather curious collection. *The*

ungodly borroweth and payeth not again.[1] That is terse,
neat, and to the point ; therefore, let it stand first in our list.

Earliest in antiquity, but neither neat nor terse, is the
worthy Andreas Hedio, who speaks for himself in his own
doggrel about 1650 A.D.—*Andreas Hedio Philosophiæ in
Academia Regiomontana* (Königsberg) *Professor. Publ.
Ordinar. Electoralium Alumnorum Collegii et Convictorii
Inspector Primarius.* (Arms of Hedio, being the head and
shoulders of an old bearded man in a fish-tailed night-cap.
Tinctures unmarked.) Below is written—the professor's
book being supposed thus to poeticise :—

> *Me sibi jure suum Dominus, propriumque paravit ;*
> *Usum concessit sponte cuicumque (?) bono.*
> *Sed tu, si bonus es, Domino me reddito, gratus,*
> *Si retines, malus es, nec bonus usus erit.'*

The mild professor lives again in these feeble numbers.
We do not think the boarders (*convictores*) of the Königs-
berg Academy can have held him much in awe.

This next example is extremely quaint. The *Wessofon-
tanum Cænobium* (Wessenbrunn) was a Benedictine monas-
tery in the Diocese of Freysingen in Bavaria, founded as
early as 753 A.D. An undated (XVth century?) *German
Chronicle* bears for imprint, *impressa in Cænobio Wessofon-
tano.*[2] This is the convent book-plate. *Design*—a Pontiff
seated, enthroned, wearing the triple crown and holding a
long pastoral staff. An escutcheon rests beside him
charged with the crossed keys. Behind, a curtain and a
column. Signed I. E. BELLING *Cath. Sc. A.V.* Then
come these two limping Hexameters, in which the
borrowed monastery volume prologizes—

[1] Ex-libris of Sherlock Willis, dated 1756 (C.) Thomas Pownall
(1760) gives the same text with reference *Psalm* xxxvii. 21 ; and adds
with less point, *Videte et cavete ab avaritia*, Luke xii. 15.

[2] See Cotton, *Typog. Gaz.*, p. 180 (ed. 1825).

Wessofontani₁proba sum₁possessio claustri.

Heus! Domino me redde meo: sic jura reposcunt.

(I am the good possession of the Cloister of Wessenbrunn. Ho there! Restore me to my master: so right demands.)

The plate is in the B. M. Library; its date is about 1730.

Next comes a bibliophile of much sterner stuff than Andreas Hedio.

The date is given here 1762.

Ex Caroli Ferd. Hommelii Bibliotheca. The design represents the interior of a comfortable library. In the centre is the full-length statue of Apollo, wreathed, with lyre in hand. On the pedestal is the date 1762. The apartment is lined to its ceiling with bookshelves, except the left wall; whereon hang seven framed portraits, and, below these pictures, two geographical globes. At the base of the design is inscribed—*Intra quatuordecim dies commodatum ni reddideris, neque bellè custodieris, alio tempore. Non habeo dicam.* Printed on lilac paper. A choice and characteristic book-plate.[1] W.

The renunciative mottoes are a somewhat notable class. They are extremely polite and quite in the great style. John Grolier's are well known, but these are not on bookplates but were stamped externally on his book-covers— *Mei Grolierii Lugdunens. et amicorum,* and varied thus *Jo. Grolierii et amicorum.*[2] But our other examples of mottoes in this vein will be all culled from genuine ex-libris. Pirckheimer's is, of course, the oldest—*Sibi et Amicis P.* This is literally rendered at a much later date, *Für meine Freunde und mich* on an anonymous German book-plate

[1] M. Poulet-Malassis describes briefly (p. 42) what is probably the same plate. He gives, however, no date on the pedestal, and varies from me in the name, and in some words of the inscription. The ex-libris does not seem French, but rather Italian or German. The name is *Charles Frederick Hommeau,* fide M. Poulet-Malassis, but the second name is clearly *Ferdinand.*

[2] Grolier died in 1565.

by Weichmann in 1791 (dated). *Sibi et aliis* also appears (1780) under a design of bees around their hive with a pretty landscape background. There is a fine plate by Brenet (1760) of one *M^r. Lambert de Villejust*, which gives *Amicis et mihi*. This is executed in a striking monumental style of design, with two greyhounds as supporters. *His utere mecum* writes *S. R. Maitland* (1780). But *Christian Charles Lewis de Savigny* leaves all the rest behind, exclaiming *Non mihi sed aliis*. Yet Savigny, if he lent freely, appears to have borrowed with equal freedom; for he plagiarises the design for his book-plate, a girlish figure at the side of a frame, seated on a book and grasping a pen, woods in the background, from *F. F. A. C. Neurath*; who, where Savigny writes his bombast, more quietly inscribes—*Nulla dies sine lineâ*—Score an item of new knowledge every single day.

Now this batch of mottoes raises the point, whether valuable books should be lent to persons who treat volumes like coal-scuttles; who perpetrate such atrocities as moistening their thumbs to turn a page over; who hold a fine binding before a roaring fire; who *horribile dictu* read at breakfast and use, as a book-marker, the butter-knife. Ought David Garrick to have lent the cream of his Shakspeare quartos to slovenly and mole-eyed Samuel Johnson? We think emphatically not. Many full-grown folks have no more idea of handling a book than a schoolboy.

This mention of the schoolboy will remind many of our readers of the rude doggerel versicles, with which, at that careless period, we were wont to protect our lesson-books, not unaccompanied by a graphic illustration of a pair of gallows with its victim pendent thereto. Of course, the schoolboy does not attain to the dignity of a book-plate. If he did, the borrower—whom he designates by a shorter term—would read some home-truths, inscribed much to his disadvantage.

Here are some effusions which are scarcely above a schoolboy's doggerel. They do not belong only to *John Hughes* from whose ex-libris we copy them, but to half-a-dozen others. They are of common book-plate occurrence. The owner addresses (why not?) his book :—

> *If thou art borrowed by a friend,*
> *Right welcome shall he be,*
> *To read, to study, not to lend,*
> *But to return to me.*
>
> *Not that imparted knowledge doth*
> *Diminish learning's store,*
> *But books, I find, if often lent*
> *Return to me no more.*

At this point Mr. Hughes's pegasus will no longer answer the poetic spur, and falls from a jog-trot into a foot-pace. Hughes now addresses the borrower and no longer his volume. *Read slowly, pause frequently, think seriously, keep cleanly, return duly, with the corners of the leaves not turned down.*

Here is another of even lower poetical level. The anapœstic measure suits the subject extremely ill.

> *This book belongs to* (a blank left for a name)
> *Neither blemish this book nor the leaves double down,*
> *Nor lend it to each idle friend in the town ;*
> *Return it when read ; or, if lost, please supply*
> *Another as good to the mind and the eye* (1820).[1]

In complete contrast to the 'unlettered muse' of these two book-plates, we may now refer to the courtly *Theodore Christopher Lilienthal, etc.* (1750), whose ex-libris is as

[1] There is a long effusion beginning 'A pleader to a needer if a reader,' on a modern book-plate, which we have not space to transcribe.

pretty as his name, rendering a group of bee-visited lilies with this delicate distich :—

> *Utere concesso sed nullus abutere libro..*
>
> *Lilia non maculat sed modo tangit apis.*

This is doubly ingenious, because it contains at once a protest against dogs-earing, and a play upon the owner's name. This plate, be it noted, is a copy of an earlier one of his ancestor, *Michael Lilienthal*, about 1700, who uses the same couplet.

Charles Woodward (1820) gives an opened volume, on one page of which is written. *Narrative—promising to take charge of me during my visit, and to send me home at the appointed time. Finis.* Whence, we may conclude that Mr. Woodward considered himself a humourist, and that this book-plate was specially intended to be affixed in his loan volumes.

Ne extra hanc Bibliothecam efferatur ex obedientia. This occurs, on a separate printed slip, below the book-plate recording the donation of his library by P. D. Huet, Bishop of Avranches, to the ' *Maison Professe* ' of Jesuits of Paris.[1] 1692 (dated).

Rendés le livre, s'il vous plâit. So begs Hugo de Bassville.[2] Another French motto, which occurs on the book-plate of David Garrick and a host of others is well known, but must of necessity be once more repeated here :—*La premiere chose qu'on doit faire quand on a emprunté un livre, c'est de le lire afin de pouvoir le rendre plûtôt. Menagiana, vol. IV.* A recent ex-libris reads thus :—*Ex libris C. Pieters Eq*(uitis) *Ite ad vendentes et emite vobis.*[3] *Matthew xxv.*, 9. 'Go ye rather to them that sell, and buy for

[1] Guigard's *Armorial*, vol. ii., 10.

[2] Poulet-Malassis, p. 42.

[3] Ib. p. 43, given as occurring also on the ex-libris of one Aubry, Doctor of Theology, *Curé* of Saint Louis-en-l'Isle. Date not indicated.

yourselves.' An ingenious application, for this was spoken to the foolish virgins, who wished to *borrow oil.* Another quaint enlisting of a scriptural text is made by the *Parochial Library of Tadcaster—Accipe librum et devora illum.* Rev. x. 9. (1710). This is accompanied by a design of the angel delivering the book, which he was to eat, to St. John in Patmos.

Do not despise honesty. Remember to return this book to ye owner Alexander Ham. (Chip. 1760 Howard).

Peruse and Return, inscribes *John Henekey. Lege et Redde,* advises *Francis John Sirebeau.*[1] But the *Parochial Library of Weobley* says placidly, quoting St. Augustine, *Tolle Lege*; which is all very well, as a public institution has a legal remedy against a defaulting borrower. But the wrongs of *O. M*(oore) have made him more dithyrambic. His recent (1820) ex-libris bears this sapphic of denunciation, beneath the crest of a moor's head, issuing from a ducal coronet:

> *Si quis hunc librum rapiat scelestus,*
> *Atque furtivis manibus prehendat,*
> *Pergat ad tetras Acherontis undas*
> *Non rediturus.*

And, inasmuch as all other book-protecting maledictions must sound weak after this one, it may as well conclude this portion of our subject.

[1] M. Poulet-Malassis, p. 42.

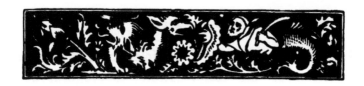

BOOK-PLATES OF HISTORIC INTEREST.

IT may have struck the reader, while perusing our dated list in the last chapter but one, that rather a dull and dead level of mediocrity prevailed among the owners of libraries in the days of good Queen Anne.

We found in that catalogue more hereditary rank than intellectual eminence. It contained politicians of the stamp of Halifax, pushing placemen like Percival, worthy and wealthy civic lights like Clayton, substantial squires like Towneley.

In this chapter no such reflection can be made; the book-plates which follow belong to men of fibre very different; in some department of human energy or mental excellence these men were in the van. They did not merely stamp their names upon the labels of their libraries, but upon the pages of our national history. It is interesting merely to hold in your hand a book that once belonged to one of them.

Gilbert Burnet heads the list.[1] The great whig partisan divine, who landed with Dutch William at Torbay; whom Sancroft refused to consecrate to Sarum; whose good-humoured but unrefined features, in his wig of many curls, beam out of old frontispieces. The bustling, noisy, boastful man, who settled between William and Mary the knotty point of their equal rank upon the throne. Full of ability

[1] If Lord de Tabley had himself lived to produce a second edition of this work Samuel Pepys would doubtless have headed this list, for I find the following qnotation noted in the author's own copy, viz. :—
'21st July 1668. Went to my *plate* makers and there spent an hour about contriving my little plates for my books at the King's four yards' (*Pepys's Memoirs*, Braybrooke edition, vol. iv. p. 488).—EDITOR.

yet full of indiscretion. Chronicler of his own times, the historian of the Reformation; theologian, debater, pamphleteer; honest amid general venality, and merciful when rancour was the order of the day.

Gilbert Burnet, Lord Bishop of Salisbury, Chancellor of the most Noble Order of the Garter.

Arms—Az., the Holy Virgin and Child, with sceptre in her left hand, all or; impaling ar. in chief three holly leaves vert, in base a bugle-horn stringed sa. (for Burnet), encircled with the garter and ensigned with an episcopal mitre; crozier and key in saltire behind arms. Slightly foliated angular inscription scroll. Mr. Carson, Mr. Franks, &c.

The ex-libris bears no date; but, as Burnet was appointed to the See of Salisbury in 1689, and died in 1715, it, of course, falls between those years. (See plate 9.)

Next comes the interesting and important plate of William Penn, the courtly Quaker, whose position at Whitehall, as the tool of such a shallow tyrant as James, seems so irreconcilable with his career as a sturdy and far-sighted pioneer of civilisation in the far west.

William Penn Esqʳ Proprietor of Pensylvania : 1703. *Arms*—Ar. on a fesse sa. three plates. *Crest*—A demi lion ramp. ar. gorged with a collar sa., charged with three plates. *Motto—Dum clavum teneam.* Mantling, less rolled than usual, to the base of the quite plain shield, showing a good deal of sable inner lining. Motto scroll narrow and small. Name-bracket slightly indented above, waved beneath. Carson. (See plate 10.)

Though a Quaker, William Penn seems by no means to have disdained his due amount of heraldic display. The phrase 'proprietor of Pensylvania,' renders the ex-libris a vivid record of the past. The book-plate of *Thomas Penn,* his son, reads—*of Stoke Pogeis in the County of Bucks, first (i.e.* chief?) *proprietor of Pensilvania* (sic).

It is interesting to be brought face to face with the

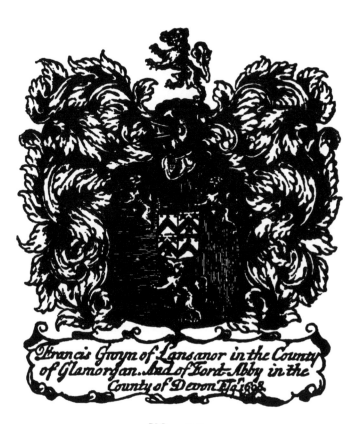

Francis Gwyn of Lansanor in the County
of Glamorgan. And of Ford-Abby in the
County of Devon Esq 1698

[No. 8.]

book-plate of Robert Harley, Queen Anne's great minister, who managed the House of Commons as few statesmen have had the tact to manage it since. No orator, and no great courtier; but with a cool head and keen eye; who knew how to gain men to his side as proud and bitter as a certain Vicar of Laracor; who understood the time and England; and, whether in the Tower, or in his library at Brampton, when his exit from the drama had been made, took life easily and smiled at the ups and downs of fortune. Here is his ex-libris—

Robert Harley of Brampton Castle in the County of Hereford Esq'. Arms—Quarterly, first, or, a bend, cotised sa. (and 19 other quarterings). *Crest*—A castle, triple-towered, ar., out of the middle tower a lion issuant, gu. *Motto*—Virtute et Fide. Simple, sparsely cut mantling of the seventeenth century style (as on the plate of Gwyn), ending on each side in two tassels. The name appears on a bracket below, which is composed of a single indented line. 5 by 3¾. W. In two sizes. This book-plate dates between 1690 and 1700.

After Harley, whose generosity smoothed the adversity of his latter days, may appropriately follow the book-plate of Matthew Prior, the wit, politician, and graceful lyrist of the palmy reign of Anne. This was the 'thin hollow-looked man,' who used to pace round the park with Swift to make himself fat, while the doctor walked for the opposite reason, namely, to keep himself down. Mat was a cheery companion for all his 'hollow-look,' and took his glass and his share in the talk well; whether with Pope and Bolingbroke, or the soldier and his wife in Long Acre. He got to be Secretary of Legation at the Hague, and at last Ambassador at Paris; but he could not assume that style till haughty Duke Shrewsbury had returned home, who did not relish being commissioned

with a vintner's son. After the Queen's death and the fall of his friends, Mat met with bad days, and to keep himself going, published his poems in folio by subscription ; and a wonderful subscription list it is—full of great names. Here is his book-plate.

Matthew Prior Esq. The Prior escutcheon set in a broad scale-covered Jacobean framework. *Arms*—Vert, a bend or cotised ar.; above in the centre of the frame a cherub's head with wings. At right and left upper extremity of the shield-border, a small angel is seated with a trumpet. Below, on an angle of the frame, is Mars, likewise seated, helmeted and holding a gorgon-headed shield. On the other side, as pendant, appears Apollo with his lyre. The name, as above, occurs beneath the design. Collection of W. B. Scott, Esq., *Notes and Queries*, 6th S., 1. 179.

The genial author of *Tristram Shandy* writing to John Hall Stevenson, from Coxwould, under date of July 28th 1761, says—'I have bought seven hundred books at a purchase, dog-cheap—and many good—and I have been a week getting them set up in my best room here.'[1] In the pride of this purchase he probably caused the following book-plate to be engraved. It shows in its accessories a clear affinity to the ex-libris of his close friend David Garrick. In earlier days, before Yorick had burst in sudden blaze upon the town in 1760, the Reverend Mr. Sterne seems to have depended for his rarer literature on the book-shelves of *Eugenius* (John Hall Stevenson); who carried on at Crazy Castle (Skelton Castle near Guisborough) rather free social gatherings of the Medmenham flavour ; and who seems to have amassed a notable collection of bibliographic ' facetiæ.' Sterne's ex-libris is as follows—

[1] Works of Laurence Sterne in ten volumes complete. London : Johnson, etc., 1798, 8vo. Vol. ix. p. 58.

The bust of a youngish man with straight features (Qy. Juvenal or Martial), placed on a slab. To right and left of the bust lies a closed book. On the first volume is inscribed *Alas, poor Yorick!* On the second *Tristram Shandy*. Below, across the outer face of the stone-work of the slab, is written in cursive hand *Laurence Sterne*. The vignette is ovally encircled above by a bordure of sloping olive or palm-leaves. The features of the bust are regular like those of Augustus on his denarius. (Mr. Russell Smith, Soho Square.) It is likely enough that Sterne designed his own book-plate. He was both a musician and an artist of the usual amateur level. During his visit to Rome he designed three illustrations for the poems of one Michael Wodhull. The book did not appear till after Sterne's death in 1772.[1] The first design is of Helicon with Pegasus and Hippocrene in the foreground. It is signed *L. Stern* (sic) *del Romæ, I. A. Faldoni inc.*. The second design is the prettiest. It is allegoric. A river-nymph reclines upon her urn in the foreground, by the side of a lake or stream. Behind, is another form, holding a lyre, with three flying cupids buzzing round her head, like flies in hot weather. The scene is laid in a pasture, outside a wood. In artistic merit it is only moderate. This plate is signed precisely as the last. The third design, also similarly signed, represents a dryad reclining again by a sedge-grown pool; a wooded hill appears behind. It is the worst of the three, and a very poor performance. But even Sterne's failures as an artist are interesting. Returning to his book-plate, if not distinctly assignable to 1761, it must clearly date between 1760, the year of *Tristram Shandy's* first two volumes, and Sterne's death in 1768.

[1] Poems by Michael Wodhull, Esq., London. Printed by W. Bowyer and J. Nichols, 1772, sm. 4to.

David Garrick's book-plate ought to have preceded his friend's, of which it is to some extent the prototype. The reputation of the Garrick library is well known. It was rich, *inter alia*, in priceless Shakspearian quartos. No bibliophile will blame their collector for not allowing Dr. Johnson to take these home with him, when engaged upon his edition of Shakspeare. The great Cham of literature greased and dog-eared such volumes as were confided to his tender mercies, with the same indifference with which he singed his own wigs. Yet he made it quite a grievance against "Davie" that these dramatic treasures were not offered with alacrity to his slovenly keeping. This is the library label which these books contained—*David Garrick.* The name is inscribed with ornamental flourishes on an oblong oval framework, faintly Chippendale in its style. This is garnished about with festoons of roses, a branch of oak, mask and punchinello, quiver and pan-pipe. Below the frame-work hang in a cluster, a lyre, sceptre, sword goblet, and crown, being, of course, theatrical 'properties.' The bust of Shakspeare crowns the design. Below is written—*La¡premiere chose qu'on doit faire quand on a em-prunté un Livre c'est de le lire afin de pouvoir le rendre plûtôt. Menagiana, Vol. IV.* (A motto repeated on many other ex-libris.) The plate is signed *I. Wood in. et sc.* The signature is minute, and may be readily overlooked. (Plate 11, p. 149.)

Horace Walpole was nearly sure *à priori* to have had a book-plate. The leading characteristic of that extra-ordinary mind was an intense love of detail, and apprecia-tion for all that was curious, abnormal, or exaggerated. This faculty made him of letter-writers the most delightful; this made him among collectors a very Briareus. This drove him to accumulate every species of gimcrack. This piled Strawberry Hill from basement to attic with armour, painted glass, miniatures, engravings, chimney

glasses, snuff-boxes, medals, intaglios, rings, a Norman pair of bellows, Anne Boleyn's clock—in fact, with all that marvellous farrago of curiosities, over which in later times George Robins, the auctioneer, was to be so pathetically eloquent. Horace Walpole has left us three very distinct book-plates which we give in the order of their engraving.

Mr. Horatio Walpole. Arms—Or, on a fesse betw. two chevrons sa. three crosses crosslet of the first, a mullet for difference.[1] *Crest*—The bust of a man in profile couped, ppr. ducally crowned or; and from the coronet flowing a long cap, turned forwards, gu. tasselled gold, charged with a catherine-wheel of the last. Motto—*Fari quæ sentiat*—on an undulated scroll above stiff voluminous mantling from the helmet. The name on a cloth, tied up in ribbon at each corner, and connected with the shield by numerous strings. 2¼ by 2 in. Engraved doubtless for Horace Walpole as a young man.[2]

When Horace Walpole acceded, late in life, in 1791, to the Earldom of Orford, he caused a second ex-libris to be engraved, which reflects something of the 'gothicism' of the *Castle of Otranto*, and Strawberry Hill. It represents a mediæval seal, reading round the exergue—*Sigillum Horatii Comitis de Orford*. Inside are placed the arms—Or, on a fesse between two chev. sa. three crosses crosslet of the first. The escutcheon is encircled by a gothic, medal-like pattern of loops and arches. At first glance it might pass for the engraving of a coin of Edward the

[1] Horace Walpole was the third son of Sir Robert Walpole, the minister; the eldest of the family was Robert, afterwards second Earl of Orford; and the second son was Sir Edward Walpole, sometime chief Secretary of Ireland, who died unmarried.

[2] We give here a naturally associated book-plate. *Sr. Horatio Mann. Arms*—Sa. on a fesse, counter-embattled, betw. three goats pass. ar. as many pellets. The design is unusual; the escutcheon is slung sideways with a great ring at the top, thro' which the motto-scroll—*Per ardua stabilis*—passes.

third's period. Anyhow, as a mediæval revival, this book-plate cannot be held to attain any great success.

At the very opposite pole of æsthetic taste is Horace Walpole's third ex-libris, which is a woodcut executed for him by Thomas Bewick ; and may thus be described. *Fari quæ sentiat.* No other inscription. A view of the House at Strawberry Hill ; clouds above and park-like pasture around it. A bordering of a withered over-arching tree, mantled with rose-briars, bramble-berries, honey-suckles, etc., rises from the right of the book-plate and bends across its whole upper margin. In this 'bush' aloft is swung the Walpole escutcheon, blazoned as before ; and the motto, as given above, occupies a ribbon, twisted in and out of the dead sprays. To the left, is a strange shrub, bearing star-like fruits or blossoms, and, behind it, a clump of trees. There is no signature. I have also the same design, somewhat varied, on copper.

The name of John Wilkes occupies the next book-plate : the turbulent member for Aylesbury, the gay Colonel of the Bucks Militia ; courageous without principle ; socially fascinating without sincerity ; scholar and fine gentleman, demagogue and voluptuary ; the originator of the *North Briton* ; the scourge of the Bute Administration ; Mr. John Pylades, as Walpole calls him, to the Rev. Mr. Charles Orestes, the satirist Charles Churchill. Him, Jack Wilkes, posterity will see for ever, as Hogarth's pencil has immortalised him, sitting so easily—the very man to a shade—and leering, the satyr-patriot, beneath his cap of liberty. He has left us an equal number of book-plates with Horace Walpole, though they are less varied.

John Wilkes,—on a corniced bracket supporting the escutcheon, which is unframed, but is flanked on each side with a loosely clinging border of springing oak-branches outermost and palm-branches innermost. *Arms*—Or, a

chev. betw. three vultures' heads erased sa., differenced with a crescent gu. *Crest*—On a mount vert. a crossbow erect or, round it, on a scroll, this motto—*Arcui meo non confido.* The escutcheon has no limiting margin at its base, but is worked imperceptibly into the foliated bordering about it. Signed—*Darly inv. et sculp.*

This is the best of Jack Wilkes's three book-plates though certainly not the earliest in date. Here is another, engraved about 1755, when Wilkes was twenty-seven.

John Wilkes Esq^r. Arms—as before; but the escutcheon is set in a Chippendale frame, with the usual shell-work and flowers. The motto scroll in this example is not placed on the crossbow in the crest, but appears at the base of the design. A third book-plate, the latest of the three, is thus :—*John Wilkes, F.R.S.* Arms as before. The escutcheon is unframed, but is flanked by two palm branches, ribboned together at their base.

The book-plate of the Right Hon^{ble.} Charles James Fox comes last, a politician of a type that has long ceased to exist; whose brilliant reputation as a statesman was continually hampered and weighted by a strange and morbid passion for the gaming-table. On this ex-libris Fox only appears as the Honourable, a prefix to which, as second son of Henry, first Lord Holland, he had, of course, full right. Fox would not become a 'Right Honourable' until 1782, in which year he was appointed Secretary of State. This book-plate therefore dates between 1768 (his election under age for Midhurst) and the former year.

The Honble Charles James Fox. Arms—Ermine, on a chevron azure three foxes' heads erased or, on a canton of the second a fleur-de-lis of the third. *Crest*—On a chapeau az. turned up, erm.; a fox sejant, or. (No motto or scroll.) Mantling to base of shield, stiffly foliated; its inner lining

H

hatched sable; name on a plain wavy-edged bracket. And with the name of Fox must close our historic series.

Thus, by the fortuitous survival of a slender link, which is common to them all—namely, the preservation of a label for their respective books—a strange assemblage of stirring names has been brought together within the limits of the present chapter; names representing men of types widely distinct; names suggesting a vast range of intellectual ability.

Let us pass them again in review. Gilbert Burnet, William Penn, Robert Harley, Matthew Prior. These are great shadows of England's Augustan age; they trod the anterooms of Anne and of Dutch William, the deliverer. They have almost passed into antiquity. But with the later contingent we have more concern:—Laurence Sterne, David Garrick, Horace Walpole, John Wilkes, Charles James Fox. Our grandfathers talked with these men. They are ' old-fashioned,' but not yet classical.

MOTTOES CONCERNING BOOKS, OR IN PRAISE OF STUDY.

WE place at the head of this section a rather solemn denunciation against *light* literature, taken from a very weird book-plate of about 1750, which no doubt belonged to a theologian. The design is as follows:—A skeleton is seated on an oblong, raised, coffin-shaped, stone tomb. In his right hand are a pair of scales, in which the lighter balance contains a scroll, lettered, *Dan.* v. 25, *Mene Teckel.* In his left hand is a scythe. Behind are two other marble monuments ; one, a high square family vault with a frieze of festoon work ; the other, an urn and pedestal embossed with classical subjects. In the farther background are three Lombardy poplars or cypresses and a line of remote hills. The whole design is enclosed in a monumental stonework frame, apparently on a church wall. In a draped medallion above is—*E. Bibliotheca Woogiana.* Below, on an oblong unshaded slab, occurs this strange device :—

> *Nominor à libra : libratus ne levis unquam*
> *Inveniar, præsta pondere, Christe, tuo.*

And below this, outside the design, *A. Wernerin del: C. F. Boetius sculp.* 6 × 3½ in. W.

Now the couplet must be rendered—I, the book (liber) am named, or etymologically derived from a weight (libra); and, lest at any time I should be found light or frivolous in my contents, etc. Of course, there is more punning than

etymology in this connection. But that was the fashion of the day.[1]

There are five varieties of this ex-libris of the *Bibliotheca Woogiana*. The larger specimens bear the signatures of the designer and engraver with their initials. The small sizes are signed only—*Boetius sc.* Some sizes are unsigned. The same play upon *liber* and *libra* occurs on this curious example, which is a good pendant to the last ex-libris. *Ex libris Petri de Maridat in Magno Regis Consilio Senatoris.* Design—a negro in a short apron, otherwise undraped, standing at full length. His right hand rests on an escutcheon. *Arms*—az. a cross ar. His left hand holds a pair of scales. Above, in a scroll—*Curæ numen habet justumque. 4° Æneid.* Below the negro is written :—

> *Inde cruce hinc trutina armatus regique deoque*
> *Milito, Disco meis hæc duo nempe libris.*

Which may be explained—Armed on this hand with the cross (in the coat of arms) ; and on this side with the pair of scales, I fight for my King and my God. I learn these two (duties) indeed from my books (or 'from my balances,' as *libris* means both). *Magni Regis* is, of course, the *grand Monarque* ; which dates the book-plate before 1715. W.

Here is another ecclesiastical book-plate of *M. Gottfried Balthazar Scharff Archidiac. ad SS. Trin. Svidnic.*

> *Sæpe parum juvit tam multos volvere libros ;*
> *Christe, tuum mortem volvere sæpe juvat.*
> *Tot libros inter quantâ versamur in umbrâ !*
> *Hic sine sol umbra splendidus exoritur :*
> *Lectio librorum sine Te labor omnis in umbra est.*
> *In Cruce da lucem cernere, Christe, tuâ.*

Design—a table, curtain, drapery, and a background of

[1] Mr. Carson suggests that *woge* may be old German for *wage*, a balance. If so, the owner of the book-plate, not the book, speaks in the couplet.

library shelves. Affixed to the centre of these is a square scroll, on which appears a crucifix. Above is written— *Sine umbra*; below, *Bibliotheca Scharfiana.* (1750) (Mr. Franks.) The city in which Scharff was Archdeacon was *Suidnitium* or *Suvidnia,* now Schweidnitz, a town of Prussian Silesia, and capital of a principality. Books exist printed there in 1683.[1]

Let us take yet a third book-plate of a priest, this time quite untinged with any ascetic gloom. For, indeed, a charming Flemish interior is presented to us in the ex-libris of Louis Bosch, whose name is given merely in initials on his book-plate, which is engraved by Fruÿtiers, about the same date 1750.[2] Bosch was the clergyman of Tamise, a village ten English miles south-west of Antwerp. *Design—* The priest (perhaps a portrait), in a long cassock and with short rolled back hair, is seated in an armchair, writing at a table with a heavy fringed cloth. On the table are books and a large erect crucifix; a curtain and tassels hang above it. Behind the writer is a many-paned window. The rest of the room is completely filled with bookshelves. The initials L. B. occur across a huge folio on the floor. The picture is enclosed all round in an irregular convoluted shell-work frame, at the base of which a ribbon band, stretched across its curves and twists, reads—

In tali nunquam lassat venatio sylva.

(A hunt in such a forest wearies never.)

The *sylva* being the rows and ranks of his reverence's books. In the left corner is *L. fruÿtiers f:* We know no other book-plate which is so strictly a *picture* as this. Perhaps it is copied from L. Bosch's portrait picture in oils by some Flemish artist. (See plate 13, p. 179.)

[1] Cotton *Typog. Gaz.* (First Series) (1831) p. 275.

[2] 'Louis Bosch, Prêtre de l'Oratoire et curé de Tamise, dont le catalogue fut publié à Louvain, en 1765.'—*M. de Reiffenberg,* p. 13.

We can now pass to lay book-plates. *J. M. Andrade* also employs a simile between books and vegetation. He engraves the fruited wild strawberry, half masked by its leaves, with *inter folia fructus* inscribed below. *Mary Berry* also utilises this same motto and design in England (1810), with perhaps a further play upon the strawberry and her own surname. A third recent German ex-libris, with the initials O. J., repeats the motto, adding a charming design of children under a leafy arbour of vine props, laden with grape-clusters.

The next batch of mottoes all recommend more or less directly a small library, as opposed to a large one. Let citizen Francis Bissari head the list. He exhorts that no one should collect more tomes than he can read, and rather quaintly insists, on the authority of Nero's tutor, that a multitude of books distracts the mind—*Ex libris civis Francisci Bissari. Distrahit animum librorum multitudo, itaque cum legere non possis quantum habueris, sat est habere quantum legas. Senec., Ep.* 2. (1750.) In the same spirit *B. A. Diesbach a Carrouge* (1805) advises *Non multa legere sed multum.* A recent book-plate, inscribed *G. L. D. Bibliotheca,* has *Pauci sed cari.* While *ex libris Johannis Loubry* (1780) adds—*Exiguus nobis, sed bene cultus ager—* meaning, My library is small but well thumbed. A modern Spanish book-plate, initialed C. M., puts this proverbially, after the manner of that people—*Libros y amicos, pogos y bonos.*

It is a little singular that so much praise of scanty collections should be found on book-plate mottoes.

Not so the *Bibliotheca Cortiniana* speaks. There is no fear of heaping up volumes here—*Egregios cumulare libros præclara suppellex.* They are the best kind of riches, says *J. L. Pettigrew—The wealth of the soul is the only true*

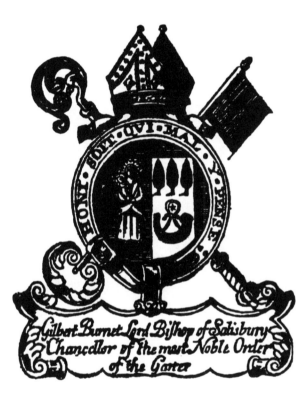

Gilbert Burnet Lord Bishop of Salisbury
Chancellor of the most Noble Order
of the Garter

[No. 9.]

wealth, for so we literally translate the hexameter from Lucian, which his ex-libris bears.

'Work hard, night and day'; so advises the *Bibliothèque de M. Houbigant*; on which book-plate appears a classically attired damsel studying with an antique lamp, burning on a column before her; and a sphinx carved in stone at her feet, with this Horatian motto—*Nocturnâ versate manu, versate diurnâ*. The versatile *A. E. Tscharner* is in the same key, he inscribes—'*S'occuper c'est savoir jouir*,' and depicts above books, globe, palette, telescope, and all the implements of his varied accomplishments. Yet some lighter studies may be advantageously blended with more solid reading; at least so thinks *Daniel Girtaner*, who surrounds his name with a circular moulding of poppies and roses, bearing *Utile miscere dulci*. Temper wisdom with wit.

Junctam Mercurio Pallada Phœbus amat. This suggestion is taken from the *ex libris Geor. Nicol a Merz* (1750); whose arms have, as supporters, a boy and a girl, masquerading as Mercury and Minerva. *Philosophemur* —says abruptly an anonymous Chippendale plate, (1760) engraved by *T. B. Green, London*; cultivate, in effect, a philosophic temper. Your studies will bring you peace of mind—*Animus si æquus, quod petis hic est*. This we get from the *Rev. John Lloyd's* ex-libris, dated 1730. Knowledge is never burdensome, inculcates *Thos. Robinson Coll: Mert. Socius* (1730) of Merton College, Oxford; for says he, quoting Cicero, *Delectant domi non impediunt foris.*[1] *William B. Grime* (1780) writes amid festoons round his armorial shield—*Studiis et literis res secundæ ornantur, adversæ adjuvantur. Jno Lowe of Ridley Hall* (1770) represents a cupid kneeling on the grass upon a pile of

[1] The motto appears on the plate of *John Wilmot* (1750) and of '*R. H.*' (R. Hoblyn) Commoner of Corpus College, Oxford.

books and fastening up the Lowe arms by a leaf festoon to the conventional broken oak tree. *Dulces ante omnia musæ*—is written on a ribbon twisted in and out of the herbage.

The next examples treat of the consolatory powers of study. *My books the silent friends of joy and woe.* This is cut on rock in a rustic vignette, after Bewick, by Bonner, for *W. B. Chorley of Liverpool.* A French advocate echoes the sentiment: *In solitudine solamen* exclaims *D. de Sᵗ Maurice in supremâ rationum curiâ præses* (1750). *Laboris dulce lenimen*—says *M. C. C. Gerkenius* (1750). Other folks announce that they mean to take their ease in their library. Count Costerbosa gives us his arms, with a rampart Pegasus, an eagle, and a smoking censer, and inscribes his book-plate, quite in the great style—*Otiis Comitis Costerbosæ!* An anonymous French ex-libris, bearing date 1736, reads merely—*Sic propriis consuluit otiis.* The plate of *Herbert Jacob Esqʳ of Sᵗ Stephens in Kent*, a most delicate piece of Jacobean engraving (1740), bears *Otium cum Libris.* 'F. A.,' whose initials float in ribbons and rose festoons (1780), has two mottoes.

> *quid datur oti*
> *Illudo libris ; hoc est mediocribus illis*
> *ex vitiis unum.*

And again on a scroll above—

> *Indocti discant, ament meminisse periti.*

The early German ex-libris are often found to bear texts of Scripture, which are neither family mottoes, nor have any reference to books or study; for instance—*Pietas ad omnia utilis, etc.*—*Vulnera Christi credentium voluptas,* both on ex-libris of the Kress family at Nuremburg; with these we have here no concern. There is, however, one exception, the text-motto occurring on Pirckheimer's

book-plate,[1] which seems to indicate the right mental mood in which a student should lay up stores of learning —*Inicium Sapientiæ Timor Domini.* This is about the earliest motto on a book-plate, to which the heading of this chapter applies, and with this we shall conclude.

[1] Frontispiece.

ENGRAVERS OF FOREIGN
BOOK-PLATES.

THIS list is a mere beginning, but it seems right that a beginning should be made. Our materials are at present very imperfect; but they will hereafter congregate and crystallise more readily round a definite nucleus, however small. In its general plan, the following catalogue is compelled, of necessity, to embrace an area of very wide extent. It is offered as the commencement of a record of foreign engravers and designers of ex-libris, down to the year 1830. That is to say, all such names signing book-plates in Germany, Italy, Spain, the Netherlands, Switzerland, Sweden, etc., are included in its scope. Of other European countries, such as Russia or Portugal, no signed examples have as yet come to hand.

Practically speaking, Germany alone will be found to furnish two-thirds of the present list. Italian and Spanish book-plates are numerically fewer and very inaccessible to an English collector. And of the scanty number which reach this country, only a small percentage will be signed.

But in Germany, ample materials exist for compiling a very voluminous list of engravers, and this no doubt will some day be done. In Germany, ex-libris have undoubtedly existed for more than three centuries and a half. The Teutonic portion of Europe is, besides, of great geographical extent. Certainly, the German list ought to double, and perhaps treble, the French one.

Now for France, alone of European nations, such a catalogue of book-plate engravers has already been compiled. It shows about 270 names during the seventeenth and eighteenth centuries. It is to the industry and exhaustive research of M. Poulet-Malassis that this catalogue is due, and to it our readers should by all means refer. We shall not, therefore, here repeat any signature which has already figured in the French list. Indeed, beyond the addition of half a dozen engravers of French bookplates, who have come to light since the second edition of the *Ex-libris Français*, France may be regarded as practically excluded from our present enumeration. It seemed superfluous to repeat here second-hand information, which most readers of the present monograph already possess in its original form. We shall more advance the general study of book-plates by diverging into new and hitherto unexplored provinces of investigation.

In Germany, artists and engravers of very great eminence have condescended to design undoubted ex-libris. Of those who did so, no less a name than Albert Durer's will head the list. Into such works of his as are, or may be, book-plates, we shall go with some minuteness. But the greater proportion also of the 'lesser masters' designed coats of arms, among which a good percentage will hereafter doubtless prove to be ex-libris. When a collector meets with one of these early German woodcuts of escutcheons still *in situ*, it is very desirable that a record should be always preserved of the volume in which the special example has done service as an ex-libris.[1] The fact of its having been so used is an important, though not by itself conclusive, link in the evidence. A mere cursory glance through one or two of Bartsch's

[1] And far better, funds permitting, to preserve both the book and its plate intact.

twenty-one volumes shows, among the *armoiries* of his various engravers, a rich mine for the critical disinterrer of early German book-plates. It is much to be wished that some one, properly qualified as a print-collector, an ex-librist, and a herald, would undertake this special department of book-plate investigation. The ex-librist of the early German engravers would, I am convinced, if exhaustively investigated, of themselves constitute a monograph equal in length to the present essay.

Returning to Albert Durer. We shall take first the best known of his book-plates, the fine woodcut[1] designed for his friend Bilibald Pirckheimer, the Nuremburg jurist, of whom he also engraved a portrait on copper, dated 1524. This ex-libris is not signed, but the best authorities concur in naming Durer as its designer, but not as its cutter upon the wood-block. The important point about this Pirckheimer plate, and also about the Ebner plate which follows, is this: both bear the distinctive word *Liber*, which places beyond all doubt the purpose for which each woodcut was intended.

This is the Pirckheimer library plate—*Liber Bilibaldi Pirckheimer*—inscribed on a plain narrow tablet at the base of the plate; above this are angels at play; one bears a little target-shield, another a stick with four spokes at its end.[2] The central portion of the design is occupied by a magnified helmet, on which is placed the equally large crest. This is the head, shoulders, and armless trunk of an elderly, bearded man; the forehead bears a crown of thorns with nails projecting above the wreath outline. Below the crested helmet appear two escutcheons, side by side: these are somewhat small as compared with crest or helmet. The dexter shield is

[1] Frontispiece.

[2] The toy called a 'windmill.' The other boy-angel seems to hold a Swedish turnip.

per fess, and bears the *birke* or birch-tree, a canting allusion
to the jurist's name;[1] the sinister is also per fess, charged
with a mermaid with two tails, crowned, holding her tails
in her hands. These are the arms of *Margretha Rieterin*,
the wife of Pirckheimer. Embracing the helmet, and as
supporters to the heraldry, appear two larger boy-angels.
At each lateral margin of the plate is placed a long kind
of cornucopia formed of intertwisted ribbon-like weavings.
In the mouth of each cornucopia are seen vine-leaves and
grape-bunches; in among these stand two diminutive
corresponding angels, bearing one end of a festoon, of
similar fruit and foliage, which swings across the plate to
a ram's head ornament in the upper centre of the design.
Level with the crest is inscribed—*Sibi et amicis P.*; and at
the top of the plate—*Inicium Sapientiæ Timor Domini*,
with translations of the same text superadded in Greek
and in Hebrew. A woodcut, nearly 7 × 5 in. W. See
the frontispiece.

The history of the Pirckheimer library is rather curious.
Thomas Howard, Earl of Arundel (1580-1645), was the
father of all English collectors, and employed agents to
seek out for him rarities in various foreign countries: of
him Peacham says—'to whose liberal charges and
magnificence this angle of the world oweth the first sight
of Greek and Roman statues.'[2] The Earl amassed a
magnificent collection; the very ruins of which, says
Walpole, are ornaments now to several principal cabinets.
He is at the present day only remembered for the marbles
which hear his name. Walpole states that Lord Arundel
'purchased part of the library of the Kings of Hungary
from Perkeymerus; Henry, Duke of Norfolk (to whom it
descended), by persuasion of Mr. Evelyn, bestowed it

[1] So the English family of Ashburner bears an ash-tree proper
for crest.

[2] *Compleat Gentleman*, p. 107 (quoted by Walpole, see *infra*).

on the Royal Society.'[1] Be it noted, however, that the
Pirckheimer of whom the Earl purchased could not have
been Bilibald himself, but may have been a great-nephew
or a grandson. A few years ago, a good many volumes of
this Pirckheimer library, most of them containing the
Durer ex-libris, were sold by the Royal Society as dupli-
cates ; one of these I purchased for the sake of the book-
plate, as did most other book-plate collectors at that time.

By the side of the Durer library plate was pasted the
Chippendale (1760) ex-libris of the Royal Society ; this
gives their arms, crest, and motto,[2] but does not bear
the Royal Society's name. In all the other volumes of the
Pirckheimer library which I have seen, these two book-
plates were placed one by the other.

Next in importance of Durer's works, for the purposes
of this essay, is the *ex-libris* of Hieronymus Ebner. It is
as follows :—*Liber Hieronimi Ebner,* inscribed across the
base of the book-plate. Above appear, side by side, two
shields, bearing the Ebner and Führer arms. The dexter
escutcheon is pily paly, for Ebner: the sinister shield
bears the dexter half of an escutcheon charged with
a wheel, impaling the sinister half of a shield charged
with a fleur-de-lis (this is called 'dimidiating') for Führer.
Crest—Two pipe-like horns. (The *Chalumeaux* of such
constant recurrence in German crest heraldry.) *Sup-
porters*—Two boys. Above the shields in the centre is
the date 1516. Along the upper margin of the design
is inscribed—*Deus Refugium meum.* Bartsch,[3] vol. vii.

[1] *Anecdotes of Painting in England* : London, Murray, 1871, p.
159 ; and *London and its Environs*, vol. v., p. 201. Dodsley, 1761.

[2] Ar. on a quarter gu. three lions pass. guard. in pale or. *Nullius
in verba.* See also W. B. S., in *N. & Q.*, 6th S., i. 178. This
associated book-plate is there mentioned as belonging to one of
the Howard family.

[3] *Le Peintre Graveur,* in 21 vols. Vienna, 1802-1821.

(under Albert Durer) about 5 in. by 4. This is the earliest dated book-plate of which I have any record.

The book-plate of Hector Pömer, Provost of the Church of St. Laurence at Nuremberg, is also ascribed by Bartsch to Albert Durer, though probably cut in the wood by a certain engraver, R. A., who signs it. It seems pretty certain now that Durer only made the designs for the woodcuts known as his. The more mechanical operation of cutting was handed over to subsidiary assistants. That this Pömer plate, important from its early date, 1525, is an ex-libris seems clear, both from analogies to the Pirckheimer design; and from the fact that a correspondent of *Notes and Queries* possesses a contemporary volume in which it is so used.[1] I also purchased a second variation of this Pömer woodcut, whose usage as an ex-libris I can guarantee. The book-plate is described by Bartsch and ' H. W. T.' There is also a specimen in the Lempertz collection.

Omnia Munda Mundis (repeated also in Greek and Hebrew)[2] *D. Hector Pomer Præpos. S. Laur.* These inscriptions are placed at the base of the plate. The large central shield is quarterly, first and fourth, a gridiron; second and third, per bend sa. in chief bendy of four (Pömer). Helmet, mantling, and *crest*, which is an armless demi nun-like figure, hooded. Round the whole, an arbour or columnar arcade of fruit and festoons. In each corner of the design hangs a small escutcheon, inclining towards the centre; first, the arms of Pömer; second, two cocks addorsed sa. (for Kummel); third, three roses in bend sinister (for Schmidmaier of Schwarzenbruck or Munsterer); fourth, two gooses' heads addorsed (for Bergmeister?). As supporter,

[1] 3rd. S. viii. 308. ' H. W. T.' is apparently unaware of the ascription of his plate to Durer.

[2] Compare the similar trilingual rendering on the Pirckheimer plate.

appears St. Laurence, holding in one hand a palm branch, in the other a gridiron. In the left corner are the signature and date, *R. A.*, 1525.[1] These initials are suggested by Bartsch as referring to the inferior wood-engraver who cut Durer's design. 10 × 7¾ in.

This is the earliest dated ex-libris which is signed by an artist. The next example is a mere variation upon the last. It is a book-plate of the Pömer family, or very likely of Hector Pömer himself, before he became Provost of St. Laurence. It resembles the preceding in all respects; except that on the large central shield the Pömer arms appear alone. There is no St. Laurence as supporter, neither does the ex-libris bear any inscription, though the bracket destined to receive the name is duly placed at the base of the escutcheon. I have an example of this woodcut, which has been indubitably put to the use of an ex-libris. Bartsch also enumerates other coats of arms attributed to Albert Durer, of which, doubtless, a good proportion will prove to be book-plates. The following descriptions are given to enable collectors to recognise these woodcuts, all details concerning which are well worth recording.

In estimating the probabilities as to which items of the ensuing list are veritable ex-libris, size is also worth consideration. Such *armoiries* as exceed 10 inches by 8 inches were possibly too large for use as book-plates. I fix this limit by the largest German specimen in my own series; which, reading *Ex bibliothecâ Christoph. Jac. Trew.*, *M.D.* (1730), is, of course, an undoubted ex-libris. The design of this measures exactly 10 inches by 8 inches. There is no blank exterior margin in my example. But it seems that the Koburger folios at Nuremberg, in which the Pirckheimer plates occur, have room for a label somewhat

[1] Bartsch gives the date 1521. I follow the Lempertz example.

larger. The inner cover of a Koburger of my own, date 1481, measures 14½ × 11 in., so that it could well accommodate an ex-libris of 13 × 10 in. Book-plates may exist of this size, but I have as yet never seen one.

We may also premise, that in this catalogue, when the name of the family is enclosed in a parenthesis, it means that the woodcut is anonymous. No tinctures are given.

(Beham Family.) *Arms*—per pale, a bend sinister wavy. *Crest*—An eagle displayed, ducally gorged. No inscription. 11 × 7¾ in. (W. B. Scott.) A. F.

(Kress of Kressenstein.) *Arms*—A sword in bend sinister, point upwards. *Crest*—The armless trunk of a man, holding a sword in his mouth. No inscription. 13 × 10¾ in. (W. B. Scott.) A. F.

(Families of Scheurl and Gender.) *Dominus Dedit, Dominus abstulit, Sicut Domino iplacuit, ita factum est,* inscribed on a bracket supported by an angel at the base of the design. Dexter shield, a double-tailed griffin (for Scheurl). Sinister, a triangle, at each angle an estoile (for Geuder). *Crest*—A griffin. In each corner of the design are four smaller shields ; three are left in blank, the fourth bears the Scheurl griffin, as before. The whole design is surrounded by a laurel wreath. N.B.—The text is printed upon the bracket from movable types. 6½ × 5¼ in. (W. B. Scott.) A. F.

John Stabius. *Joann. Stabius. Flammeus ecce volat— Sacra contulit arma. Arms*—An eagle displayed. Above, a combination of compasses, pincers, a ring, a palm-tree, and a tree of some other kind. 11 × 7½ in. The original wood-block is in the Imperial library at Vienna. There is another variety of this woodcut.

Laurence Stabius. *Romischer, Kayserlicher, und Hispanischer Kön. Mayestat etc. Diener Laurentz Staiber. Omnia ex Deo veniunt,* and *Alle ding kommen aus Gott. Arms*—

Per fesse, in chief, a leopard within a bordure quarterly, in base, per bend sinister, a greyhound counter-changed. *Crest*—A lion between two bull's horns. A second variety of this cut exists, in which the text—in Latin and German—is omitted. The lion of the crest is crowned, and from the crown issue two standards. 15½ × 12 in.

Anonymous—*Soli Deo Gloria*, on a bracket above. *Arms* — A savage man, sounding a hunting-horn, and holding two greyhounds in a leash. Two vines, springing from vases on each side, form an arch above the escutcheon. Durer's cypher appears on the left-hand vase. 6¾ × 5¾ in. (W. B. Scott.) A. F.

Kilgen von Berlingen. *Kilgen von Berlingen* at the top of the design. *Arms*—A wheel. *Crest*—A wolf, holding in his mouth a lamb. 16 × 10¾ in.

(Gabriel d'Eyb, Bishop of Aichstädt.) *Arms*—Quarterly, first and fourth, a crozier; second and third, three escallops. *Crests*—First, a hand holding a crozier; second, a swan with wings expanded. Below, the date is inscribed—1525. No other inscription on the woodcut, 4½ × 3 in.

John Ferenberger. *Johann. Ferenberger zu Egenberg.* *Arms*—Quarterly, first and fourth, three lions' heads; second and third, two pallets. *Crest*—A peacock's tail between two pipe-like horns. (*Chalumeaux.*) 16½ × 13 in.

Dr. John Gasteb. *Hans Gastgeb Doctor.* *Arms*—On a bar sinister a lion ramp. *Crest*—A wing.[1] 7 × 4½ in.

(Family of Haller of Nuremberg.) *Arms*—Quarterly, first and fourth, a pile in bend fimbriated; second and third, per fess, in chief a pile, in base a lion pass. *Crests*—First, a demi-woman without arms between two pipe-like horns;

[1] That is *un demi-vol*, the *vol* being the two wings conjoined without the rest of the bird. In Latin, *ala*, two wings expanded, *ala simplex*, a single wing.

William Penn Esq.ʳ Proprietor
of Penʃylvania ·1703

[No. 10.]

[146]

second, a wing and the horn of a buck (un demi-bois, half an attire). $6\frac{1}{2} \times 4\frac{1}{2}$ in.

Gabriel, Count of Ortenburg, etc. *Gabriel, Graf zu Ortenburg, Freiher zu Freistein und Carlespag, etc.* Arms —Quarterly, first and fourth, tierce in fess, five eaglets, three in chief and two in base; second and third, a fleur-de-lis between two lions ramp. combatant. *Crests,* three; all of wings, the first pair charged with a bar; the second, semée of hearts; the third charged with a demi-lion. $7\frac{1}{2} \times 13$ in.

(Rehen Family.) *Arms*—A bull. *Crest*—The same bull repeated. At the base is placed the date M.D.XXVI. No other inscription. 8×7 in.

John Revelles, Bishop of Vienna. *Johannis Revelles Granatensis*(Granada), *Episcopus Viennensis.* *Arms*—First and fourth, tierce in fess, in chief a cross crosslet; second and third, a moor's head betw. a rose and a pomegranate slipped and leaved. The escutcheon is ensigned with the episcopal mitre. Above is the date 1524. $17\frac{1}{2} \times 13$ in.

John Segger Zu Messenbach. *Hanns Segger zu Messenpach. Alls von Got. Arms*—A ship in full sail. *Crest*—A mast with an unfurled sail. 18×12 in.

Anonymous. *Arms*—A boar salient on a mountain with three summits. *Crest*—Out of a crown a demi-boar ramp. No inscription. 13×11 in.

Anonymous. *Arms*—A crown. *Crest*—A demi-savage crowned with vine-leaves. A vacant inscription bracket below, and an empty motto-scroll above. 17×12 in.

Anonymous. *Arms*—Per pale, a bend. *Crest*—A pair of wings, each charged with a bend. $13\frac{1}{2} \times 11$ in.

Anonymous. *Arms*—A fess betw. three lions' heads. Above, to the left, two hands holding a vase of flowers. No inscription. The wood-block is preserved at Vienna. 10×7 in. A. F.

Scheurl and Tucher (Mr. Hodgkin) reimpression. The plate in size and style much resembling the Pömer.

This concludes the catalogue of *armoiries* assigned by Bartsch to Albert Durer. Their descriptions will be found under the master's name in the seventh volume of the *Peintre Graveur.* It would be very interesting to disentangle the genuine ex-libris from the rest of the series.

Let us take one more early German engraver, namely, Jost Amman. It seems perfectly clear that he designed and signed an ex-libris for the Nuremberg family of Holzschuher. The wooden shoes or sabots appear as charges on the shield. The supporters are two angels and a lion. Signed below, J. A. $7\frac{3}{4} \times 6\frac{1}{8}$ in. on copper. There are modern impressions of this ex-libris also current.

In the *Allgemeines Künstler's Lexicon* (Leipsic, 1872), edited by Dr. Julius Meyer, are entered a number of other *armoiries* engraved by this prolific artist; but the descriptions are so brief, that we know not which among these coats of arms are or are not likely to be bookplates. Here is the catalogue—

The family of Fernberger. Motto—*Virtute duce*, etc. The arms of Fernberger and Fürleger. Arms of the Fletchtner family, with the mermaid. Arms of Julius Geuder, with uninscribed name bracket. Arms of Gugel with signature J. A. Arms of Haller von Hallerstein, in oval spaces. Arms of Huls von Ratzberg, of Kress von Kressenstein (signed), of Hermann Müller, of Pfinzing von Henfenfeld, of Pömer von Diepoldsdorf, of Scheurl von Defersdorf, of Rieter von Kornberg, of Schwingsherlein, of Welser, with the initials of the motto words V. C. P., of Kurz von Augsburg, with the demi-goat, etc. etc.

This list, though tantalising, is not uninstructive. It shows that the leading Nuremberg families are constantly recurring on the armorial designs of the contemporary engravers in that city.

Any tolerable collection of old German ex-libris is sure to contain book-plates of the Kress, Scheurl, Rieter, Pömer, Haller, Kurtz, etc., families. This recurrence of certain given houses renders the attribution of any particular ex-libris of a family to some special engraver all the more hazardous; unless, of course, a signature comes in to assist the student.

Hans Sibmacher or Siebmacher, another Nuremberg engraver, who worked between 1595 and 1611, executed on copper a book-plate of the above Holzschuher family, which is as follows—

Arms—Quarterly, first and fourth the wooden shoe; second and third, an old man's head couped; over all, a cross also couped. *Crest*—the armless trunk of a man in a peaked cap; helmet, and mantling. The whole in a wreath of tightly strung leaves, with fruit clusters and jewelled ornaments at intervals. Above, right and left, two cherubs, full-length and undraped, seated on the wreath, each reading a book. Below, a carved, oblong, indented bracket. At the base of the design the engraver's initials, H. S. $4\frac{1}{2} \times 3\frac{3}{4}$ in. W. See also Nagler's Künstler Lexicon, vol. xvi., p. 342.

We now take another Nuremberg family, mentioned above, that of Kress of Kressenstein. Hans Troschel, also a Nuremberg artist, born in 1592 and who died in 1633, designed, signed, and dated this book-plate of John William Kress. Let us describe the ex-libris.

Johannes Guilhelmus Kress à Kressenstein, upon an indented bracket with four rolled-up corners, and, resting on its upper margin, a moulding of a cherub's head with leaf-like wings. This bracket is placed at the base of the design. Below it comes the signature, *H. T. scu.* 1619 *Hh.* The two initials of the engraver's name are in ligature. *Arms*—A sword in bend sinister, the point upwards. The shield set in a slightly angular leaf-work

bordering. Above the escutcheon is a helmet full forward,
open-faced, and garde-visure, whose damascened bars
terminate in fleur-de-lis at their points of attachment.
On the helmet is placed a ducal coronet, with peacock
feathers appearing above its strawberry leaves. Out of
this coronet issues the *Crest*—which is the armless trunk or
bust of an aged bearded man, also crowned with peacock
feathers, and in his mouth a sword fess-wise. From the
helmet, below this, spreads forth right and left a fine and
intricately folded mantling. An oval circle of berried
olive branches encloses the shield and crest. Outside this,
at the four corners of the plate, are seen the respective
escutcheons of *Kress, Freidel, Haller, Schweikhart,* each
being duly named on a label below. At the top of
the design is a four-limbed scroll, reading—*I. Timoth.* :
4. *Pietas ad omnia utilis, promissionem habens vitæ, quæ
nunc est, et futuræ.* Among the mantling to the left
hangs a diminutive escutcheon, bearing an annulet on a
plain field (tinctures, of course, uncertain). These are the
arms of Susanna Kolerin, the wife of John William Kress.
$5\frac{1}{2} \times 3\frac{1}{2}$ in., on copper. W. The plate is extremely
delicate in execution ; but, like most of Troschel's work,
is rather stiff, and somewhat over-elaborate.

 There is a notable genealogical ex-libris of *Wilhelm
Kress,* son of the last Johann Wilhelm Kress, and his
wife *Clara Geborne Viatissin,*[1] dated in 1645. This is
interesting as giving, among other escutcheons in the
pedigree, one labelled *Margretha Rieterin,* with the charge
of the crowned, double-tailed mermaid, as on the Pirck-
heimer sinister shield. This lady appears as the second
wife of one Peter Haller, whose first marriage is dated in
1387. She was, doubtless, sister to the grandfather or great-

[1] By birth of the family Viatis.

grandfather of Pirckheimer's wife. The leading Nurem-berg families seem to have intermarried a good deal.

The next noted engraver in our catalogue is Wolffgang Kilian, of Augsburg, who signs, and what is better, dates, in 1635, the book-plate of Sebastian Myller, Canon of Augsburg and Bishop (in partibus) of Adramytteum in Asia Minor. The ex-libris reads—*Sebastianus Myllerus, Episcopus Adramyttenus Suffraganeus, et Canonicus Augus-tanus, Anno* 1635. It is signed *Wolffgang Kilian fecit* (at full). See plate 14, page 192.

Wolffgang Kilian was the younger brother of the more eminent Lucas Kilian. He was born at Augsburg in 1581, and died in 1662. Both brothers studied at Venice and were taught by their step-father, Dominick Custos.

This relative of theirs, also, on his own account, designed the ex-libris of *John George à Werdenstein*, 1592 (dated) (W.); and of *Zacharias Geiskofler*, 1605 (dated) (W.). We are forced for want of space to dismiss with a brief mention these additional important book-plates by celebrated en-gravers. By *Virgil Solis* the dated but unsigned ex-libris of *Andreas Imhoff*, 1555 (Lempertz). By *Giles Sadeler* the book-plate of the *Count of Rosenberg*, 1609 (dated) (L. and W.). By *John Sadeler*, his nephew, the ex-libris of *Ferdinand von Hagenau*, 1646 (dated) (W.). By *Heinrich Ulrich*, an anonymous book-plate of the *Imhoff* family again (1600) (W.). These other ex-libris are by less known artists, but their dates render them of interest. By *J. Pfann* the book-plate of *John Vennitzer*, 1618 (dated) (L.). By *Tobias Bidenharter* an ex-libris with *Constanter. Non Fata Recusant, &c.*, 1620 (dated) (L.). By *Matthew Zundt* the book-plate of *Pfinzing von Hen-fenfeld*, 1569 (dated) (L.). By *Ja. de Lespier* the ex-libris of *John Charles Seyringer*, 1697 (dated) (W.).

We now leave Germany and pass to France and Switzerland.

Raigniauld, Riomi, 1644. This engraver signs and dates a fine, but coarsely executed, anonymous armorial plate. The shield is untinctured, and quarterly ; first, a star, on a chief, three trefoils slipped ; second, a cross pattée ; third, a wing ; fourth, two bars, in base, a wheel ; over all, an escutcheon charged with a fesse. Fine leaf-like simple mantling to helmet. No crest. I have no further knowledge of the artist. The more modern French form of this surname is Regnault. Riomi is an old-fashioned town in Auvergne, just north of Clermont, said to contain many interesting specimens of domestic architecture, dating about the time of this ex-libris.

Among the signed, but undated, book-plates, one of the most quaint is that of Charles de Salis, brother of St. Francis de Salis, and his successor in the See of Annecy in Savoy. The ex-libris reads—

Eud. Iague Sinton fecit Annesy. Design—The De Salis arms—Ar., two bars fimbriated gu. betw. as many es-toiles, one in fess, and one in base, in chief a crescent. The shield appears very gigantic, in a frame of heavy curves ; which is set in the centre of a huge sideboard-like monumental structure. On the top ledges of this, two full-grown long-skirted angels, seated right and left, up-hold the episcopal hat,[1] with its usual knotted ropes and tassels, in air above the escutcheon. At the base of this structure, to the right, appears a portrait figure of St. Francis de Salis, seated, holding an olive branch in one

[1] Every hat with tassels on a book-plate is *not* a Cardinal's. When correctly engraved, the Cardinal's hat is red with fifteen tassels on each side ; the Archbishop's hat green with ten tassels ; the Bishop's hat green with six tassels ; and the Mitred Abbot's hat black with the same number. But note, the book-plate engravers often give these incorrectly.

hand; while beneath his other arm is a profuse cluster of fruit. To the left, also seated, is a portrait of St. Jane Frances de Chantal, holding a palm branch, also with fruit beneath her other arm. Each portrait is realistic and not the least flattered. Between them is a medallion bearing the crossed papal keys. The plate, except the engraver's name and city, bears no other inscription. It dates about 1642, though it appears to be much earlier; which is often the case with provincial work. The original copper plate was recently discovered in Savoy, and is now in the possession of M. Bilco, the well-known French collector, through whose kindness and the good offices of Mr. Carson I am supplied with an impression.

The following signed plates in our list may be also noted, as their workmanship indicates a seventeenth century engraver.

The first one is a gloomy yet striking heraldic study of a Spanish Bishop's arms, executed in the Netherlands, about 1650, and signed *P. B. Boutats scul.* The escutcheon is surmounted by a plumed helmet, and this again by a bishop's hat with pendent ropes and tassels. *Arms* —Or, two oxen pass. gu. The shield set in an oval, beaded border with a richly foliated external frame. *Motto* (on a separate scroll beneath) *Por la Leÿ Bezerra ÿ por el Rëy.* 7½ × 5½ in. W.

There were four engravers of this Boutats family at Antwerp,[1] of whom this the youngest, Philibert Boutats, was born in that city in 1650. He also engraved a number of portraits.

We have a remarkable rather than beautiful plate

[1] The original Boutats had twenty sons, twelve becoming engravers; one of these twelve sons produced another dozen, of whom four engraved. Walpole *Catalogue of Engravers* (ed. 1794, p. 169).

designed by *John Jacob von Sandrart,* and engraved by one *Homann.* It is inscribed *Godefridi Jac. F. Thomasi Philosophi et Medici* ; and represents Minerva and an emblematical figure of Theologia, or Heavenly wisdom, standing on each side an altar, inscribed—φρονεῖν εἰς τὸ σωφρονεῖν. The whole in a heavy square border of oak-leaves and strings of pearls. 7 × 5 in. Very elaborate, but in the drawing and taste very poor. W. John Sandrart died at Nuremberg in 1698. The plate probably dates about 1690.

Another Bishop's ex-libris, signed *Störklin sc.,* gives the episcopal arms, surmounted by the crozier and mitre, with lion supporters. Beneath, a cherub's head and various fine arabesque work. Above, *H. A. Z. R.* This is probably South German work, of about 1690. It is well engraved and pure in art; but of its engraver I know nothing.

John Ulrich Kraus of Augsburg, born in 1645, died in 1719, has left a fine signed plate. A list of his works will be found in Nagler. The ex-libris is this—

Ex Libris Bibliothecæ D. Zach. Conr. ab Uffenbach, M. F. Design, a finely engraved and elaborate library perspective interior. Above—*Non omnibus idem est quod placet.* Signed *J. U. Kraus sculp.* (1705). W. and Brit. Museum. There is also a fine ex-libris of the *Tegernsee* monastery signed by Isaac Stenglin and dated 1700.

After 1700, the number of signed book-plates increase upon us; and though some particulars are known of many of these engravers in the eighteenth century who figure in our list, it is not our purpose to allude here to any of them, except to two or three really eminent artists. We shall, therefore, skip a herd of second or third-rate names, and pass, by rather a long leap, to times more modern, and to the engravers of days much nearer our own.

Among these more recent artists of note, we are able to instance four ex-libris by the industrious and celebrated *Daniel Nicholas Chodowiecki*; he was born at Dantzig in 1726, where his father was a drug merchant. He became a prolific illustrator of books, and had great knowledge of costume. He inclined somewhat to sensational motives; and the design of one of his ex-libris, that of a doctor in 1792, is characteristic of the peculiar sentiment which pervades many of the works of this remarkable genius. The book-plate indeed in its motive reminds us much of those allegoric framed certificates of membership, which various Sick Clubs and Benefit Societies accord to their members at the present day. In the foreground, Æsculapius is pushing out a skeleton, draped in a long white sheet, with a scythe across its shoulder. The god is sturdily applying his serpent-twined staff to the somewhat too solid back of the terrible phantom. Behind, beneath a kind of pavilion, lies a sick person in bed; his hands are upraised in silent thankfulness, as he watches the prowess of the healing deity. The plate reads— *C. S. Schinz, Med. D^r.*, and is signed in the left corner, *D. Chodowiecki f.* 1792 (dated). Chodowiecki died in 1801. The catalogue of his works is very voluminous.

A name even greater follows. This is Raphael Morghen, one of the distinguished engravers of recent times. He was born at Florence in 1758 and died there in 1833. He is said to have been able to engrave a tolerable plate at twelve years old. We are here concerned, of course, with some of his smallest and, speaking artistically, least important works. Not with the *Transfiguration*, or *Guido's Aurora*, but with a certain small armorial book-plate of the Duca di Cassano, which is as follows [1]—

[1] R. Morghen also designed, we are informed, a card or book-plate for Joachim Murat, King of Naples, and Marshall of France. Not having seen this, we can give no further particulars.

Il Duca Di Cassano Serra. Arms—Or, two bars counter-compony ar. and gu., surmounted by a coronet, and framed in a coarse shell-work frame with a heavy wreath wrapt closely around it. The inscription is on a scroll, which winds in and out of the wreath. Signed *R. Morghen f. Serra*, was a branch of the Cassano family. W.

With R. Morghen our list of foreign book-plate engravers may be said to conclude. When fuller information renders such a catalogue more complete, art critics will be surprised to find how many really great artists have condescended to 'the mean occupation of engraving arms.'

Should the reader wish to know something more of some of the minor names comprised in our list, he will find additional particulars of Aberli and these other engravers in Bryan's *Dictionary of Painters and Engravers, Ed. Stanley, London, Bell*, 1878—

John Audran. Christian Frederic Boetius. Balthazar Antoine Dunker. J. Goeree. Johann Heinrich Lips. John William Meil. G. D. C. Nicolai. John Andrew Benjamin Northnagel. Martin Tyroff. Jerome Wachsmuth. Adrian Zingg. John Martin Bernigeroth. Note also that Jos. Adam Schmutzer signs himself '*Senior Fratrum.*' Some particulars of these brothers Schmutzer will be found; but Stanley only knows the elder as Adam Schmutzer, and states that he died about 1739.

The collector will soon learn to detect a decided difference of artistic character, which exists, in book-plates of the last century between the North and South German examples. This is well seen, on contrasting a Hanoverian, say, with a Strasbourg book-plate. Again, the Swedish examples extremely resemble the Hanoverian, exaggerating their leading peculiarities. The Russian style, again, is very

different and distinct ; indeed, this is a little like the French in the more violent and windy heraldic plates of the Louis XV. epoch. The Italian book-plates are flat, faint, and insipid, without any remarkable features of either excellence or defect. The Spanish are bold and gloomy, often showing a certain harshness of touch. The Swiss are stiff, disjointed, and ill-arranged.

For clearness and rapid reference, a tabular arrangement has been adopted. It is thought worth while to preserve in the second column of the following list the various phrases and abbreviations by which the artist expresses his execution of the particular book-plate. Some of these deserve noting—*Fait à l'eau forte par le Capitaine Rottios ce* 30 *Août,* 1808 ; or, in Latin, *L. M. Steinberger sc. A. V.* (Augustæ Vindelicorum—Augsburg); or, in German—*Rad* (irt) *von Ch. Wilder* 1806.— Etched by Christopher Wilder, 1806. Cross references are given, when the same book-plate has both a designer and an engraver. The dates in the last column are all approximate, unless when followed by the word *dated.* It is convenient to know, even roughly, the period of any special quoted book-plate. In the first column, I generally copy the engraver's name exactly as it appears on the plate, and I do not change the initials into names at length ; nor do I introduce initials, even where they are known, if the engraver signs this or that special bookplate without them, though this fuller information is sometimes elsewhere procurable : *e.g.* taking the first name—This was John Louis Aberli, born at Winterthur in 1723, etc. Audran : this is John Audran, for whom see *Bryan.* He is entered, though a Frenchman, as not occurring in M. Poulet-Malassis' List.

K

Engraver's Name.	Manner of Signature.	On Whose Book-plate.	Nation.	
A. (R.)		Hector Pömer (see Albert Durer)	German	1525 date
A. (I.) (Justus Amman)		Family of Holzschuher etc. (see page 136)	,,	1580
Aberli (J. L.)	del.	Vincent Frisching	,,	1780
Aberli (T. L.)	inv.	Em. Frid. Fisher (engraved by Zingg)	,,	1750
Audran		J. M. H. Michan de Montaran	French	1750
Audran (I.)	sc.	Lewis XV. (This plate reads *A. Dieu inv.*)	,,	1750
Autvein (W. D.) or (Antnein)	sc.	Jos. Bap. Laderchij Fauenti	Nether.?	1710
B.	f.	Bibliotheca Eckiana	German	1750
B. (J. C.)	sc.	Marc. C. Frauenknecht	,,	1790
B. (L. F. D.)	del.	Indians round Minerva (Dutch American?) (eng. by Tahjé)		1750
B. (M.)	sc.	Jo. Georgii Burckhard	,,	1740
B. (N.) (in ligature)		*Arms*—Az. a lion ramp. ar. holding in the dexter paw a dagger	,,	1760
Bacheley	sculp.	D. Gonzenbachii (des. by Descamps)	,,	1770
Back	sc.	Herr Adolf von Trott zu Solz (Treves)	,,	1766 date
Beer (J. F.)	fec.	Franz Kern s. g. Humser	,,	1730
Behrisch (C. S. W.) Lips.	sc.	Bibliotheca Hoermanniana	,,	1761 date
Beck (see Waser)		*In Utroque Clarescere*,		1780
Bella (Stephano della)		&c. Anon 'a blank shield prepared to receive arms.' *N. & Q.*, 4th S. iv., 518		1650
Belling (Jos. Erasm.) Cath : sc. Aug. V.	sc.	Frantz Antoni Frëyherr von Brutscher.	,,	1720
,, ,,		Claustrum Wessofontanum (Wessenbrunn)	,,	1730
Berndt	fec.	August C. B. von Schuler	,,	1784
Bernigeroth, 1745	del. et sc.	E Museo El. de Danckelmann	,,	1745 date
Bernigeroth, Lips. 1762	sc.	Aug. Scholtzii, Canonici (Magdeburg)	,,	1762 date
Bescher	sc.	Comte Karl de Mercy-Argenteau	Netherld.	1820
Bidenharter (Tobias), 1620	scalp.	D. P. S. D. S. C. M. C. *Constanter,&c.* 1624 (the plate is twice dated)	German	1620 date

Engraver's Name.	Manner of Signature.	On Whose Book-plate.	Nation.	Approximate Date.
Boetius (C. F.)	sculp.	Bibliotheca Woogiana (see under Wernerin)	German	1725
Boutats (P. B.)	scul.	Anon. *Motto*—Por la Lëy Bezerra ÿ Por la Rëy	Netherld.	1650
Brockes (B. H.) S. R^{mi} ac Rev^{mi} Electoris Consil.	inv. et sc.	C. A. nobis Clemens Augustus Sibi	German	1760 dated
Br. (J. M.)	f.	J. Math. Brunings (the engraver's initials the same)	,,	1750
C. (F.) a R.	i.	*Fortes Nascuntur.* Arms—Ar. two lions crowned pass. gu. (see J. A. Z.)	,,	1740
Carden (A.)	sculpt.	C. van Hulthem (designed by Lens)	Dutch	1780
Cataneo (G.)	inc.	Vinc. M. Kar. Ca. S^t. Pr. Amphiss.	Italian	1810
Charles (C.)	in.	J. G. F. Chassel (in MS.)	French	1792 dated
Chodowiecki (D.) 1792	f.	C. S. Schinz, M.D.	German	1792 dated
,, ,,		Chodowiecki's own book-plate	,,	1770
,, ,,		Bibliothèque du Séminaire (the French Seminary in Berlin)	,,	1780
,, ,,	inv. et sc.	David Fridlaender	,,	1790
Cöntgen (H. O.) & (B. A.), Mog.	delin. et sculp.	Johannis Phil. Burggravii	,,	1750
Cöntgen (H.), Mog. (Mentz)	sculp.	Frid. Car. de Moser (designed by Northnagel)	,,	1740
Crahay	fe.	*Non sibi sed aliis*	,,	1760
Crusius (C. L.)	f.	Caroli Benjamin Lengnich	,,	1750
Cucó (Pasq¹.)	f.	Anon. Arms & Military insignia	Italian	1800
Custodis (Dominic)	fe.	Joh. Georgii a Werdenstein	German	1592 dated
C. (D.) (Dom. Custos)	f.	Zacharias Geizkofler de Gailenbach	,,	1603 dated
D.		J. F. Mückeÿ	,,	1805
,,		Von Mulinen	,,	1810
D. (D.)		Henricus Epis(copus) August. (Augsburg)	,,	1610
De la Rosée (see under Rosée)				
Delsenbach	sculp.	Ex hoc fundamine surgam	,,	1750

Engraver's Name.	Manner of Signature.	On Whose Book-plate.	Nation.	Approximat Date.
Derichs (Sophonias de), Peintre Sue-dois	ipse fecit	His own book-plate	Sweden	1750
Descamps	inv.	Ex libris D. Gonzen-bachii (eng. by Ba-cheley)	German	1770
Dunker	sculp.	Jo. Freudenberger	,,	1800
Dupuis (C.)	fecit	Petrus Dominicus Haack (of Treves)	,,	1790
Dupuis (C.), Officier	,,	Le Commandeur de Forstmeister, &c.	,,	1790
Durer (Albert)	unsigned	Bilibaldus Pirckheimer	,,	1520
,, ,,	,,	Hieronymus Ebner	,,	1516 date
.. ..	,,	Hector Förner, Abbot of St.Laurence. (See R.A., and see page 129)	,,	1525 date
Du Palluët	Ft.	J. A. T. Chambon de Contagnet	French	1740
Durig, à Lille		Seraphin Malfait, Ne-gociant à Lille	,,	1780
Eben (J. M.)	sc.	Fratres Liberi Barones de Vogelius	German	1720
.. ..	sc.	Aus dem Orthischen Buchervorrate (des. by Orth.)	,,	1700
Eickstedt (Augusto d')		Bibliotheca del Conte Luigi Massimil.	Italian	1730
Euelmi (Ang.)	del.	Dominicus Rosy Mo-rando Patr. Veron. (Verona)	,,	1740
Fehr (P.) 1725	del. et fecit	Bibliotheca Loeniana (Fine library inte-rior)	German	1725 date
Fischer Mon. (Mu-nich?)	sc.	P. Anianus Hornspue-cher	,,	1740
Franck (see under Ostertag)	fec.	Phil. Charles, Arch-bishop of Mayence	,,	1740
Fridrich (J. A. jun.) A. V. (Augsburg)		Bibliotheca Erhardi Riedlin	,,	1720
Fridrich (I. G.) Ratisb.	del. et sc.	Johann Christoph Harrer, M.D.	,,	1740
Fridrich (J. A.)	sculps.	Conventus Ratisbo-nensis F. F. Ord. Præd.	,,	1750
Fridrich (B. G.) in Regensp.	sculps.	Ad biblio. S. Emme-rani J. O. G. D.	,,	1750
Fritesch (J. C. G.)	sc.	Anon. A bee-hive. *Sibi et Aliis*	,,	1800
Fruÿtiers (L.)	f.	L(ouis) B(osch)[1] *In tali nunquam, &c.*	Netherld.	1740

[1] See Reiffenberg, pp. 17 and 22.

DAVID GARRICK.

La première chose qu'on doit faire quand on a
emprunté un livre, c'est de le lire afin de pou
voir le rendre plutôt.

Menagiana Vol IV

[No. 11.]

Engraver's Name.	Manner of Signature.	On Whose Book-plate.	Nation.	Approximate Date.
ruÿtiers (L.)	scul.	I. G. M(ichiels) *Medio lutissimus*	Netherld.	1740
unck (J. P.), Numb. (Nuremberg)	sculpebat	Biblioth. Wagneriana.	German	1750
. (G.)		Anonymous of the Stabius Family	,,	1605
.	f.	*Harmonie.* Cupids with owl	,,	1815
. (L.)		Salomon Schweigger, Sultzensis	,,	1650
autrÿ (J. B. de)	fecit	Anon.	Netherld.	1740
eisler (C. G.)	del. et sculp.	Marc Lefort	German	1750
erisce, Berol		Jo. Car. Vil. Moehsen	,,	1758 dated
ericke(F.E.)Berol. (Berlin)	sc.	Thomas Philipp Von Der Hagen	,,	1764 dated
ͮericke, Jun.	inv. del. et sc.	Raymundus Dapp	,,	1774 dated
eyser	fecit	E. F. Wernsdorf, Viteb(urga)	,,	1710
oeree (J.)	del. et fec.	Bibliotheca Wittiana Pars II. (Qy. if an ex-libris?)	Dutch	1750
ͮow (J. P.)	sc.	Christiani F. Schnaussii	German	1780
raf	sc. f.	Professori Baader	,,	1820
uibal (N.) Pᵗ Peintre du Duc de Wurtemberg		His own ex-libris	,,	1775 dated
aller (Schrazen)	Fec.	H.(probably for Haller)	,,	1810
arrewyn (J.)	sculp.	Anon. Arms on carved bracket	Dutch	1760
arrewyn (J.)	sculp.	Johannis Fran. Foppens, Bruxellensis	,,	1770
eumann (G. D.), Norib.	sc.	Omnia explorate, Retinete Bonum	German	1750
eumann	sc.	Joannis Stephani Püteri	,,	1750
eÿlbrouck (F.)	Fecit.	Anon: *Ad altiora semper.* A fesse dancette gu. betw. three eagles displayed sa.	Dutch	1750
oldenrieder (Ig.), Mogunt	sculp.	Franc. Anton. Xaver. de Scheben	German	1680
oltzmann (C. F.)	sc.	Bibliotheca Electoralis publica	,,	1780
omann (J. Bapt.)	sculpsit.	Godefridi Jac. F. Thomasi (des. by Sandrart)	Dutch	1690

Engraver's Name.	Manner of Signature.	On Whose Book-plate.	Nation.	Approxima Date.
Heumann (G. D.), Norib.	sc.	Ex. biblioth. F. M á Léon (fine library interior)	German	1750
Huhn (G. L.)	sculps.	*Delectando, pariterque docendo.* Female seated by a broken fluted column.	,,	1780
Ihle (J. E.) Direct. (eng.bySchweikart)	del.	J. G. M. Weidmann, Past. Altenmünster	,,	1760
Jungwierth, M.	Del. et sc.	Francis. Præ. Cann. Reg. in Polling.	,,	1744 dat
Jungwierth, Mon. (Munich)	sc.	Franciscus Praepositus Cann. Kegg. in Polling. *Inventa Levetur*, &c. (This is a much larger plate than the last)	,,	1744 dat
K.	fecit	Recumbent boy, tree stump and bushes, draped shield marked—B.	,,	1790
Kauffer (Michael)	sc.	*Fortiter et Constanter.* Arms under a pavilion of mantling.	,,	1720
Kenckel V. (Vienna ?)	sc.	Johannes A. De Brosamer	,,	1706 dat
Kilian (P.)	s.	Monasterium Garstense (designed by Nejpoort)	,,	1640
Kilian (Wolffgang)	fecit	Sebast. Myllerus, Epis. Adramyttenus, Canon. Augustanus	,,	1635 date
Köler (G.)	f.	Sola facta, Deum Solum &c.	,,	1700
Körner (C.)	fe.	Leopold Freyherr von Hohenhausen	,,	1730
Kraus (J. U.)	sculp.	Zach. Conr. ab Uffenbach, M.F.	,,	1730
Kütner (S. G.)	inv. et sc.	C. G. Gunther	,,	1780
L. (F.)		Chartreuse De Beaune	French	1750
Laporterie	sc.	Library bequest by Boursheit Burgbroel family	,,	1710
Lens C.A.T.(Andrew Cornelius)	del.	Ex bibliotheca C. van Hulthem. (See Carden)	Dutch	1780
Lips (H.)	del. et sculp.	Daniel Girtanner	German	1825
Lohrmann (F.B.A.)		G. I. Weickhmann	,,	1720
Lordonné, à Dole	F.	De Saporta	French	1740
Loreau, à St. Omer		Louis de Givenchy	,,	1780

Engraver's Name.	Manner of Signature.	On Whose Book-plate.	Nation.	Approximate Date.
M. (or perhaps M. C. in ligature)	sc.	G. H. F. C. Comes Lepell et Amicorum	Italian	1800
Maag (J. N.)	sc.	Jo. Fer. Maria Comes Salern.	Swedish	1770
M. (J. H.)	f.	Glücksbrunner Berg-bibliotheck	German	1750
M. (J. W.)	f.	L. P. A. Hagemann	„	1780
Mansui	F.	Joann. Bapti. Berna L'Abbe	French	1750
Marchand	F.	C. M. Gattel	„	1790
Mayr, Ratisb.	sc.	Mallersdorf Monasterium, O.S.B.	German	1750
Meil (J. W.), 1767	inve.et fe.	F. A. M.	„	1767 dated
Meil (J. W.)	inve. et. fecit	*E. I. von B.* Trophy of arms, cupid & eagle	„	1780
Minguet (Paulus)	fe.	Ant. Alvarez de Abreu.	Spanish	1680
Montalegre (J. D. de)	fecit	Anon. (Polycarp Muller). *His modo præsidiis, &c.*	Italian	1750
Morghen (Raphael)	fe.	Duca di Cassano	„	1810
Müller (par son ami) 1779		I. I. Reuss	French	1779 dated
Müller	sc.	Anon. *L. G.*	German	1830
„	sc.	Eu. Luth. Waisenhaus	„	1740
Müller (J. J.)	inv.et fec.	Anon. *Principiis obsta.*	Dutch	1780
Müller (J. C.)	sc.	Sub. Abbate Januario I.	Italian	1770
Naert (P.) Br. . . . (Bruges?)		Anon.	Dutch	1700
Nathe		Ins. Bibl. C. G. Anton Biblio(poli.)	German	1760
Nestler (C. G.)	fe.	M. Car. Chr. Gerkenii	„	1750
Nejpoort	del.	Monasterium Garstense. (eng. by Kilian)	„	1640
Nicolai, Vieña	sc.	H. W. Ochs ab Ochsenstein	„	1720
Northnagel (I.A.B.) fr.	del.	Frid. Car. de Moser (eng. by Cöntgen)	„	1740
Onghena (Ch.), Gant (Gbent)	inv. et sc.	Ex-libris Borluut De Noortdonck	Dutch	1830
Opdebeeck (Ant.), Mechlin	fecit	Anon., with marshal's baton	Netherld.	1758 dated
„ „	„	Another with *Bienfaire et ne rien craindre,* or betw. three stags at full speed, a chev. gu. Another with *Justè et intrepidè.*	German	1700
Orth (B. P.)	del.	Aus dem Orthischen Büchervorrate (eng. by Eben)	„	1700

Engraver's Name.	Manner of Signature.	On Whose Book-plate.	Nation.	Approximat Date.
Osterländer (Dr.)	inv.	John Bernard Nack, Frankfort (engraved by St. Hilaire)	German	1759 date
Ostertag (H. J.) et Franck, Mog.	fec.	Philippus Carolus, Sedis Mog. Archiepiscopus (Archbishop of Mayence)	„	1740
P.	f.	Fidelitas et Amor Patrum.	„	1760
P. (C. n. e.)		Ex bibliotheca G. M. C. Masch	„	1750
Pfann (J.)	sculps.	Johannes Vennitzer, Messerschmidt. (Cutler)	„	1618 date
Piedra	ft.	*In hoc signo vinces.* Anon.	Italian	1720
Pingeling, Hamburg	sculp.	Joh. Herm. Schnobel C.L.	German	1740
Pock	sc.	Moll, Kammer Director	„	1810
Polak	sculp.	Aerssen van Sommelsdyck	Netherld.	1780
„	„	Anon. *In curis quies*	„	„
Polack	fecit	Vredenburch	„	1770
Preisler (J. J.)	del.	Joannes Ambrosius Reurer. (eng. by Tyroff)	German	1750
Raigniauld, Riomi 1644		Anon. (See p. 139)	French	1644 date
Reiboldt (de)	sc.	Bibliotheca Mufflingiana	German	1800
Reinhardt (A.)	sc.	Joan. Christ. Seiffii (Frankfort)	„	1743 date
Reinhardt	sculp.	Val. Ferd. Frëyherr von Gudenus	„	1732 date
		Andreas Reinhardt, Kupfferstecher (engraver on copper) in Franckfurt	„	1730
„	sc.	Heinrich Georg Philipp Ochs	„	„
Rentz (M.)	sc.	Friderici Roth-Scholtzii	„	1750
Ricarl (G.)		P. F. Mann	„	1780
Rosée (Aloÿs Comes de la)	inv.del.& sculpsit	Com. de la Rosée	„	1769 date
Rössler	sculpt	Münch De Bellinghausen	„	1750
	sc.	J. H. Harpprecht Ass. C. J.	„	1760

Engraver's Name.	Manner of Signature.	On Whose Book-plate.	Nation.	Approximate Date.
Rottios (Le Capt.), ce 30 Août 1808	Fait a L'ean forte par	Anon. Sa. a satire ar. *Optimus Quisque nobilissimus*	French	1808 dated
üffner (P.)	sc.	Erhard Christoph. Bezzel	German	1750
. (F.)		Ehrenfrid Klotz	,,	1750
. (C.)		Sigmond Held	,,	1590
. (H.) (Hans Siebmacher)		Family of Holzschuher	,,	1600
.	sc.	Franc. Xav. Scherer Theol. Doc.	,,	1800
g.	sc.	Christian Graf zu Stolberg		1721 dated
andrart (Joh. Jacob de)	delineavit	Godefridi Jac. F. Thomasi. (Eng. by Homann)	,,	1690
adeler (Joann.)	fecit	Johan. Adolp. Freiherr Wolff Metternich,&c.	,,	1590
t. Hilaire (de)	del. et sc.	J. B. Nack (see Osterlander)	,,	1759 dated
cheurman (J.)	sculp.	Tscharner	German	1820
chellenberg, 1796	f.	Anonymous *Virtute duce, &c.*	,,	1796 dated
chettanberg (J. R.)	fec.	Diethelm Lavater,M.D.	,,	1810
chön (A.)	sc.	Ad bibliothecam Canoniae Regularis in Diessen. B.P.—J.D.	,,	1755 dated
chink (C.) 1816	sc.	Fridericus Cellarius	,,	1816 dated
chnapper (J. J.) a Offenbach		Joannis Noé de Neufville	,,	1750
chüle (C.)	fec.	Geo. Frid. de Martens	,,	1750
chütz (Je. J.)	sculpsit	Insignia Schütziana	,,	1700
chweikart (J. A.)	sc.	J. J. M. Weidmann (see Ihle)	,,	1760
chwendimann (Jos.)	del. et sc.	Sub Regimine Rev. D. Dom. Martini Abbatis. (The convent name omitted)	,,	,,
copp (J. G.)	fec.	Georgius C. Roth Jur. U.D.	,,	1750
cotto	f.	Comte D. Bourtourlin	Italian	1810
chmutzer (Jos. Adam), Senior Frat. sc. Vien.	sc.	Joannes Fridericus Guntter de Sternegg	German	1710
inton (Eud. Jaque), Annecy	fecit	Charles Aug. de Salis (brother of the Saint)	Swiss	1642
öckler (J. Mich.), 1779	sc.	Biblio. Electoralis Monacensis (see Wink)	German	1779 dated
olis (Virgil)	not signed	Andreas Imhoff	,,	1555 dated
pyk (J. v. d.)	del. & fecit	Bib. Meermannianæ	Dutch	1780
tahl (J. L.)	del. et fec.	D. G. E. Kobesii. Consil. Norimb.	German	1780

Engraver's Name.	Manner of Signature.	On Whose Book-plate.	Nation.	Approximat Date.
Stallin (E.)	F.	M. De Lorme, gentilhomme ordinaire du Koy	French	1750
Steinberger (L. M.), A. V.	sc.	*J. S. T.* Arms in shell frame	German	1740
„	sc.	Collegium Evangelicum Aug. Vindel.	„	1750
Stenglin (I. C.)	f.	Monasterium ad Locum Tegernsee	„	1700 date
Stock	fecit	Cupids round a female figure	„	1760
Störchlin	sc.	H. A. Z. R. with a bishop's arms	„	1690
Stör, Norimb.	sc.	Orths Ottenwald Biblioth.	„	1750
Störchlin (C.), Tugy (Zug?)	sc.	Bibliothecæ Wildermetianæ	Swiss	1750
Strahousky (B.)	sculp.	*Virtus sibi pulcherrima merces*	German	1770
Strachowsky, Vrat.	sc.	Vratislaviæ ad aedem S. Elis. Ecclesiates (Breslau in Silesia)	„	1740
Streidbeck (J.)	sc.	Phil. Hen. Boeclerus, &c. Argent. (Strasbourg)	„	1720
do., Argent.	fecit	Anon. Or, three roses gu.	„	1730
do., do.	del. et sculp.	Jacob Reinhold Spielmann	„	1740
Susernihl (C.)	sc.	J. C. à Neurath, patris et filii	„	1800
Sysang, Halae (Halle in Saxony)	sc.	*Tessera Imp. Nobilitatis indulta, &c.* J. P. de Ludewig	„	1719 date
T. (I.) (John Toustain)[1]		Mgr. Pellot (First President of the Parliament of Normandy)	French	1670
T. (H.) in ligature (Hans Troschel)		Insignia Resleriana	German	1625
„ „		Anon. Perseveranti Corona, &c.	„	„
T. (H.) (in ligature) 1619. Hh (follows)	scu.	Johannes G. Kress à Kressenstein	„	1619 date
Tanjé (P.)	sculp.	Indians round Minerva; and Arms—az. three sceptres ar. (see L. F. D. B.)	Dutch	1750
Terrens	sc.	T. Panton	Netherld.	1750

[1] See Poulet-Malassis, p. 24.

Engraver's Name	Manner of Signature.	On Whose Book-plate.	Nation.	Approximate Date.
Tischbein	inv. & del.	Eu. Luth. Waisenhaus (eng. by Müller)	German	1760
Tscherpinus (C. G.), Lipsiæ	del. et sculps.	Bibliotheca Poeppingiana	„	1740
Tyroff (M.)	facieb.	Acad. Altdorf ex beneficio fundation. Pauli Jacobi de Marperger	„	1753 dated
Tyroff (M.)	fec.	Anon. Minerva, stag, and shield	„	1750
..	sc.	Johannes Ambrosius Reurer (designed by Preisler)	German	1750
W. (F.) (or perhaps F. W.)		Schurer. Ph. P. (Professor of Philosophy)	„	1780
Wachsmann, 1791	inv. et fecit	Schwarzkopf. Boy in garden with tree and tall sunflower. *Fur meine Freunde und mich*	„	1791 dated
Wachsmut	sculp.	J. L. Blessig Prof.	„	1760
Walwert (G. C.)	fecit	Ex Bibliotheca Williana	„	1740
Waser (de), Lieutn. Ing. (Lieutenant of Engineers) see Beck	inv. et del.	*In utroque clarescere pulcrum est*	„	1780
Weigons (M. E.), Coll.		*Vigor omnis ab alto*	„	1750
Weis	sc.	Johannes Boeclerus, M.D.	„	1710
Weiss	fecit	Ferd: R. Edler von Hosson	„	1780
Wernerin (Au.)	del.	Bibliotheca Woogiana (see Boetius)	„	1725
Whitehand (Robertus)	fecit	Jure non Vi.	„	1750
Wicker	sc.	Jacoh Friedemann	„	1810
Wicker (Anna Ros.)	sc.	J. C. Gerning of Franckfort	„	1779 dated
Wilder (Ch.) 1806 (*radiren*, to etch)	rad. von.	G. C. Wilder Diac. Laur.	„	1806 dated
Wink (Christian)	del.	Bibliotheca Electoralis Monacensis. (See Sockler)	„	1779 dated
Winkler	sc.	Valentine Jamarai Duval	French	1750
Wirsing (A. L.), N.	dess et gravé par	Kesler	German	1750
Wollmann (J.) Tilse	sc.	Bib. Galleskyana Tils(it)	Lithuan.	1760
Z. (J. A.) sc. A.V. (J.A.Zimmerman)	sc.	*Fortes Nascuntur.* Ar. two lions pass. gu. *Constans et fidelis* (designed by F. C. a R.)	German	1740

Engraver's Name.	Manner of Signature.	On Whose Book-plate.	Nation.	
Z. (M.) (Matthias Zündt)		Pfinzing von Henfenfeld	German	1569 date
Zell (J. M.), ffurt. (Frankfort)	sc.	J. J. Zur-Mühlen	„	1750
Zick (J. C.)	fec.	Joh. Ferd. Rothius and Schubart	„	1750
Zingg (A.)	sculp.	*Mens conscia recti famæ mendacia ridet.* Anon. Eagle flying with escutcheon	„	1780
	„	Em. Frid. Fisher. (des. by Aberli)	„	1750

ADDITIONS WHILE PRINTING.

Most of these names are new, but some are added because a new da
or a new town or new initials follow an engraver already given.

Engraver's Name.	Manner of Signature.	On Whose Book-plate.	Nation.	Approximat Date.
Berndt, Francoft	fec.	Dietrich Reus	German	1780
Bolt (fr.), 1800	f.	G. I. Göschen	„	1800 date
Brupacher	fecit	Arms—Az. a chev. between three roses, &c.	Swiss	1740
Clausner, Zug	sc.	Lib. Baro Zur Lauben de Thurn	„	1700
Cöntgen, Francfurt	sc.	Johann Ernst Ascani	German	1780
Duvivier (B.), Brugensis, 1806	delᵗ	G. Van Hulthem. *Omnes artes, quæ ad humanitatem, &c.* A female studying in a library. (Eng. by De Ghendt)	Netherld.	1806 date
E. (J. v.)	sc.	M. Benzelftierna	Dutch?	1770
Feuerbach (J. A.) fil.	sculps.	Jo. Wilh. Phil. Feuerbach	German	1760
Fridrich (Jac. Andr.) Ser. Duc. Würt. Sculptor Aul.[1] A.V.	sc.	Gottlieb Ettling	„	1750
G. (E.), a Neuwied	fec.	Biblioth. Abb. Saÿn Ord. Præmonstr. (Chippendale)	„	1745
Ghendt (E. de)	sculpᵗ	C. Van Hulthem. *Omnes Artes*, &c. A female studying in a library (des. by Duvivier)	Netherld.	1810

Court Engraver to the Duke of Wurtemberg.

Engraver's Name.	Manner of Signature.	On Whose Book-plate.	Nation.	Approximate Date.
Grünter	fec.	A wood scene, urn, owl, trees, &c.	German	1780
Heumann (G. D.) 1743	fecit	*Non tota perit.* Crysalis and butterflies	,,	1743 dated
Heumann (G. D.), Gottingæ	del. et sculp.	*Juste, Honeste, Benigne.* Library interior	,,	1760
Junker	gravépar.	Ex bib. Com. Franc. Szechenyi	Austrian	1790
K.	sc.	Bibliotheca Pezoldiana	German	1770
L. (A.) (The L. is under the crossbar of the A.)		Sebastiani Stor	,,	1680
Lespier (Ja. de)	fe.	Joan. Caroli. Seyringer J.U.D.	,,	1697 dated
Luengo en (a convolvulus flower)		L.D.S.M.D.G. Arms: Lozengy ar. and gu.; impaling, or on a bendlet ar. six plates		
Maurhoff (G. F.)		Wilhelm A. F. von Münchhausen	,,	1740
Necker, 1779	f.	M. Jerem. David Reuss	,,	1779 dated
Nestler (C. G.)	sc.	Ex bibliotheca Fritzschiana	,,	1760
Neubauer	sc.	Baron Wiesenhütten	,,	1780
Nilson (Jean Esaie), Peintre [1]	sc.	His own book-plate	,,	1720
Nunzer (A.)	scu.	*Volunt sed non possunt.* A man secured by a river between from wild beasts	,,	1740
Pintz (Johann Georg.) A.V.	sc.	S. V. G. *En dextra, fidesque*	German	1730
Philippin (J. D.)	sc.	E. Bibliotheca P. I. Scharno	,,	1750
Sadeler (Aeg.) S. G. Mtis Sculptor	fecit	Count of Rosenberg	,,	1609 dated
Sadeler (Joannes), 1646	d. d.	Ferdinand von Hagenau	,,	1646 dated
Schaffhauser S. C. M. Calco., Viennæ	sculp.	Antonius Rambaldi, Comes Collalti	Austrian	1750
S. (C.) in ligature		Zacharias Geizkofler, &c. Maria Geizhoflerin, geborne von Rehelingen	German	1605 dated
Schellenberg (J. R.)	fec.	J. B. Tandem. (Curious design like Hogarth's ' Boys peeping at nature.')	,,	1730
Siherer	sc.	Johannes Philippus Jordis D,	,,	1740

[1] Bryan gives the second name wrongly as *Elias.*

Engraver's Name.	Manner of Signature.	On Whose Book-plate.	Nation.	
Sp. (J.)	fec.	Jacobus, Canonicorum Chiemensium Præpositus, &c.	German	1690
Strachowsky (J. B.), Vrat.	sc.	H. S. (Quite Chippendale in style)		1750
Tyroff (H. J.), Norimbergæ	sculp.	Chris. Guil. Staudnerus, Consiliarius Norimbergensis	,,	1760
Ulrich (Heinrich)	fe.	*Virtute non Sanguine* (Imhoff family)	,,	1610
Valesi	in.	Jacobi Muselli	Italian	1770
Viero (T.)	inc.	Jacob. Maximilian, Count Collalti	,,	1750
Wauters (P.), 1754	sc.	*Pour Bien* and *In hoc signo.* Episcopal arms, gu. three keys	German	1754 date
Wit(?) (Ant.)	sc.	Bibliotheca Nicholspurgensis Scholarum Piarum	,,	1700

ENGRAVERS OF ENGLISH BOOK-PLATES. FIRST PERIOD.

(1660-1760.)

IT has been found desirable to divide the English engravers of ex-libris into two periods. It seemed incongruous to place side by side, in one and the same section, an escntcheon of William Marshall and a fishing vignette of Thomas Bewick. The first period, therefore, will reach from the Restoration to the accession of the third George, and will comprise exactly one hundred years. Our second epoch includes the long reign of that monarch and the briefer one of his successor; it falls short of a century by some thirty years. We do not propose to take any cognisance in this essay of book-plates in date more recent than 1830, the year of George the Fourth's death. For the purposes of this work such ex-libris are considered as modern, and are excluded from our consideration.

In an artistic point of view this our first period will be found to contain the lion's share of the finest book-plates in our national series. It includes all the ex-libris designed under the Jacobean influence. It embraces, moreover, all the purest and most graceful examples of that later and succeeding decorative fashion, which we have designated as the Chippendale. It is true, that, during the first decade of George the Third's reign, Chippendale book-plates were still current; yet these specimens unmistakably convince

us that this vogue was already past its best. In their art, as in their designs, they bear undoubted symptoms of decadence and efflorescence. By 1780, Chippendalism had become on book-plates practically a thing of the past.

When do engravers' names first begin to appear on ex-libris in England? This question will suggest itself on the very threshold of the present chapter; and we may at once confess that our materials are, at present, far too imperfect to enable us to answer it with anything like precision. We can only speak as far as we know.

The earliest English book-plate carrying an engraver's signature, which has as yet come to hand, is one of a cadet of the family of Lyttelton, by the well-known William Marshall. We ascertain by his signed frontispieces that Marshall was still extensively employed down to 1650; but how long he lived after that date, I have been hitherto unable to determine. It is impossible to date a purely heraldic book-plate with any great exactness; but I believe the Lyttelton ex-libris is, at latest, of a period soon after the Restoration. It resembles in artistic details the dated plate of Nicholson of Balrath, in 1669; but the resemblance is that of an original to its copy, not of a copy to its original. The Lyttelton book-plate seems in fact some six or eight years older than the Nicholson one. Let us date it approximately in 1662.[1] The ex-libris itself may be thus described:—Anonymous. *Arms*—Quarterly, first, ar. a chev. betw. three escallops sa., differenced with a crescent on a mullet;[2] second, ar. a bend cotised sa. within a bordure engr. az., charged with ten plates; (and fifteen other quarterings). *Crest*—A moor's head in profile, couped at the shoulders, ppr. wreathed about the temples, ar. and sa. *Motto*—Ung Dieu, ung Roy. Shield quite plain without

[1] In 1659 George Tooke published *the Belides Eulogie of John, Lord Harrington, Lond.*, 1659, 4to, with a frontispiece by Marshall.

[2] For a second son of the third house.

any bordering, surmounted by a closed damascened helmet. The mantling is of fine early leaf-work, simple and un-usually curved. It ends at each side in a tassel. The motto is on a detached scroll below. In left corner, *Will. Marshall sculpsit.* For the folio, 7 × 5¼ in. W.

At whatever epoch designed, this is unquestionably a fine bold example of the heraldic book-plate pure and simple.

The long gap, which intervenes before our next dated example, infers plainly enough the incompleteness of our materials. The striking example, signed by James Sartor, has been already described at p. 20, and figured in plate 5. This is not much earlier apparently than 1710. But the plate bears no date, and may possibly be older. It seems, next to Marshall's example, our most ancient book-plate with an engraver's name. Who James Sartor was, and whether domiciled in London, or only settled there for a season, I am unable to determine. There is one Jacob Christopher Sartorius, a Nuremberg engraver, whose engravings are dated between 1674 and 1737, a limit which fits exactly the probable execution of this book-plate; but I have met with no record as yet of his ever having resided in London.[1]

The firm ground of an engraved date, associated with an engraver's signature, is for the first time found soon after the accession of the first George, an epoch singularly late, as contrasted with the signed and dated specimens of the Continent. We allude to John Pine's allegoric ex-libris, described at p. 38, and reproduced in plate 4, reading *Munificentia Regia.* 1715. *J. Pine sc.*

In the next year Michael Vandergucht appears to have executed a library label for a Westmoreland Baronet, as follows :—*The Paternal Arms of Sir William Fleming of Rydal in the County of Westmoreland, Baronet. Arms—*

[1] But Bernigeroth may be cited as engraving both German and English ex-libris.

Quarterly, first, gu. a fret ar. (and eight other quarterings).
Crest—A snake nowed, holding in the mouth a garland, all
ppr. *Motto*—Pax, Copia, Sapientia. The escutcheon is
unframed, and the mantling reaches to its base. Below
is inscribed—*Anno* 1716, *Vandergucht.* The plate is a fine
one, for the folio, and may be quoted as another remark-
able specimen of the purely heraldic style. (P.)

The illustrations of Michael Vandergucht are well known
to those collectors who are interested in the literature of
Queen Anne. He was a native of Antwerp, and instructed
by one of the many Boutats. The date of his arrival in
England is uncertain;[1] but he received in this country
extensive employment from the booksellers, and died in
Bloomsbury in 1725. George Vertue was his most
distinguished scholar.

Simon Gribelin's career was very analogous to that of
Vandergucht. A Frenchman, born at Blois in 1661, he
came over to England in 1680, and continued here till his
death during 1733, in Long Acre. He was equally well
known with Vandergucht as an illustrator of books. Of
such cuts, those in *Shaftesbury's Characteristics* (2nd edit.,
3 vols., 1714, 8vo) may be selected as striking and elabo-
rate. Lord Orford specially mentions that Gribelin pro-
duced a vast number of small plates; of which Walpole
possessed a thick quarto volume, collected by Gribelin
himself. Among these smaller efforts of this artist may
be confidently included the two *Parochial Library* book-
plates, which were designed in blank for general use by
such societies throughout this kingdom. Spaces being
left for the special parish to fill in its name.

The finer plate represents St. John at Patmos, the coarser

[1] In my own collection, the earliest illustrations, executed in
England by his hand, are those to the *Satires of Juvenal and
Persius,* '*made English by Mr. Dryden,*' Tonson, 1697, 8vo.

[No. 12.]

[178]

one a figure in prayer. Both are signed S. G., and may be dated about 1720. The Jacobean book-plate of the *Hon^ble Charles Hamilton Esq^r.*, which is also signed *S. G.*, may likewise be executed by Simon Gribelin (1720).

George Paterson, a Scotch artist, signs an ex-libris of James, Earl of Bute, who died in 1723. His book-plate must therefore be dated *before* that year; but unfortunately Paterson has placed no date on his handiwork.

James Hulett, an indifferent engraver, of whom Bryan gives a brief notice, signs and dates in 1725 an ex-libris of John, Lord Boyle. The book-plate is merely armorial, and calls for no special comment.[1]

We have nothing now for four years, the next signed book-plate belongs to some member of the Dugdale family, but does not bear any name. It is, of course, heraldic— *Arms*—Ar., a cross moline gu., in dexter chief a torteaux. *Crest*—A griffin's head and wings endorsed, or. The mantling with stiff foliations. A rudimentary Jacobean bracket is visible at the base of the escutcheon. *Motto*— Pestis patriæ pigrities. The plate is signed—*Nicholls sculp.* 1729 (dated). (C.) We may note that the full name of this artist was Sutton Nicholls; he was an engraver in London from 1710 and onwards. A slight notice of him will be found in *Bryan*.

George Bickam, a name rather better known, but not in the first or even in the second rank, has left us a book-plate in the next year. This reads—*The Reverend John Lloyd, A.M.*, 173(0). *Arms*—Ar. a chev. betw. three crows sa., each bearing in the beak an ermine spot. The plainly framed escutcheon is raised on a broad and substantial shelf-like bracket. As quasi-supporters, on its ledges right and left are seated two undraped boys, holding books.

[1] John, Lord Boyle's quarrel with his more illustrious father, and his consequent loss of the Boyle library, are well known.

Across the bracket is written—*Animus si æquus, quod petis hic est.* A large scallop shell and coral branches appear above the oval shield. The same shell is repeated on an estrade below, across which a ribboned drapery hangs which bears the name. The signature (exceedingly minute), just above this drapery, is—*Bickam Jun. fecit* 1730. (W.) An interesting, but not uncommon ex-libris. I have seen a *Life of Peter the Great* with cuts by G. Bickam, Jun., 1740, also a thin folio volume of this artist's designs was published in 1757, entitled — *Ornamental Villas and Pavilions for Landscape Gardens.*

The graceful and important book-plate designed by George Vertue for the Countess of Oxford is placed by its manuscript memorandum in this year.[1]

An engraver, who assumes some importance in the book-plate series, is one J. Skinner of Bath, of whom I would gladly learn some biographical details. He is much to be commended for always dating his ex-libris. Six of these are given in the ensuing list ; their dates range from 1732 to 1747. He is probably related to Matthew Skinner of Exeter, who engraved, say, fifteen years later.

A premium of Trinity College, Dublin, dated in MS. 1733, is signed thus—*K. O'Hara fecit.* There seems no reason to doubt that this was the work of the dramatist, when quite a young man. The date of his birth is nncertain ; but he died, old and blind, in 1782. I owe this interesting plate to Mr. Carson, who supplies me with the following extract :—'The extremely meagre notices of O'Hara extant contain no reference to his skill as an artist, of which we have a specimen in his etching of Dr. William King, Archbishop of Dublin, in a wig and a cap, of which portrait a copy has been made by Richardson.[2]

[1] See p. 41, and plate 7.
[2] *A History of the City of Dublin*, by J. T. Gilbert, M.R.I.A., vol. iii., p. 270. Dublin, J. Duffy. 1861.

Dr. William King died in 1729, so that if Kane O'Hara etched his portrait from life, he may have well executed this ex-libris.

A very exceptional book-plate is signed *J. June*, 1745. A brief notice of this engraver occurs in *Bryan*, who dates him in 1760. The ex-libris would certainly pass at first sight for a foreign one. The frame-work of the shield is the foreign analogue of Chippendale, which may be called *Rococo*. The landscape accessories, a birch-tree on the right, a cypress on the left, with a brook flowing out from underneath the escutcheon frame, are at this period on the English book-plate most unusual. A single cupid is seated as a quasi-supporter on the right of the shield. The plate is anonymous, but belongs to the Herbert family. *Arms*—Per pale az. and gu. three lions ramp. ar. *Crest*—A wyvern, wings elevated, vert, holding in the mouth a sinister hand, couped at the wrist, gu.

R. Mountaine appeared as a very prolific engraver of book-plates about 1745 or 1750. He was a neat artist in the early and hardly developed Chippendale style, and in a curious arabesque fashion of his own. He did not date his ex-libris, some fourteen of which are here catalogued. The collector will do well to endeavour to complete the list of his works. I know of no particulars respecting Mountaine's life.

William Hogarth engraved about 1720, quite at the beginning of his career, two book-plates at least. One of John Holland, heraldic artist, and another of George Lambert, the scene painter. Both are in the allegoric style.[1]

Certain ex-libris in our list of the names of Jones, Jolliffe, Collyer, and Russell, are signed W. H., and have been erroneously attributed to Hogarth. These plates

[1] See p. 44. His other small plates, such as Ellis Gamble's, etc., are trade-cards, tickets, impressions from tankards, etc., and do not come into the category of ex-libris.

are none of them earlier than 1745, at which time Hogarth was better employed than on such small work as this. They must be assigned to one William Hibbart, whom Bryan mentions as residing at Bath in 1750 and etching portraits in the manner of Worlidge. This W. Hibbart, moreover, signs his name in full with this very date, 1750, on the book-plate of Deburgh, Earl of Clanricarde.

Of Thomas Worlidge, an eminent name, incidentally mentioned above, I have only as yet seen the book-plate of the Hon. Henrietta Knight, in the Jacobean style, of about 1735. Worlidge signs the ex-libris in full.

There is a pictorial ex-libris of Andrew Lumisden, signed by that eminent engraver Sir Robert Strange, which dates about 1750, early in that artist's career.[1]

Notices will also be found in Bryan's Dictionary of the following occurrent names :—J. Cole, G. Terry, W. H. Toms, John Wood, etc. It may be noted that, as compared with our list of foreign engravers, few designers' names occur on the English book-plates of this period. I can only name three—Gravelot, Ross, Hains.

In the list itself, which now follows, the first column presents the engraver's name, just as it appears on the ex-libris itself; at times with the fore-name omitted, at times merely in initials. The second column gives the technical term, usually abbreviated, by which the artist's execution of the special book-plate is recorded. The third column declares the name of the owner of the ex-libris ; or, where this is anonymous, some motto, heraldry, or initials, whereby it may be identified. The fourth column is a rough attempt to indicate the style or subject of the ex-libris. The

[1] See, to explain this association, *Memoirs of Sir Robt. Strange, engraver, and of his brother-in-law, Andrew Lumisden, private secretary to the Stuart Princes, etc., by James Dennistoun (with plates),* 2 vols., 8vo, 1855, and especially ii. 284, where the book-plate is mentioned and referred to.in the year 1747.

descriptive terms, used in the column for this purpose, are—Armorial; Jacobean; Chippendale; Allegoric; Pictorial; or book-plates bearing various picturesque adjuncts, which are not classible either as landscapes or allegories; Landscape; Transitional, that is to say, the Jacobean style passing into the Chippendale. *Flowers, Festoons, Chinese*; and a few others. When this column is left blank, the style or subject was not noted at the time of the book-plate's inspection. In both lists of English engravers I am greatly indebted to the valuable assistance and co-operation of the Rev. T. W. Carson, whose fine collection supplies no inconsiderable quota of the names.

TABULATED LIST OF ENGLISH ENGRAVERS.
FIRST PERIOD.

Engraver's Name.	Manner of Signature.	On Whose Book-plate.	Style of Book-plate.	Approximate Date.
A. (M.)		*Nocte virescunt*	Armorial	1730
Ashby, Russell Court, London	sculp.	Bryan Edwards	,,	1755
		Anon.	Chip.	1760
Austin (W.)	fecit	Lord Walpole of Woolterton	Armorial	,,
,,	sculp.	Lord Dacre	Chip.	,,
	sculp.	Sol. Dayrolles Esqʳ	,,	1755
B. (M.)	s.	William Bucknall		1720
Bache, Birmingham	sculp.	John Cobbell, M.D.		1755
Batley, London	fecit	Edmᵈ Strudwick Esqʳ	,,	,,
Bernigroth	scul.	Edward Eliot Esq. (of Port Eliot)	Armorial	1740
Bickham, Jun., 1730	fecit	Rev. John Lloyd A.M.	Jacobean	1730 dated
Bickham	sc.	W. Wollaston, Finborough, Suff.	Armorial	1740
Billinge	sculp.	Or, three lions couch. in pale az.	Chip.	1750
		Peter Salusbury	Pictorial	1755
Bramston (Ed.)	sculp.	(Pyott Family). Anon.	Landscape	1760
		Pietatis Amator		
Burden (Arᵈ.)	sculp.	Birnie of Broomhill	Armorial	1730
Calender (J.)	sculpsit	John Spotiswood of that Ilk [1]	,,	1750
Chinnery		Philip Burton	Chip.	1760
Cole (B.)	sculp.	Darcy Lever, Alkington, Lancaster	,,	1750

[1] Some Scotch plates are very difficult to date. This is one. Birnie of Broomhill is another.

Engraver's Name.	Manner of Signature.	On Whose Book-plate.	Style of Book-plate.	Approximate Date.
Cole (B.)	sculp.	Randolph Greenway, Thavies Inn.	Chip.	1750
Cole, Oxon.	sculp.	W. Holmes, St J. B. Coll.	Jacobean	1730
Cole	sculp.	Fillingham	,,	1730
Cole (J.)	sculp.	Anon. *Ditat servata fides*		1755
Evans	sct.	Robert Cunliffe	Pictorial	1760
G. (S.) (Simon Gribelin)		Parochial Library of Chippenham, &c.	,,	1720
G. (S.) (do.)		The Honble Charles Hamilton	Jacobean	,,
Gard. (F.) (F. Gardner)	in. scu.	Edwd Southwell Esqr	,,	1735
Gardner (F.)	S.	Pawlet St John	,,	1740
,,	sculpsit	Wm Pescod	,,	,,
Gravelot	inv.	J. Burton D.D. (Eng. by Pine)	Allegoric	,,
Green (T. B.), London	fecit	Anon. *Philosophemur*	Chip.	1755
H. (N.) see N. Hurd				
H. (W.) see W. Hibbart				
Hains (G.)	Delin.	Anon. With military implements (eng. by Toms)	,,	1752 date
Hawes (H.)	sct	Anon. Motto—*What is best*	Late Chip.	1760
Hibbart (W.)	sculp.	Deburgh, Earl of Clanricarde	Armorial	1759 date
H. (W.) (W. Hibbart)		E. Jones, Fellow of King's College, Camb.	Chip.	1745
H. (W.) (W. Hibbart)		Jolliffe. (In Mountaine's style)	Trans.	,,
H. (W.) (do.)		Honble Capt Stuart. (Military)	Chip.	1750
H. (W.) in ligature (W. Hibbart)		Daniel Collyer	,,	1755
H. (W.) (do.)	fet	Henry Russell	,,	1760
Hillyard (T.)	sculpt.	Robertus Nash, Diœces Norvic. Cancel.	Trans.	1735
Hogarth (W.)	unsigned	George Lambart (for Lambert)	Allegoric	1725
	,,	John Holland	,,	,,
Hulett	sc.	John, Lord Boyle	Armorial	1725 date
Hurd (N.)	scp.	Henry Pace		1755
H. (N.) (N. Hurd)	scp.	Benjamin Greene	Jacobean	1757 date
H. (N.) (do.)	scp.	Danforth	Chip.	1760
Johnston (A.)	sculp.	H. E. Robert Hunter, Esqr, Captain General and Chief Governor of Jamaica	Jacobean	1740

Engraver's Name.	Manner of Signature.	On Whose Book-plate.	Style of Book-plate.	Approximate Date.
Joyce	sculpt.	Burges Family	Jacobean	1735
June (J.), 1745.	sc.	Anonymous. (Herbert Family) see p. 162	Chip.?	1745 dated
Kirk (J.), St Paul's Churchyard	del. et sc.	John De Chair	,,	1760
,,	,,	Ar. a chev. az.(?) three ducks pass.	,,	,,
Kirk (Jas.)	,,	Inner Temple Library	Armorial	,,
Kirk (J.)	fecit	Gift of George, Prince of Wales	,,	1757 dated
Kirk (J.), Pauls Church yd.	sculp.	Isaac Mathew	Chip.	1760
Kirk (Js.)	sc.	Willm Fentham	,,	,,
K. (J.)(James Kirk)	sct.	Thomas Elrington		,,
Levi (I.) (and M. Mordecai)	scu.	Mors sola resolvit.	Trans.	1750
Levi	sculp.	Isaac Mendes, London	Chip.	1746 dated
Levi, Port(sea)		Thos. Dunkerley Fitz-George	,,	1750
M. (G.)		Lieut. Genl Campbell of Monzie	Armorial	1730
M. (M.)	sculp.	*Nil Desperandum*	Chip.	1750
M. (R.) see R. Mountaine				
Marshall (Willm)	sculpt	Anon., of the Lyttelton family	Armorial	1660
Mole, Oxon.	sculp.	Thomas Mansel, Lord Mansel, of Christ Church, Oxon.	,,	1740
Moses	sculpt	Sophia (Wisdom). (In Greek Letters)		1760
Mordecai (M.) and Levy (I.)	scu.	Mors sola resolvit	Trans.	1750 ?
Mordecai	sculp.	E. H. Sandys.	Chip.	,,
,,	,,	Jonathan Battishill	Armorial	1755
Mountaine		Pringle	Chip.	1750
,,		Thos. Worsley	,,	,,
,,		B. F. R.	Armorial	,,
M. (R.) (R. Mountaine)		Henry Bowles		
,,	(do.)	W. Harrison, D.D., Fellow of C. C. C. Oxon.	Flowers	,,
,,	(do.)	S. J. Collins	,,	,,
	(do.)	Ed. Gore, Kiddington, Oxon.	,,	,,
,,	(do.)	John Duthy	Trans.	,,
	(do.)	John Hoadly, LL.D. (the dramatist, brother to the bishop)	Chip.	
	(do.)	Sophia Penn	,,	,,

Engraver's Name.	Manner of Signature.	On Whose Book-plate.	Style of Book-plate.	Approximate Date.
M. (R.) (R. Mountaine)		Jos. Portal	Chinese	1750
„ (do.)		C. S. Powlet, Itchin		„
„ (do.)		Geo. Powlet, Esq^r	Chip.	„
„ (do.)		John Sturgis		„
Nicholls	sculp.	Anon. (of the Dugdale family)	Armorial	1729 date
O'Hara (K[ane])	fecit	Trinity College Dublin Præmium	„	1733
Paterson (Geo.)	sculp.	James, Earle (sic) of Bute. Fine old armorial work, coronet and mantling quite dwarfing the escutcheon	„	before 172
Pine (J.)	sculp.	J. Burton, D.D. (des. by Gravelot)	Allegoric	1740
P. (J.) (J. Pine)	sc.	Munificentia Regia, 1715 (signed also in full)	„	1715 date
Robinson (John), Lancaster	sc.	Samuel Winstanley	Chip.	1750
Ross	in. et desin.	John Wiltshire, Bath, (eng. by Skinner)	Pictorial	1740 date
Robson	fecit	T. P. Young, D.D.	Chip.	1760
S. (W.) See W. Stephens				
S. (J. H.)		Samuel Norris	Armorial	1760
Sartor (Ja.), Londini	fecit	Ar. three dragons' heads erased sa. (Qy. Willison)	Jacobean	1710
Scott (B.)	f.	John, Earl of Hindforth	Armorial	1730
Skinner (I.), Bath	sculpt.	John Wiltshire (des. by Ross)	Pictorial	1740 date
--	„	C. Delafaye, Wichbury, Wilts	Trans.	1743 date
	„	Musgrave of Edenhall		1732 date
Skin^r (sic) (I.)	sculpt.	Hen. Toye Bridgeman of Princknash, Gloucestershire		1746 date
„	„	Benja. Adamson	„	1746 date
„	„	Henry Walters	„	1747 date
Skinner (Matt^w), Exon.	sculp.	Peregrine F. Thorne. Military implements in background	Late Chip.	1760
Spendelon (Theo.)	scu.	Thomas Parker of the Inner Temple	Jacobean	1740
Stent, Gutter Lane	sculp.	Daniel Olivier, London	Chip.	1760
S. (W.) (W. Stephens)	fec.	Joh. Colbatch S.T.P. Trin. Coll. Cant. Socius Sen.	„	1755

Engraver's Name.	Manner of Signature.	On Whose Book-plate.	Style of Book-plate.	Approximate Date.
tephens (W.), Can.	sculp[t]	Christopher Montagu	Jacobean	1740
,,	,,	R[dus] Smith Coll. Jesu Cantabr.	,,	1760
	,,	Trinity College, Cambridge	Chip.	1755
,,	,,	Samuel Berkley	Armorial	1750
trange (R.)	sculp.	An[w] Lumisden	Pictorial	1760
erry (G.), Paternoster Row	spt.	John Silvester	Late Chip.	1760
,,		Peter Muilman	Allegoric	1760
		Nath[l] Highmore	Flowers	1760
oms (W. H.), 1752	sculp.	Anon., of Sir C. Frederick, with military implements (des. by Hains)	Chip.	1752 dated
oms (W. H.)	,,	Pleydell Nott		1763 dated
,,	,,	*Invitum sequitur honor.* (Chichester.)	Chip.	1755
,,	,,	S. Ricardi Walwyn de Com. Hereford	Late Chip.	1760
andergucht, anno 1716		Sir William Fleming, of Rydal, &c., Baronet	Armorial	1716 dated
ertue (George)	not signed	Countess of Oxford	Jacobean	1730
V. (R.)		Rich. Jenkins, Esq[r]	,,	1730
		Rich. Price, Surgeon		,,
V. (S.)		Henrietta, Countess of Pomfret	Pictorial	1740
Vills (J.)	sculp.	A. C., God is Love (in Greek) red printed	,,	1760
Vood (I.)	in. et sc.	David Garrick	,,	1760
Vorlidge (Thos.)	fecit	Hon. Henrietta Knight	Jacobean	1735

ENGRAVERS OF ENGLISH BOOK-PLATES. SECOND PERIOD.

(1760-1830.)

A GENERAL review of our second period leads to the conclusion that, neither in interest nor variety, is it able to compete with our earlier catalogue. Long before its commencement, the Jacobean ex-libris had become obsolete. The Chippendale book-plate was fast falling out of popular favour. Engravers still continued, it is true, to encase escutcheons in borderings of flowers and shell-work; and, to the names already mentioned at p. 35, may be added these artists who worked at the lowest ebb of the Chippendale vogue, and who are probably among the very last producers of the English *rococo* book-plate. They are half a dozen in number—Crowe, 1767 (dated); Darling, Great Newport Street; Foster, Fetter Lane; M. Hanbury; Hughes; Stayner. Of these Hughes is better known as an allegorist, and Darling adopts several pictorial styles, and but rarely touches a Chippendale ex-libris.

When Chippendalism was dead and buried for good and all, the average English book-plate art ultimately settled down into a mere plain and prosaic transcript of the heraldic details without extraneous addition of any kind. During the last decade of the eighteenth century, and notably after the present century had commenced, the per-

centage of such purely armorial book-plates largely increased. These differ really very little in style from the armorial ex-libris as at present produced. All ornamental shield-border is discarded. The name is hardly ever placed on a bracket, but is merely written unenclosed across the base of the field of the book-plate. Helmet and mantling are often omitted, or, if present, are represented without any of the breadth or boldness given to those adjuncts on the ex-libris of Anne and the two first Georges.

But a revolution so thorough, as from Chippendalism to the modern heraldic plate, could not be accomplished *per saltum.* We are able to indicate at least one pausing point ; and accordingly about 1780 there arose, from the ruins of the Chippendale ex-libris, that intermediate style of book-plate decoration, which may be compendiously termed the *Ribbon & Wreath* period.

This came in as follows : by about 1775, the Chippendale fashion was quite exhausted and run out. Its conventional frame had been gradually tumbling to pieces. The perpetually recurrent shell-work had exhausted the patience of the engraver and of his patrons. So the shell-frame was set aside for good. But the flowers and sprays outlived the more conventional inner bordering, and were still retained for some twenty years on book-plates. They made up for the loss of the shell-border by the combination of a good deal of floating ribbon in various bows and loops. As a centre of the design, appeared the armorial shield without frame or border of any kind. Around this, and apart from it, were drooped and hung, above, below, and at the sides, festoons of leaves and flowers, here and there be-ribboned. These wreaths in their curves more or less adapted themselves to the varying outline of the central escutcheon : with which, however, they were seldom in actual contact.

M

This fashion, which lasted from about 1775 to 1795, we have already named *the ribbon and wreath*[1] period ; and the book-plates designed under its influence are sufficiently numerous. The year 1780 may be taken as the climax of this vogue.[2]

Let us take the dated specimens first. *G. L. Bishop of Kilmore,*[3] 1774. Here are an oak and a palm branch crossed below ; pendent rose festoons above. *Sir Thomas Bankes J'anson, Baronet, of Corfe Castle, Dorset,* 1783, (dated), bears, left and right, a single detached spray of flowers and tulip-like buds, hanging beside the escutcheon. *Rev⁴. George Pollen,* 1787, (dated), gives two berried olive branches, crossed and ribboned. *John Holcombe, New Cross,* 1799, (dated) ; festoons of various flowers quite surround the shield. Below, comes in a ribbon length of loops, bearing the motto.

The engravers of *ribbon and wreath* book-plates are— *Ezekiel,* who profusely ornaments the ex-libris of *Laurence Hynes Halloran,* (1775), with wreaths and ribbons both above and below, and with crossed palms behind the shield. *Neele* engraves the plate of *Rob⁴. Surtees, Mainsforth,* (1780), with crossed olive branches and the usual ribbon. Here, however, an unusual hatched back-ground is added. The ex-libris of *Mick⁴. H. Fitzpatrick, Waterford,* is signed *Billow sc.* This has a floral branch, left and right, and the motto again on a ribbon. Then we may instance *Nathaniel Highmore's* ex-libris, which is signed by *Terry* ; where the shield is represented in a circular festoon with numerous

[1] In the ensuing list the single word 'festoons' denotes the ex-libris of this school of ornamentation.

[2] The designs of Sheraton for contemporary furniture are often quite in the *Ribbon & Wreath* style. See *Cabinet-Maker and Upholsterer's Drawing-Book,* by *T. Sheraton ; with* an *Appendix,* 2 *vols.,* 116 *plates,* 1793, 4to.

[3] George Lewis Jones, D.D.

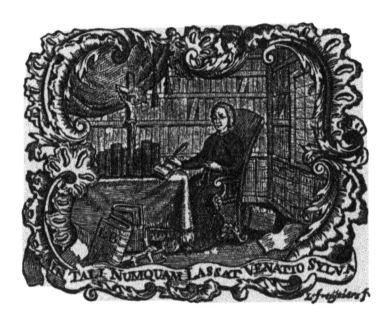

[No. 13.]

The 191

blossoming heads. Terry had also designed book-plates under the lately declined Chippendale fashion. *Merrifield, 77 Piccadilly*, engraves the common oak and olive branch for *Robert Clutterbuck*. The plate of *Crewe Hall* by *Stuart*; of *Barton Bouchier* by *Lucas*; of *John Pugh* by a firm signing *W. et W.*; Anon, *In Deo Confido* by *Lake*; of *R. Broderip* by *Doddrell*; of *Henry Boulton* by *J. Ford, Strand*; of *J. Smith Budgen* by *Hughes*; of *W. Boldero* by *V. Woodthorpe, 27 Fetter Lane*; of the *Blair* family by *Deeble*—are all referable to the 'ribbon and wreath' influence, and range in date between 1775 and 1795.

But some of the most graceful and characteristic plates in this vogue are neither signed nor dated. We have not space to describe them in detail. They are inscribed respectively *Smith, John Symmons Esq*., and *Samuel Enderby*. They all date about 1780.

After the disappearance of the *ribbon and wreath* book-plates, there does not appear to have arisen any new and permanent mode of ornamentation, which deserves a detailed notice. We may just note a curious fashion of depicting the escutcheon as suspended in mid air with a background of sky or clouds. This prevailed about 1805—1815. The plates of *John Fiott, B.A., S^t. John's College, Cambridge*, 1806 (dated); of *Nicholas Westby*, 1811 (dated); and the ex-libris of *William Terrell*, signed *Cook sc.*; and of *George Browne Grant*, signed by *G. Burke, 5 Palace Street*, are typical examples.

The other styles seem merely passing fancies of one or two engravers. For example, a certain *Palmer of London*, on the book-plate of *R. Guthrie, Berwick*, simulates the provincial bank-note of the period. Then there is the curious fashion of portraying a kind of monumental urn, as an excuse for the inscription of the book-collector's name. *Darling*, among other engravers, adopted this device.

Quitting now its decorative fashions, and passing to a relative estimate of its foremost artists, we shall find that this second period is mainly remarkable for the prominence of two great names, Bartolozzi and Thomas Bewick. In very different directions of art, each of these gave, so to speak, a new 'departure' to the book-plate style of their time. Around these a host of lesser artists in ex-libris congregate. In Thomas Bewick the new landscape school found its most varied and original interpreter. By Bartolozzi the half obsolete allegories of an earlier generation were revived. At his hands they received new life, far greater delicacy of touch, and a wonderful, if a slightly affected, gracefulness. But Bartolozzi is very inadequately represented by his book-plates. He is seen to far better advantage on his benefit tickets, his concert tickets, memorial cards, trade cards, *et id genus omne*, which do not strictly come within the purview of this monograph. On the other hand, Thomas Bewick figures prominently as an engraver of book-plates. No one could make more than Bewick, of a small and circumscribed space; but Bartolozzi wanted greater room for his allegories than the normal-sized library label supplied. Bewick's special genius *in minimis*, gained him a multitude of book-plate commissions; a large percentage of which, however, were local orders. Some critics, however, like Walpole, and some poets, like Southey, had the good taste to employ him from a distance. Accordingly, between seventy and eighty ex-libris, executed by Thomas Bewick, are known to exist. We have already stated, at p. 51, the general character of these charming vignette book-plates.

Passing now from the two foremost figures in our second period, Bartolozzi and Bewick, to their respective scholars and imitators, we may note that the school of Bartolozzi is represented, among others, in our list by John Keys Sherwin, one of his most eminent pupils. The Mitford ex-libris

appears from its date, 1773 (written shortly 73), to have been engraved the year after Sherwin gained the gold medal for drawing at the Royal Academy. It is allegoric[1] and pretty enough, though not of any high importance. Ford, Yates, Legat, Hughes, and T. King respectively figure as allegorists on the book-plates of this period. We have also several graceful but rather weak allegories by W. Henshaw, a Cambridge engraver, to whom Bryan accords a passing notice in connection with an etched portrait of the poet Gray, in whom doubtless a strong interest would be felt at Cambridge after his death in 1771. A fine plate of a member of the La Tour d'Auvergne family in the same vogue is signed Barnes and Co., Coventry St, and bears its date, 1793. Darly slightly touches allegory, but may be considered with James Kirk as among the best engravers of heraldic ex-libris at this period.

Turning now to the satellites of Thomas Bewick in the new landscape style, the following names from our list range themselves around that great and original genius. Ralph Beilby, Thomas Bewick's master, and subsequently his partner. Henry F. Hole. J. Bailey; and in less immediate connection, some being before and some after Thomas Bewick, come—J. Pye, Lambert, J. Scott, Allen of Birmingham, Bonner, Audinet. All these executed landscape ex-libris. Additional particulars of J. Scott and J. Pye will be found in Bryan, also of these other names which occur in our list—Robert Blyth, Andrew Johnston, Francis Legat, J. Mynde, and Richard Cooper. Of Cooper, Bryan catalogues some eleven engraved portraits, and his editor, Stanley, adds—'It is conjectured that he (Cooper) was a native of Edinburgh, and born about 1730.' A conjecture

[1] Sherwin carried the allegoric fashion so far, as to compose a finding of Moses, in which the beautiful Duchess of Devonshire appeared as Pharaoh's daughter.

to which our book-plate, signed — R. Cooper, Edin^rd, supplies corroborative likelihood.

After these few prefatory explanations, our second list may now speak for itself.

A TABULATED LIST OF ENGLISH ENGRAVERS (*Second Period*)

Engraver's Name.	Manner of Signature.	On Whose Book-plate.	Style of Book-plate.	Approximate Date.
Adams	sc.	Sir John de Keulle		1810
Allen, Birmingham	sc^t	James Yates	Land.	1800
„	„	Joseph Priestley	„	1790
„	„	James Woolley	Armorial	1800
Appleby, 9 New Cut, Lambeth	sculp^t	Edward Darley	„	1820
Audinet (P.)	sculp.	Rev. H. S. Cotton	Land.	1810
B. (G. C.)	fecit	Rev^d W. Shepherd	Allegoric	1808 dated
B. (J. S.), 1789	fecit	J. Symonds Breedon, Bere Court, Berks		1789 dated
B. (R.), see Ralph Beilby				
Bailey (J.)	Ft.	Geo. Allan, Darlington	Land.	1780 dated
Banister	sculpsit	James Gomme, High Wycombe	Armorial	1780
Barnes and Co., Coventry S^t		Family of La Tour d'Auvergne	Allegoric	1793 dated
Bartolozzi (F.)	fec.	Sir Rob^t H. Cunliffe & Sir Foster Cunliffe	„	1795
Bartolozzi (F.) R.A. 1796	sculp.	H. F. Bessborough (des. by Cipriani)	„	1796 dated
„	invenit	Miss Callender (eng. by Blyth)	„	1780
„	inv. sculp.	(George the Third)	„	„
„ Engraver to His Majesty, 1798		D. Isabel de Menezes	„	1798 dated
[Beilby (Ralph)], (signs R. B.)		J. Brand, A.M. Coll. Linc. Oxon.	Land.	1800
Berry (Agnes), Londini, 1793	inv^t et del^t	Anna Damer (eng. by Legat)	Allegoric	1793 dated
Bewick (John)	not signed	John Bewick (his own bookplate)	Land.	1790
„	„	R^t Wilson (and other book-plates)	„	„
Bewick (Robert Elrington) signed R. B.	sculp.	R. Beilby Nov. Cas. Sup. Tin. &c. (a funeral card)	„	1817 dated
Bewick (R. E.)	not signed	Anon. Arms of Bell and Brockett	Armorial	1810
do.	„	Rev. T. H. Yorke	„	„
do.	„	Rob^t Oliver (and other book-plates)	„	1808
Bewick (Thomas)				
Bewick (T.)	scul^t	*Fuimus*. Anon. Of Carlisle family	Land.	1810
„ „	scul^t	James Charlton, Gateshead	„	„

Engraver's Name.	Manner of Signature.	On Whose Book-plate.	Style of Book-plate.	Approximate Date.
ewick	sculp[t]	*Non in visco fides*, &c. (R. Murray)	Land.	1805
. (T.)		Rev. H. Cotes, Bedlington, &c.	,,	1802 dated
?ewick (Thomas)	not signed	(Robert Southey) Anon. *In Labore Quies.* Arms—Sa. a chev. betw. three crosses croslet ar.	,,	1810
do.	,,	Thomas Bell	,,	1797 dated
do.	,,	Sol. Hodgson (a funeral card)	,,	1800 dated
do.	,,	B. Liddell (and the book-plates of about 73 other individuals)	,,	1821 dated
illow	sc.	Mich[l] H. Fitzpatrick, Waterford	festoons	1780
lyth (R.)	sculpsit	Miss Callender (des. by Bartolozzi)	Allegoric	1780
onner	sc.	W. B. Chorley, Liverpool	Land.	1820
?ooker, 56 Bond S[t]		George Goold	Bookpile	1815
?owley, Salop.		Thomas Whitmore	Armorial	1810
?owley	fec[t]	John Kynaston Powell	,,	1820
romley (W.)	sculp.	R. Elsam, Architect	Land.	1810
rook, 302 Strand	sc.	Anon. Motto—*Constantia*	Armorial	1815
rooke, Fleet S[t]	Fecit	John Spencer, Esq.	late Chip.	1770
urke (G.), 5 Palace Street	sculp[t]	George Browne Grant	clouds	1810
urne[ll]	sc.	James Elton	Armorial	1820
urtenshaw (E.), Dover	sc[t]	H. Carter	late Chip.	1780
utter (D.), Edinburgh		D[r]. D. Butter (eng. by J. and G. Menzies.)	Allegoric	1820 dated
. (W.)	sculp.	W. H. Longstaff	Pictorial	1820
ipriani	Delt.	Jean Tommins (eng. by Ford)	Allegoric	1770
ipriani (G. B.)	inv.	H. F. Bessborough	,,	1796 dated
ook	sc.	William Terrell (with clouds)	Armorial	1805
ooper (R.), Edin[rd]	fecit	Charles, Lord Elphinstone	,,	1762
oulden, Cam[ge] (Cambridge)		A. Nash		1820
row	Fecit	Anon.	late Chip.	1767 dated
urtis (J.)	Printer	Edward Bury		1820
arling (W.), G[t] Newport S[t]	s.	Sir John Smith, Sydling S[t] Nicholas	Pictorial	1780
arling, G[t] Newport S[t]	fe.	Philip Van Swinden	,,	,,

Engraver's Name.	Manner of Signature.	On Whose Book-plate.	Style of Book-plate.	Approxima Date.
Darling, Gt. Newport St.	fect	William Osborn. Military Trophies	Armorial	1770
„ „	fecit	Verney	late Chip.	1770
Darly	inv. et sculp.	John Wilkes	Armorial	1780
„	sculp.	C. E. Woodhouse	„	„
„ 39 Strand		Lodge Evans Morres	„	1765
Dawson	sc.	J. B., & a cat for crest	„	1780
Deeble	sct	Blair	festoons	„
Delegal, New Bond St	sculp.	Thos. Underwood	late Chip.	1770
Doddrell	sculpt.	R. Broderip	festoons	1780
Drew	sculpt.	Hibernian Academy, Dublin (a prize)	Allegoric	1765
Duff (J.)		Edward Fitzgerald, Athy	Alle. and Land.	1780
Eben, Gt Suffolk St	sculpt	Hastings	Armorial	1810
Edwards	scpt	William Castell, A.M. (copies an old Jacobean plate)	„	1820
Ellis (J.), 1780	sct	Charles Hurt	„	1780 date
Elsam (R.)	inv. sc.	R. Elsam, Architect	Land.	1810
Esdall (W.)	delt et sculpt	Michael Smith	„	1790
--	sc.	Whyte's Grammar School, Dublin (a prize)	Allegoric	„
Ezekiel	sculp.	Laurence Hynes Halloran	festoons	1780
Fenner, Paternoster Row	sc.	William Henry Green	Armorial	1825
Ford (J.), Strand	sculpt	Jean Tommins (des. by Cipriani.)	Allegoric	1770
		Henry Boulton, Esqre	festoons	1780
Foster, Fetter Lane	sculp.	Edwd Hugh Boscawen	late Chip.	„
G. (S.)		William Gilpin	Armorial	1800
Giles	sc.	Ford Family. Anon.	„	1780
Grey	sc.	Thomas Croker	„	1810
H. (W.)[1]		Champneys, Orchardley, Somerset	„	1790
Hanbury (M.)	scul.	John Wallis	„	1765
Henshaw (W.)	sct	E. T. Bridges Col. Regin. Cantab.	„	1775
-	sculp.	Verney Lovett, Trin. Coll. Cant.	Allegoric	1780
	sc.	Wm Bennett		„
„	sct	W. F. Gason, Clare Hall, Camb.	„	1775
Hewitt, Pickett Street	sc.	Joseph Neeld	Armorial	1810

[1] Not the same as W. H. of the earlier series.

Engraver's Name.	Manner of Signature.	On Whose Book-plate.	Style of Book-plate.	Approximate Date.
[Hole (H. F. P.)]	not signed	C. L. A pyramid with Trees.	Land.	1798
Howe	Fct.	Thomas Dethick	flowers	1790
Howitt		G. C. Bainbridge	Pictorial	,,
Hughes	fecit	*Foy est Tout.*	late Chip.	1780
Hughes	,,	E. Rolfe, Heacham, Norfolk	Armorial	1770
,,	fect	R. H. Alexan. Bennet	Allegoric	1780
,,	fecit	J. Smith Budgen	festoons	1790
,, Bond St	,,	T. Gascoigne, Parlington	Allegoric	1780
Huntly, 74 New Bond St	sc.	Sir T. Stamford Raffles (died in 1826)	Armorial	1816
Inglefield (Sir H.)	inv.	Mary Berry. *Inter folia fructus*	Allegoric	1810
Johnson, Cheltm	sc.	Lord Northwick	Armorial	1820
,,	eng.	Charles Lake	,,	1825
Johnson (G.), Bristol	sc.	Peter Baillie		1815
,,	,,	Jeremiah Hill	Armorial	,,
,,	,,	Gillery Piggott	,,	1810
Johnston (W. and A. K.)	sculpt	Lt Colonel R. S. Seton	,,	,,
Johnstone (J. & J.)	sc.	James Russell	,,	1815
King (T.), Homerton, Hackney	sculp.	Fran. Hayward	Allegoric	1780
L. (W. H.) (W. H. Longstaff)	Del.	W. H. Longstaff	Pictorial	1820
Lake	sc.	W. R. Highmore, M.D.	Armorial	1779 dated
,,	,,	John Eamer		1785
,,	,,	*In Deo Confido*	festoons	,,
Lake, Bartholomew Lane	,,	John Randall		1810
Lambert, Newcastle	sc.	I. H. Fryer	Land.	,,
,,		Ralph William Grey, Backworth	Armorial	1815
		Esperance en Dieu (Percy Arms)	,,	1810
		Ant. Hedley	,,	1820
Legat (Franciscus)	sculp.	Anna Damer (des. by Agnes Berry)	Allegoric	1793 dated
Lewis		Henry Studdy		1820
Lucas, Ashn	sc.	Barton Bouchier	festoons	1790
Lyons (E.)	ex.	John Bagot		1780
,,		*Virtus in arduis.*	Armorial	1790
Mathews (W.), Oxford	Sc	Sandys Lumsdaine	,,	1820
Menzies (J. and G.) (Edinburgh)		Dr. D. Butter (des. by r. . Butter himself)D	Allegoric	1820 dated
Merrifield, 77 Piccadilly		Robert Clutterbuck	festoons	1780

Engraver's Name.	Manner of Signature.	On Whose Book-plate.	Style of Book-plate.	Approximate Date.
Merrifield, 25 Dean St, Soho		Laurence Donovan	Armorial	1820
Michell, Bond St		Honble Wm Walde-grave	festoons	1780
		Henry Beauclerk	Armorial	"
Mutlow, Walbrook[1]	sculp.	Mr. Lucombe	Allegoric	1800
Mynde (J.)	"	Sir Peter Thompson, F.R.S.	late Chip.	1770
Neele, 352 Strand	sculpt	R. Surtees of Mains-forth (des. by Sur-tees himself)	festoons	1780
..	sculpt	*Leo de Juda est Robur Nostrum*	Armorial	1790
"	"	John Ellis		"
O'Connor	sc.	Rochfort	"	1815
Osborne, 72 Lom-bard St	sc.	W. H. Williams, M.D., &c.	"	1820
Ovenden, Butcher Row		(Palmer) *Palman tulit et Coronam*	"	1800
"	sct.	James Lahy	Land.	1790
Paas (C. and A.), No. 53 Holborn	sculpt.	Joshua Scrope of Cockerington	Pictorial	1795
Palmer, London	sculp.	Robert Guthrie, Ber-wick	simulates an old bank note	1790
Peel	eng.	Gilmour Robinson, Clerk		1800
Pemberton	sculpt	Carrington Garrick	Land.	1780
Perkins and Heath		(Duke of Sussex)	Armorial	1825
Pigott	"	Richard Mangnall		1820
Polak	sculp.	Edward Roger North, Trin. Coll. Camb.	festoons	1780
Pollard (R.)	del. et inv.	Ar. a lion ramp. sa. Minerva under a tree.	Allegoric	1790
Pye, Birm(ingham)	sculp.	T. W. Greene, Lich-field	Land.	"
Pye . . . 1798	delin. et ect.	Thomas Nicholson		1798 date
Roe (R.)		Dobree Legacy, Trin: Coll: Cam:	Allegoric	1826 date
Roe, Cambridge		J. R. Buckland, Cam-bridge		1820
Roper	sc.	Jane Legh	Armorial	1810
Sandys	sculpt.	Feinaglian Institute Dublin (Prize)	festoons	1815
Sansom (E.)	del. et sculp.	Johannes Symmons Arm.	Land.	1790
Scare and Co.	sc.	Landsdowne	Armorial	1810
Scott (J.)	sculpt.	James Hews Bransby	Land.	"

[1] There is another *Mutlow of York St., Covent Garden*, who engraves later and beyond our period, 1830-40.

Engraver's Name.	Manner of Signature.	On Whose Book-plate.	Style of Book-plate.	Approximate Date.
herwin (J.), 73	fecit	W^m Mitford, Pitts Hill	Allegoric	(17)73 dated
herwin (W.)	sculp.	William Bentham, Lincolns Inn	Land.	1780
ilvester, 27 Strand, London	sculp.	John Meybohm	Armorial	1820
,,	sc.	John Morse	,,	1830
,,	sc.	Anon. *Amo.*	Armorial	1810
tayner	sculp.	Henry James Pye, Esq.	late Chip.	1765
tuart	sc.	Crewe Hall (Cheshire)	festoons	1795
uffield	sculp^t	James Ogilvie	Armorial	1825
,,	,,	Newman Smith	,,	,,
,,	,,	William Pott	,,	,,
,,	,,	P. Renny, M.D.	festoons	1810
urtees (R.)	delin^t	Rob^t Surtees, Mainsforth (eng. by Neele)	,,	1780
utherland (J.), Aberdⁿ	sculp^t	John Forbes of Blackford	Armorial	1800
. (W.)		Henry Aylorde	Allegoric	1820
aylor (J.)	sculpt.	Tanrego, Co. Sligo.	Land.	17[86] dated
hompson (C.), Cross, Edin^g	sculp^t	John Borthwick of Crookston	Armorial	1800
Thompson (J.), Belfast	drawn & engraved	Anon.	,,	1820
oleken	scul.	Henry Hardy	festoons	1780
olley	sc^t	George Burrish	Armorial	,,
nkles	lithog.	*In Deo spes.*	,,	1825
ining (J.), 120, Pall Mall	sc.	Earl of Morley	,,	1810
W. (J. P.)		M. Smith	Land.	1800
W. et W.	sculp.	John Pugh	festoons	1780
Warwick, 145 Strand	sc.	Hon. W. M. Noel	Armorial	1820
,,	,,	Jacobus Haviland	,,	1807 dated
,,	,,	Samuel Mills	,,	1815
,,	,,	William Henry Merle	,,	1820
Vells	sculp.	J. Sheppard	Land.	1800
,,	del. sculp.	Anon. *Vero nihil verius*	,,	1790
Welsh (T.)	sc.	Edmund F. Bourke	Armorial	1820
White (W. J.), no. 13 Long Acre	Del. et sc.	Champneys, Orchardleigh, Somerset (7 by 9¼ in.)	,,	1810
Woodman & Mutlow	sc.	Marquis of Donegall	,,	,,
Woodthorpe (V.), 27 Fetter Lane	sc.	William Boldero A.M.	festoons	1790
,, ,,	,,	J. H. Beaufoy		,,
	,,	Pruen	pictorial	,,

Engraver's Name.	Manner of Signature.	On Whose Book-plate.	Style of Book-plate.	A
Yates	sculp.	Thomas Anson, Shugborough	Allegoric	1800
,,	,,	Marquiss of Donegall	Armorial	1780
,,	,,	Rev. W. Leigh, Rushall, Stafford	,,	1790
		John Tarleton	,,	1785

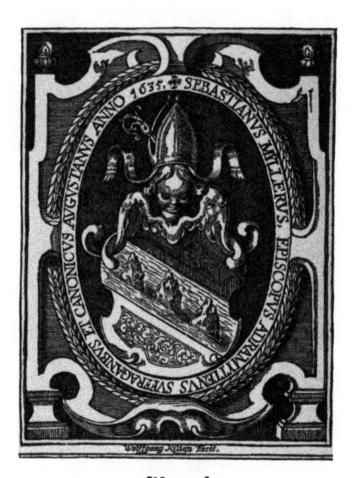

[No. 14.]

FOREIGN DATED BOOK-PLATES.

(*Sixteenth and Seventeenth Centuries.*)

A FAIR general idea of the antiquity and of the extent of
the book-plate record upon the Continent may be gathered
from a perusal of the ensuing list. As compared therewith
our English dated series is but a thing of yesterday. In
artistic excellence, by the side of these German examples,
our catalogue of English dated ex-libris is homely, recent,
and inconspicuous.

The list, which follows, professes to be an enumeration
of all the foreign book-plates, bearing an engraved or
printed[1] date, which the author has seen or heard of, down
to the year 1699. And it must be once more emphatically
premised, that a date, written in manuscript upon a book-
plate, does *not* constitute that ex-libris *a dated one* for the
purposes of this work. It is submitted that the authen-
ticity of an engraved date rests on a much higher ground;
and it is to be hoped that collectors will adopt and insist
upon this most vital distinction.[2]

[1] The book-plates of John Faber, 1540, of Charles Albosius, 1574,
and of Andrew Lisiecki, 1636, are each purely typographical.

[2] Many MS. dates on ex-libris will prove, no doubt, authentic, but
spurious ones are by no means uncommon. For instance, I have
before me the book-plate of *Sir John Anstruther of that ilk, Baronet.*
This is dated on the name bracket in MS. 1683. Now this Sir John
Anstruther did not come to the title till 1711, and the creation of the
Baronetcy was in 1694, eleven years *after* the MS. date. The plate
itself is of the normal armorial style of Queen Anne, and dates pro-
bably soon after 1711.

It was our original intention to have given detailed descriptions of all these foreign dated ex-libris; but their number increased so much, that want of space compelled us to restrict ourselves to recording merely their inscriptional portions. The inscription, therefore, of each individual specimen is here set down. This is copied exactly as it appears on the ex-libris. The abbreviations and even the misspellings, which are found on the original, are faithfully reproduced. All matter or comment, extraneous to the actual inscription, will be enclosed in a parenthesis. A general heading, for the reader's convenience, will be prefixed to each example. This will enable him to take in at a glance the purport, date, and adscription of each individual book-plate.

Liber Hieronymi Ebner, 1516. *Deus Refugium meum.* This interesting example heads our list. It is peculiarly fortunate that, on this our earliest dated book-plate, the formula—Hieronymus Ebner, his book—should leave no kind of doubt that this woodcut is a genuine ex-libris. As a rule, the older the book-plate, the more often does this tantalising hesitation obtrude itself upon the mind of the conscientious collector. Often will he have to reject some charming piece of mediæval wood-engraving, because the evidence of its use as an ex-libris is at best equivocal.

Deus Refugium meum. These Scripture texts will be found extremely differential of the early German book-plates. The instances of their use are legion. Of our ten earliest examples in this list, seven bear such biblical quotations. Christopher Scheurl, 1541, has no less than five texts on one ex-libris. They seem in Germany to precede the true heraldic motto; and, in some measure, to do duty for it. Sometimes their selection is quaint—*Omnia munda mundis.* And again—*Estote prudentes sicut Senpentes.* The earliest approach to an actual heraldic motto is found

under 1565—*In spe contra aspem*; or, again, in 1569—
Patriæ et Amicis. Now and then we get what are neither
texts nor mottoes, but rather 'sentiments.' As—*Joh.
Georgii à Werdenstein Insignia et Progenitores*, 1592. *Non
omnibus omnia placent.* Where the stately heraldic exor-
dium ends rather fish-like in the concluding platitude.
Or the moral sentiment is versified ; as by *Nicholas Firlei*,
1570—

> *Pietas homini tutissima virtus.*

Who enforces this lesson on his ex-libris by a picture of
the young stork bringing food to his decrepit parent in
the nest.

One Jodocus, on our third earliest book-plate in 1522,
explains the heraldry of his library label by an appended
distich of Latin doggerel verse—

> *Propria Jodocus gerit hæc sua signa parentum ;*
> *Matrem virgo notat, fibula dupla patrem.*

The arms of either parent here Jodocus hath displayed,
His father bears the buckles, and his mother bears the maid.

Now and then we get other poetical mottoes equally
quaint, not heraldic or moral, but bearing special reference
to study, and so appropriate enough to be placed on
an ex-libris. The dictum of an Austrian lawyer, John
Seyringer, under the year 1697, is the best—

> *Haurit aquam cribris qui vult sine discere libris.*

He who would learn without the aid of books,
Draws water in a sieve from running brooks.

So again, John Giles Knöringen enunciates a touching
belief in the comparative purity of bygone ages. This he
expresses in poetry, to be found under the year 1565, of
which here is rough translation—

These are the famed insignia of my sires,
 Which in their proper tinctures thou mayst see.
Not bribes, as is the fashion of these days,
 But virtue raised them to nobility.

The *depicta suo rite colore* of the original means, of course,
that this book-plate is actually coloured. I have in my
own collection some more of these coloured woodcut
German book-plates. They are all probably anterior to
1600. Among them occur—*The Municipal Library of
Nuremberg. Hieronymus Schenck, Joannes Ecker, Præ-
positus in Schefftlarn*, etc. etc.

 Some of the heraldic examples in our list are very elabor-
ate and stately. On these old German book-plates, what we
call the 'quarterings' are not massed together upon one
shield, but are ranged round the exterior of the design in a
number of separate escutcheons, each duly named beneath.
Instances of this practice will be found on the book-plates
of John George à Werdenstein, 1592, of Zachary Geizkofler,
1603, and of John William Kress, 1619. In the Werden-
stein plate there are no less than sixteen of these 'progeni-
torial' shields, eight on each side. A still finer anony-
mous plate, signed at full—*Heinrich Ullrich fe*—has twenty
such escutcheons, besides the central one of the Imhoff
family, to which the ex-libris belongs. This is charged
with a lion-poisson, or fish-tailed lion, which is repeated
on the crest. The motto—*Virtute non sanguine.* Henry
Ulrich was of Nuremberg, and worked from 1590 to 1628.
The plate is undated, and therefore, strictly speaking,
does not come within the scope of this chapter, except as
an illustration of profuse heraldic detail. (W.)

 The Legacy book-plates in our list are curious and note-
worthy. In 1588, Wolfgang Andrew Rem à Ketz, Provost
of the Cathedral at Augsburg, bequeaths to the library of

the Monastery of the Holy Cross in that city—*librum hunc und cum mille et tribus aliis, variisque instrumentis mathematicis.* So that allowing, as we are bound, for 'this book,' the exact sum total of the library was 1004. Surely the good Provost might have thrown in the four odd volumes, and recorded his munificence in round numbers.

John Faber, Bishop of Vienna, who was named by his admiring contemporaries, the 'hammerer of the heretics' (malleus hereticorum), when the mallet of orthodoxy was about to slip from his wearied grasp,[1] made in 1540, the year before he died, this bequest; and added on the book-plate, which decked these volumes, this very lawyer-like statement. John Faber commences at once to the following sledge-hammer effect:—

'This book was bought by us, Doctor John Faber, Bishop of Vienna, and assistant in the government of the New State,[2] both as Councillor and Confessor to the most glorious, clement, and pious Ferdinand, King of the Romans, Hungary, and Bohemia, and Archduke of Austria. And, since indeed that money (which purchased this volume) did not arise from the revenues and properties of our diocese, but from our own most honest labours in other directions; and, therefore, it is free to us to give or bequeath the book to whomsoever we please—We accordingly present it to our College of S' Nicholas; and we ordain that this volume shall remain there for ever for the use of the students, according to our order and decree. Done in our Episcopal Court at Vienna, on the first day of September, in the year of grace, 1540.'

We may well fancy, after reading this, that the Bishop was a decidedly awkward opponent for a nervous heretic.

[1] 'My father, Pip, he hammered away at my mother most onmerciful.'—*Great Expectations*, by Charles Dickens.

[2] Hungary and Bohemia were first united to Austria under this Archduke Ferdinand in 1526.

Next year, as we have said, the hammering was to cease for good. The curious likeness of this book-plate to a legal document is, as far as I know, without parallel.[1]

The minuteness of these old ex-libris is most naïve and characteristic. If Wolfgang Rem counts his library to the last pamphlet, John Vennitzer, knife-smith or cutler, informs us on his library label, dated 1618, that he was born in the good city of Nuremberg at 22 minutes past 5 in the afternoon, on the 14th day of May, 1565.

No doubt the worthy swordsmith conscientiously believed that the condition of his whole life depended upon that particular moment at which he entered the world. And he was probably deeply versed in the mysteries of horoscopy. He seems to have combined book-collecting with cutlery, and speaks with very complacent modesty of his library in these verses, of which the jolting metre of the original version, to be found under the year 1618, is somewhat, we hope, preserved :—

> The book-collection, which I've made,
> In Laurence Priest-house[2] safely laid,
> Is not for glory of my own,
> But made to honour God alone ;
> Bestowed, as the Holy Spirit leads,
> From whom all earthly good proceeds.

He opens, in fine, with a horoscope, and ends with an epitaph! And all upon an ex-libris. The reader will agree, that it would be difficult to find a more curious example in the whole range of book-plate lore.

We have already hinted, that in artistic excellence this

[1] I cannot resist here recording my obligations to Mr. T. U. Fletcher of the B. M. Library, in whose company, during a dusty hunt in the labyrinths of the National collection, this charming book-plate came to light. *In tali nunquam lassat venatio sylva!* Since then, I have luckily secured a second example.

[2] The residence of the priests who officiated at St. Laurence's church.

foreign series leaves our English list very far indeed behind. A good proportion of its ex-libris would be acceptable in any collection of engravings, quite apart from the fact, which specially concerns us here, that they happen to be book-plates. Some twenty or more constituents of the ensuing catalogue merit this eulogium, and of their designs we would gladly furnish detailed descriptions. But as want of space renders this impossible, let us describe, as a sample of what a German book-plate can be, the magnificent ex-libris of Peter Vok, Ursinus, Count of Rosenberg.

Let us premise that this is engraved and signed by Giles Sadeler, born at Antwerp in 1570; who, after studying in Italy, was invited to Prague by the Emperor Rodolph the Second, who took him into his service and gave him a regular salary. Sadeler also retained the favour of the next two Emperors, Matthias and Ferdinand II. He died at Prague in 1629. It will be seen that in his signature of this plate he alludes to his employment by the Emperor. This ex-libris is on copper, 10 inches by 6; the design is as follows: In a central circular medallion, $3\frac{3}{8}$ inches in diameter, appears Peter Vok in complete armour, charging on a war-horse richly caparisoned. On his breastplate lies an escutcheon with these arms—bendy of six, on a chief a rose, barbed and seeded, over all, upon a fesse a flame. The knight's sword is in his hand. On his helmet-spike, and on the steed's furniture, the rose of his escutcheon is repeated. The war-horse's head is plumed, and it is going at full gallop across a little landscape of hillocks. Round the margin of the medallion runs a wreath of roses. At each side stand on a platform, as quasi-supporters, two figures about 5 inches in height. The one to the left is a female symbolical form in fine flowing drapery, holding the cup of the eucharist in one hand, and a short slender cross in the other. The form on the right is also a symbolical feminine

figure, holding a tablet inscribed—*Verbum Domini manet in eternum.* Her hair is drawn back from her forehead. The medallion rests on two bears, in allusion to the family name *Ursinus.* These appear crouching between the two female supporters. The face of the altar-like platform below is divided into one central and two lateral compartments, of which the side ones project forward. On the right lateral slab is placed an escutcheon, charged simply with the Rosenberg rose; on the left slab recur the family arms, blazoned more elaborately as on the breastplate, but ensigned with an ermine-faced crown. On the central slab of this platform is a skull resting on two shin bones; and immediately behind is written—*in silentio et spe.* Beneath this is the signature—*S. C. M^{tis} Sculptor Æg. Sadeler fecit.* (engraver to His Imperial Majesty). At the top of the plate, and reaching right across its upper portion, is an oblong tablet with indented shelly scroll-work edges, and a background border of large full-blown roses with thorny stems, an extremely graceful ornamentation. The tablet reads—*Ex bibliothecâ Illustrissimi Principis Dñi Petri Vok, Ursini, Domini Domus à Rosenberg, Ultimi & Senioris, & e Primatibus Bohemorum celsissimi et antiquis: Anno Christi M.DC.IX.* (*i.e.*, 'From the Library of the most Illustrious Prince, Peter Vok, Ursinus (a family name); the seat of this Lord's family is in Rosenberg; he is the highest, the first in precedence, the most exalted, and the oldest in race among the primates of Bohemia. In the year of Christ, 1609'). The roses of the escutcheon, which are also so plentifully sprinkled across the decoration of the plate, allude to the name of Rosenberg. The cradle of the family is the Castle of Rosenberg, which is some six miles S.W. of Horn, and is still one of the largest and best preserved feudal fortresses in Austria. The lists and galleries for the old tournaments are still quite perfect. So

doubtless at tournament, or in the more serious onset of war, looked Count Rosenberg as we see him here in panoply.

It takes one back a long way into the past, and one certainly hardly expects, after the pacific opening formula *ex bibliothecâ,* to find the owner of that library portrayed in full armour, galloping into battle with drawn sword in hand. A specimen of this grand ex-libris is in the Lempertz collection at Leipsic, and I have another example, unluckily rather imperfect.

It will be by this time very apparent to the reader that German specimens preponderate greatly in our list. The respective nationalities of the ex-libris quoted are Polish—one ; Swiss—one ; Spanish—one; French—eight; German —eighty-seven ; Netherlandish—one. Total, ninety-nine. But we have ex-libris in two separate years of Loelius, Scheurl, Baron von Wolckenstein, Baron von Windhag, and Geizkofler ; so that the number of distinct individuals, or communities, who have left dated foreign book-plates, is ninety-four.

It will be observed that a reference is appended at the end of each description, where the particular ex-libris may be found. A large section are included in a remarkable collection made by M. Lempertz, sen., of Cologne, and at present transferred to the Museum of the Bookseller's Exchange at Leipsic. (*Buchhandler Börse.*)[1]

M. Poulet-Malassis describes the ex-libris of Melchior de la Vallée, Canon, etc., of St. George at Nancy,[2] as bearing the date 1611 ; but afterwards, in reviewing the book-plates of this his first period, he says that not one of them is dated.[3] In this uncertainty it is deemed best to leave out this ex-libris from our dated list.

[1] These specimens are followed by the abbreviation *L. B. Mus.* Leipsic Bookseller's Museum. My own examples are followed by W.

[2] Page 7. [3] Page 19.

Since this list and these pages were in type, I have acquired the ex-libris of *N(icholas) R(emy) Frizon de Blamont, Con'. (Conseiller) au Parlement. A Paris,* 1694 (dated). (W.) M. Poulet-Malassis mentions that these three engravers have signed book-plates with the following dates. *I. Colin,* 1685; *Seb. Le Clerc,* 1655, and another, 1660; *Ogier à Lyon,* 1696. But having no further particulars of these dated ex-libris, we can merely indicate them thus.

Again, the fine book-plate of *Carolus Agricola Hammonius,* engraved by Mr. Leighton in the Gentleman's Mag., June 1866, unfortunately has the last two numerals of its date blurred and uncertain: thus, 15—. We may be sure, therefore, that the plate is anterior to 1599, but no more can be said.

The list itself now follows.

A LIST OF DATED FOREIGN BOOK-PLATES ANTERIOR TO 1700.

1516. *Hieronymus Ebner of Nuremberg.*

Liber Hieronymi Ebner, 1516. Deus Refugium Meum. (Designed by Albert Durer, see Bartsch, vol. vii., under *Durer.*) A. F.

1516. *The Schönthal Convent at Basle.*

Apud Inclytam Germaniæ Basileam, M.D.XVI. (L. B. Mus.) (The arms enable this ex-libris to be identified.)

1522. *The Arms of Jodocus.*

Propria Jodocus gerit hæc sua signa parentum ;
Matrem virgo notat, fibula dupla patrem. 1522. (L. B. Mus.)

1525. *Hector Pömer, Provost of S^t Laurence, Nuremberg.*

D. Hector Pömer Præpos. S. Laur. (signed) R. A., 1525. Omnia munda mundis. (Designed by Albert Durer. The initials refer to some wood-engraver.) (L. B. Mus.—N. & Q., 3rd S. viii. 308; Bartsch, vol. vii., under Durer.) (The motto is repeated in Greek and Hebrew.) A. F.

1534. *Anthony, Titular Bishop of Philadelphia, Suffragan of Eichstädt.*

Antonius D. G. Episcopus Philadelphiæ, Suffragan. Eistetten, M.D.XXXIIII. Dominus Adjutor et Protector meus. (L. B. Mus.)

1536. *The Book-plate of W. H.*

W. H.—In domino Confido., 1536. (And then apart) M. R. A.—I. H. S.—I. O. E. S. (L. B. Mus.)

1539. *Justus Syringus.*

Justus Syringus, 1539. Estote prudentes sicut serpentes. (L. B. Mus.)

1540. *Testamentary Gift of Books by John Faber, Bishop of Vienna, to the College of S*[t.] *Nicholas in that City.*

Emptus est iste liber per nos Doctorem Joannem Fabrum Episcopum Viennēsem, et Coadjutorem Nove Civitatis, Gloriossimi et clementissimi, Romanorum, Hungarie, Bohemieque etc. Regis, ac Archiducis Austrie Ferdinandi pientissimi a Consiliis et a Confessionibus. Et quidem non ea pecunia, quæ ex proventibus et censib.[1] *Episcopatus provenit, sed ea, quam ex honestissimis nostris laboribus aliunde accepimus, proinde liberum est nobis donare ac legare cui voluerimus. Donamus igitur Collegio nostro apud Sanctum Nicolaum, ordinamusque ut ubi in'perpetuum Studentibus usi sit, juxta statuta et prescripta nostra.*

Actum Vienne in Episcopali Curia, prima die Septembris. Anno Salutis, M.D.XXX.

(In the British Museum, and W. The text is in black letter. 11 × 7½ inches.)

1541. *Christopher Scheurl, a lawyer.*

Liber Christophori Scheurli J. U. D. qui natus est 11 Novemb. 1481. Mihi autem adherere Deo bonum est,

[1] Revenues and properties of the diocese.

ponere in Domino Deo spem meam: Psal. LXXII.
Beatus vir qui timet Dominum in mandatis; gloria et divitiæ
in domo ejus: Psal. CXI. Divites eguerunt et esurierunt,
inquirentes autem Dominum non deficient omni bono:
Psal. XXXIII. Fecit mihi magna qui potens est, et
sanctum nomen ejus: Luc. I. Justus qui ambulat in
felicitate sua, beatos post se filios relinquet: Prov. XX.
(L. B. Mus.) (It seems more appropriate to class this
ex-libris under the year 1541, the date given on its variety,
than under the year 1481, which applies only to the birth
of its owner.)

1541. *Christopher Scheurl, a lawyer.*

Liber Christophori Scheurli J. U. D. qui natus est 11
Novemb. 1481. Psal. LXXII. Mihi autem adhaerere
Deo bonum est, ponere in Domino Deo spem meam, 1541.
(L. B. Mus.)

1554. *Anonymous Bookplate.*

S. M. P. V. I. D., 1554. (W.) (Out of a ducal crown a
demi-man in a long cap, holding in one hand an arrow and
in the other a kind of javelin (?). The whole in a wreath.)

1555. *Andrew Imhoff.*

Andreas Imhoff, 1555. (By Virgil Solis, but not signed.)
(L. B. Mus.)

1558. *A Legacy of Books by Daniel (Brendel of Hamburg), Archbishop of Mayence, to the Jesuit College in that City, which he had founded.*

Societatis Jesu, 1558. Ex liberalitate Reverendissimi
& Illustrissimi Principis ac Domini D. Danielis, Archi-
episcopi Sanctæ Sedis Moguntinæ, Sacri Rom. Imperii per
Germaniam Archicancellarii, Principis, Electoris, Primi
Fundatoris hujus Collegii Moguntini, etc. Deus Opt.
Max. retribuat. (L. B. Mus.) A. F.

1560. *Philip. A. Pianus.*

Insig. Philippi A. Piani, 1560. (L. B. Mus.)

1564. *Francis Pfeil.*

Frantz Pfeil, D., 1564.

Subditus esto Deo, mandato munere fungens.
Et spera in miseris et pete rebus opem.

<div align="right">Phil. Mel.</div>

Thue Recht—Las Gott Walten—

Firma velut geminis stant lilia fulta columnis,
Perfodiat quamvis sæva sagitta [1] latus.
Inclyta sic dubiis virtus exercita rebus
Durat et exuperans cuncta pericla viget.

(L. B. Mus.) <div align="right">Seb. Ge.</div>

1565. *John Giles Knöringen.*

Jo. Eg. Knöringen.

Majorum sunt hæc insignia clara meorum.
Quæ depicta suo ritè colore vides.
Munera non illos, ceu mos est temporis hujus,
Sed propria Virtus nobilitavit ope.

M.D.LXV. In Spe, Contra Aspem. (L. B. Mus.)

1566. *Philippus Agricola (Hodgkin).*

1567. *George, Provost of S^t. Cross, Augsburg.*

Georgius, Præpositus S. Crucis Augustæ, electus et confirmatus Anno. M.D.LXVII Mense Decemb. In manu Dñi Sortes meæ. (L. B. Mus.)

1567. *Michael Pühelmair, a lawyer.*

Insignia Michaelis pühelmair U. J. Doct., 1567. (L. B. Mus.) A. F.

1568. *The Abbey of Weissenau in Swabia.*

Abtei Weissenau, 1568. (L. B. Mus.)

[1] *Pfeil* in German means an arrow. The first quotation is from Philip Melanchthon. The second, Mr. Carson suggests, is from Sebastian Castalio, Genevensis.

1569. *Pfinzing von Henfenfeld.*

Pfinzing von Henfenfeld, 1569. Patriæ et Amicis. (Signed) M. Z. (Matthias Zündt). (Henfenfeld was a Nuremberg family.) (L. B. Mus.)[1]

1570. *Wolfius Christopher of Enzersdorf (Austria).*

Wolfius Christoferus ab Enzestorf, 1570. Dirige me in semita recta. (L. B. Mus.)

1570. *Sebalt Millner von Zwai Raden (the two wheels).*

Schalt Millner Von Zwai Raden, 1570. (L. B. Mus.)

1570. *Nicholas Firlei of Daubrawitz in Bohemia.*

Pietas bomini tutissima virtus. Nicholaus Firlei in Dambrovizca, 1570. (Mr. Peckett.)

1572. *Philip James Wernher, a lawyer of the Imperial Court of Justice at Rothweil in Swabia.*

Philipp Jacob Wernher J. U. D. Kaysserlichen Hoff-gerichts Advocatus und Procurator Juratus zu Rothweil, 1572. (L. B. Mus.)

1573. *Balthazar, Abbot of Fulda, etc.*

Balthasar Dei Grat. Abbas Fulden. D. August. Archican. et P. Germa. ac. Gall. Primas. 1573. Collegii ad S. Petrum Societatis Jesu. (L. B. Mus.)

1574. *The Monastery of Tegernsee in Bavaria.*

Adalbertus et Ockarius, Fundatores Monast. Tegerns. Quirinus Dei Gratia Abbas Monasterii In Tegernsee. An. 1574. (L. B. Mus.)

1574. *Charles Albosius, Bishop of Autun near Chalons.*

Ex bibliothecâ Caroli Albosii E. Eduensis. Ex labore quies, 1574. (Poulet-Malassis, p. 4.)

1575. *Ulrich, Grand Duke of Mecklenburgh.*

1575. E. H. G. V. V. G. Ulrich H. Z. Mecklenburg. (W. and N. & Q. 1st S. vii. 26.) (The E really divides the date, thus 15. E. 75.)

1576. *Mauritius Winkelman (Hodgkin).*

[1] Andresen Peintre Graveur Bd. 1 Jug. 29.

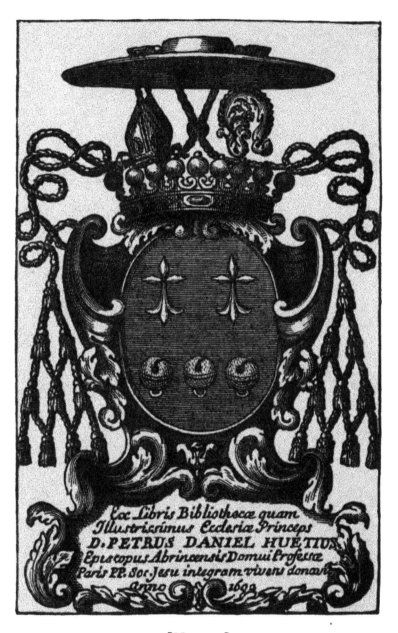

Ex Libris Bibliothecæ quam
Illustricrimus Ecclesiæ Princeps
D. PETRUS DANIEL HUETIUS
Episcopus Abrincensis Domui Professæ
Paris PP. Soc. Jesu integram vivens donavit
Anno 1692

[No. 15.]

1575. *George von Vechelde.*

Georg. von Vechelde, 1575. (L. B. Mus.)

1580. *Hieronymus Nutzell fecit.*

1584. *Oberkamph von Dubrun.*

Oberkamph v. Dubrun, 1584. (EO? in corner. An uncertain engraver's monogram.) (Mr. Peckett.)

1587. *Erhard Voit, Abbot of some German Monastery.*

Erhardus Voit, Dei Gratia, Hujus Monasterii Abbas, ac Bibliothecæ hujus Auctor et Fundator amplissimus. M.D.LXXXVII. (N. & Q. 5th S. viii. 397.)

1588. *A Legacy of Books to the Monastery of St. Cross, Augsburg, by Wolfgang Andrew Rem à Ketz, Provost of the Cathedral in that City.*

Reverendus et Nobilis Dominus Wolfgangus Andreas Rem à Ketz, Cathedralis Ecclesiæ August: Sum: Præpositus, librum hunc unà cum mille et tribus aliis, variisque instrumentis Mathematicis, Bibliothecæ Monasterii S. Crucis Augustæ ad perpetuum conventualium usum, Anno Christi M.D.LXXXVIII, Testamento legavit. (L. B. Mus.) A. F.

1590. *Thomas Lunde or Lunder, a Canon of St. John's Church at Ratisbon.*

Thomas Lunde Canon. S. Johannis Ratis. ('G. W. D.' in Notes and Queries, 6th S. vol. i. p. 4). (I have an ex-libris of the same person reading—*Thomas Lunder Cano. S. Joannis Ratis. Nihil Virtute Nobilius*—but in my example there is no engraved date.)

1592. *John George von Werdenstein.*

Joh. Georgii à Werdenstein Insignia et Progenitores. Non omnibus omnia placent. (Signed) Dominic Custodis fe. aº 1592. (W.) (The escutcheons of the 'progenitores,' each duly labelled, hang on either side of the plate.)

1593. *John Christopher Prueschench, Pontanus.*

1593. Johannes Christophorus Prueschench, Pontanus. (L. B. Mus.)

1594. *Christopher, Baron of Wolckhenstain.*

Christophorus Baro à Wolckhenstain & Rodnegg, etc.
M.D.XCIIII. (W.) (3½ × 2½ in.)

1595. *Christopher, Baron of Wolckhenstain.*

Christophorus, etc. (Inscription as on the preceding,
except the date, which is) M.D.XCV. (This plate is much
larger also, being 7½ × 5½ inches.) (W.) (In the larger
plate the field of the escutcheon is less shaded than on
the smaller one of the previous year.)

1595. *Andrew Beham, the Elder.*

Andreas Beham der Elter, Anno Domini 1595. Cum
bonis Ambula—Omnia a Deo—Ora et Labora. (L. B.
Mus. and N. & Q. 4th. S. vol. v. p. 66.)

1600. *Henry, Bishop of Augsburg.*

Henricus D. G. Eps. (Episcopus) August 1600. (L. B.
Mus. and Hodgkin.)

1603. *Zachary Geizkofler de Gailenbach, Grand
Treasurer of the Holy Roman Empire under
Rodolph II.*

Zacharias Geizkofler de Gailenbach in Haunsheim et
Mos. Eques aurat. Divo Rudolpho II. Rom. Imp: et
Sereniss. Archiduc. Austriæ Dño Matthiæ et Maximiliano
à consiliis ac Sac. Rom. Imp. Summus Thesaurarius.
Anº. Dñi M.D.CIII. (Signed) D. C. F. (Dominic Custos
fecit.) (Eight escutcheons, named beneath, are arranged
on each side of the ex-libris.) (W. in two sizes; for the
folio, 8 × 6 in.; for the quarto, 5½ × 3½ in.)

1604. *Albert Hunger, Doctor of Theology.*

Albertus Hungerus S. S. Theologiæ Doctor, Professor,
etc. (L. B. Mus.) A. F.

1605. *Zachary Geizkofler von Gailenbach and his Wife Maria, born Rehel.*

Zacharias Geizkofler von Gailenbach, Ritter, etc.—Maria Geizkoflerin, geborne von Rehelingen, 1605. (Signed) S. C. (or perhaps C. S.). (L. B. Mus.)

1605. *Adam Schwindt, a lawyer.*

Adam Schwindt J. U. Licentiat, 1605. (L. B. M.)

1606. *John, Provost of St. Cross at Augsburg.*

Johannes Præpositus Sanctæ Crucis Augustæ. Anno Dⁿⁱ. M.D.CVI. (L. B. Mus. & N. & Q. 4th S. iv. 518.)

1608. *James Keim, Abbot of the Monastery of St. James at Mayence.*

Jacobus Keim, Abbas Monasterii S. Jacobi, Mog. 1608. I.H.S., M.R.A. (Maria Regina Angelorum.) (L.B. Mus.)

1609. *Peter Vok, Ursinus, Count of Rosenberg, a Bohemian Nobleman.*

Ex Bibliotheca Illustrissimi Principis Domini Dñi Petri Vok, Ursini, Domini Domus à Rosenberg, Ultimi & Senioris & è Primatibus Bohemorum celsissimi et antiquiss. Anno Christi M.D.CIX. Verbum Domini manet in eternum—In silentio et Spe. (Signed) S. C. Mᵗⁱˢ. (suæ Cæsareæ Majestatis) Sculptor Aeg. Sadeler Fecit. (L. B. h. 5. Mus.) A. F.

1610. *A Gift from M. E. to E. G. L. O.*

E. G. L. O. (above; then come the *arms*—Quarterly, first and fourth, a boar salient on a mountain with three peaks; second and third, a fleur-de-lis. *Crest*—A demi-boar erect between two wings; each per fess sa. and ar., and charged with a fleur-de-lis). (Below on a band) M. E. D. D. (dono dedit), 1610. (W.) (The whole in a laurel wreath. This book-plate probably belongs to the same family as the first anonymous one, ascribed to Durer, at p. 135.)

1611. *William Blumenthal of St. Peter's on the Haymarket at Cologne.*

Wilhelm Blommendal In S. Peter uff dem Heumart in Cöin, 1611. (L. B. Mus.)

1612. *J. C. Herwart, Privy Councillor to Maximilian, Duke of Bavaria.*

Johannes Christophorus Herwart ab Hohenburg D. U. Serenissimi Ducis Bavariæ Maximiliani Consiliarius Aulicus. A.D. M.D.CXII. (W.)

1614. *Michael Bardt (Bighe).*

1618. *The Electoral Library of the Dukes of Bavaria at Munich.*

Ex Bibliotheca Serenissrum. Utriusque Bavariæ Ducum, 1618. (W.) (In two sizes, $7 \times 5\frac{1}{4}$ in. and 4×3 in.)

1618. *An Anonymous Bookplate.*

Quid retribuam Domino pro quæ tribuit mihi. (*Arms* —(untinctured) per chev., in chief two trefoils slipped, in base a man pass. holding in his dexter hand a sceptre. Below, on a bracket with carved angels, the date 1618— The owner's name has, I think, been cut away from the centre of the bracket.) (W.)

1618. *John Vennitzer, Cutler, born at Nuremberg.*

1618. Fides. Charitas—Christus ist mein Leben, Sterben ist mein gewin. Johannes Vennitzer, Messerschmidt. natus Norimbergæ, Anno 1565. Die 14 Maii. h. 5. m. 22 p. m. 1618.

> Die Bibliothec von mir g(e)stifft,
> Im Lorenzer Pfarshoff auffg(e)richt,
> Ist nicht zu ruhm dess Nahmens mein,
> Sondern zur Ehre Gottes allein;
> Bescherhrt aus trieb dess Heijlign (*sic*) Geist,
> Aus Welchem alles gutes fleust.
> (The plate is signed) J. Pfann sculp.

1619. *John William Kress.*

Johannes Guilhelmus Kress à Kressenstain. H. T. scu. 1619. H. H. (W.) (See p. 137 for rest of the inscription.)

1621. *Dietrich von Riedenburg 'of that Ilk.'*

Dietrich von und zue Riedenburg, 1621. (L. B. Mus.)

1622. *Candide et Sincere.*

Luce Kilian sculp. (H.)

1624. *A Book-plate with various initials.*

D. P. S. S. C. M. C.—M.D.C.XXIV. Constanter. Non Fata recusant. Utcumque Ferar. Quocumque Ferar— Deus noster in coelo. Coelo Duce, reduce Fortuna. (Signed) Tobias Bidenharter, scalp. 1620. (L. B. Mus.)

1630. (*John William Kress.*) Anon. W.

1634. *Erhard von Muckhenthall.*

Erhardus à Muckhenthall in Hæcksennackher, 1634. Post Nubila Phœbus. (Mr. Pearson, W. and L. B. Mus.)

1635. *Sebastian Myller, Bishop of Adramytteum, etc.*

Sebastianus Myllerus, Episcopus Adramyttenus Suffraganeus et Canonicus Augustanus. Anno 1635. (Signed) Wolffgang Kilian fecit. (W.) (See plate 14, p. 192.)

1636. *S^t. Peter's Monastery at Saltzburg (Austria).*

Conservando Cresco. S. P. Monasterii S. Petri Salisburgi, 1636. (L. B. Mus.)

1636. *The Library of the Poor Students of the Gregorian Convent at Munich.*

Ex Libris Pauperum Studiosorum Domus Gregorianæ, Monachii, 1636. Date et Dabitur. D. G. (in ligature). Deo Gratias. (L. B. Mus.)

1636. *Andrew Lisiecki, Public Prosecutor, etc., of Kalisz in Poland.*

Ex dono Mag. Dñi. D. Andreæ Lisiecki Instigatoris Regni. Surrog. Jud. Castrensis Calissiensis. A. D. 1636. Mens. Sept. (Siennicki. plate 6, page 21).

1638. *Wolff James Ungelter.*

I. H. S.—M. R. A.—1638.—Wolff Jacob Ungelter von Deissenhaussen.

1640. *Christopher Hieronymus Kress von Kressenstain.*

Christophorus Hieronymus Kress à Kressenstain, A°. 1640. Pro Religione et Patria—Christe, Hostia Credentûm, atq. calix sanctorum. (L. B. Mus.)

1642. *Baltazar Raupech.* (H.)

1643. *The Book-plate of G. S. K. U. N.*

G. S. K. U. N., 1643. (L. B. Mus.)

1644. *An anonymous ex-libris by Raigniauld, an engraver of Riomi in Auvergne.*

Anonymous; Armorial; signed *Raigniauld, Riomi,* 1644. (Mr. Carson.) (See p. 140.)

1645. *William Kress and his wife Clara, born Viatis, both of Nuremberg.*

Wilhelm Kress von Kressenstein. Clara geborne Viatissin, 1645. Vulnera Christi, Credentium Voluptas. (W.)

1646. *Ferdinand von Hagenau.*

Insignia Ferdinandi ab et in Hagenau ad S^{tum} Petrum, &c. (Signed) Honoris et debitæ observantiæ ergò, Joannes Sadeler, &c., D.D. Anno MDCXLVI. (W.) (8 × 7 in.)

1646. *The Weihen Monastery.*

Closter Weihen—Stephen. 1646. (L. B. Mus.)

1650. *Andrew Felibien, Chronicler Royal, &c.*

André Félibien escuier sieur des Avaux seigneur de Iavercy, etc. Historiographe du Roy. 1650. (W. and P. Malassis, p. 21.)

1654. *Anthony Biderman.*

Antonius Biderman. 1654. (Signed) S. S. H. (W.) (3 × 2½ in.)

1654. *Baron von Windhag.*

1656. *Joachim Baron von Windhag.*

Joachim L. Baro in Windhaag, Dns in Richenau, Pragthal, Saxenegg, et gros Poppen. S. C. M. Consil. et Regens. A° 1656. (L. B. Mus. See also under 1661.)

1656. *Joannes Schwegerle.* (Hodgkin & W.)

1657. *Pierre Coloma, Baron de Moriensart. (French.)*

Messire Pierre Coloma Baron De Moriensart, &c. 1657. (Mr. Carson.)

1658. *John Philip Mockel, an ecclesiastical lawyer.*

Joan. Phi. Mockel Proton. Ap. J. U. L. Aº. 1658. (L. B. Mus.)

1659. *William Van Hamme, a Dignitary of the Cathedral at Antwerp.*

Ex Bibliotheca Reverendi, Nobilissimi, Consultissimique Viri, Dñi D. Guilielmi Van Hamme, Patricii, Bruxel. Phri. J. U. L. Prothonotarii Apost. Cathedralis Eccl(es)iæ Antverp : Canonici, Scholastici, etc. 1659. (L. B. Mus.) (Roziere.)

1660. *An Anonymous Conventual ex-libris.*

Medio Tutissimus Ibis. 1660. (*Arms*—Sa. two cinquefoils ar., on a canton or, a symbol unknown gu. (like two T's united, the lower one being inverted.) Below, in a medallion, an angel flying, and fruit festoons round the arms frame.) (British Museum).

1661. *Joachim Baron von Windhag.*

Joachim L. Baro in Windhag, Dns in Reichenau, Pragthal, et Saxenegg. S. C. M. Consil. et Regens. A. 1661. (L. B. Mus.)

1661. *An ex-libris of the Breiner Family.*

Ex libris S. S. C. G. B. L. B. S. S. 1661. Deo et Cæsari. (*Arms*—Quarterly, first and fourth, ar. a pale counter-compony, or and sa. ; second and third, or a beaver erected ppr.) (W.) (The arms are the same as those of Maximilian Lewis Breiner on his fine book-plate (1630).)

1663. *Matthew, Abbot of Ursperg in Swabia.*

Spera in eo : & Ipse faciet. Matthæus Abbas · Urspergensis, 1663. Elect. 1628. (L. B. Mus.)

1666. *Theophilus Krannost.*

Theophilus Krannost. 1666. Est animæ Christus spesque, salusque, meæ. (L. B. Mus.)

1667. *The Thierhaupten Convent.*

Closter Thierhaupten. 1667. Corbinianus Abbas. (L. B. Mus.) (Ponson, 2 shields, 1 demi-hind, 2 bear statant.) A. F. & W.

1668. *Francis, Provost of St. Cross at Augsburg.*

Franciscus D. G. Præpositus Sanctæ Crucis Augustæ. A° 1668. In manibus Domini sortes meæ. ps. 30. v. 16. (W.)

1669. *André Felibien, &c.* W.

1672. *Charles Maurice Le Tellier, Archbishop of Rheims.*

Arms—Az. three lizards erect in fess ar., on a chief gu., three stars or; (signed) *I.Blocquet,* 1672. The plate bears no other inscription. (Guigard, vol. ii., p. 59. Poulet-Malassis, p. 23.)

1672. *Book-plate of one C. R.*

C. R. 1672. fe Grassanter. (L. B. Mus.) (W.)

1672. *A Legacy of Sebastian Denichio, Bishop of Almeria in Grenada.*

Ex Hæreditate Revmi Dñi D. Sebastiani Denichii, Episcopi Almirensis, etc. MDCLXXII. (W.)

1673. *Leonor Le François, a French gentleman.*

Leonor Le François escr Sr de Rigawille. 1673. Meliora sequenti. (Poulet-Malassis, p. 23.)

1676. *The ex-libris of L. W. M. B.*

L. W. M.—M.D.C.LXXVI.—B. (L. B. Mus.)

1678. *Christopher, Provost of the Holy Cross, Augsburg.*

Christophorus, D. G. Præpositus Sanctæ Crucis Augustæ. A° 1678. Dominus Protector Meus. (W.) (See another book-plate of the same series under the year 1668.)

1679. *An anonymous German heraldic ex-libris.*

Arms—Ar. three lions passant purp. (?), on a chief gu. a mound az. (?); and above the date—1679. (W.)

1681. *John Laurence Loëlius, Doctor of Medicine.*

Johannes Laurentius Loëlius Philosophiæ et Medecinæ Doct. 1681. (W.)

1682. *John Junkersdorff.*

Johan Junkersdorff. 1682. (L. B. Mus.)

1682. *J. T. Hauser de Gleichenstorff, Canon of the Cathedral at Constance, &c.*

Jo. Theodoric. Hauser de Gleichenstorff Cath. Eccles. Constant. et August. Canonic. 1682. (Mr. Franks and W.)

1685. *Roland, by Colin.*

1688. *Charles Andrew von Schlechten, a Bavarian government official.*

Caroli Andreæ à Schlechten Serenis^mo Electori Bavariæ à Consiliis Cameræ Officii ædilitii & utriusque Hospitalis ad S. Elisabed : & S. Joseph : Commisarii. In solo spes tuta Deo. 1688. (W.)

1689. *A gift or legacy by M. Melchior Thumb, Priest of Frankenhausen in Saxony.*

Fidus amicus crit, qui plus me, quam mea quærit.
Hunc fidum dico, prece qui succurrit amico.

(*Arms, &c.*) Sit quisque gratus, & ob hoc munus præsentis benefactoris, atque post funera absentis memor boni amici, qui ad conservandum longævæ amicitiæ & rei memoriam hunc librum vobis reliquit, vel donavit, aut legavit. M. Melchior Thumb, Decanus & Parochus Frantenhusii. Anno Domini 1689. (W.)

1690. *Anthony von Sohleren, an imperial official at Treves.*

Anton Edler Herr von Sohleren Kayserlicher Majestät Reichs Hoff Rath Churfurstlicher Trierischer Geheimbder (*sic*) Rath U. Canzler und Hoff Richter. 1690. (L. B. Mus. and A.F. and W.)

1690. *John Laurence Loëlius, Doctor of Medicine.*

Johannes Laurentius Loëlius Philos. et Medecinæ Doctor. 1690. (W.) (See under 1681.)

 1692. *Legacy of Giles Menage, the Scholar, to the Paris Jesuits.*

Ex libris quos Domui Professæ Parisiensi Soc. Jesu testamento reliquit vir Clarissim : D. Ægidius Menagius Patritius Andegavensis vir inter Literatos Eruditissimus. Anno 1692. (W.)

 1692. *Legacy of Peter Daniel Huet, Bishop of Avranches, to the Paris Jesuits.*

Ex libris Bibliothecæ quam illustrissimus Ecclesiæ Princeps D. Petrus Daniel Huetius Episcopus Abrincensis Domui Professæ Paris P. P. Soc. Jesu integram vivens donavit, anno 1692. (Large size 9¼×6 in., W. Second size, Mr. Pearson.) (See plate 15 at p. 207.)

1695. *John Francis, Prince-Bishop of Freysing in Bavaria.*

Jo. Franci. D. G. Epūs Frisi. S. R. I. Princeps. 1696. (W.)

 1697. *J. P. Storr.*

Ad Libros J. P. Storri. 1697.

 —et trunca et saucia cresco.

 Jugiter ut stirps haec et trunca et saucia crescit.

 Sub cruce sic crescit jugiter alma Fides.

(L. B. Mus.)

 1697. *John Charles Seyringer, an Austrian lawyer.*

Haurit aquam cribris qui vult sine discere libris. 1697.

Ex libris Joan. Caroli Seyringer J. U. D. et Judiciorum Advocati in Austria Superiori. (Signed) Ja. de Lespier fe. (W.)

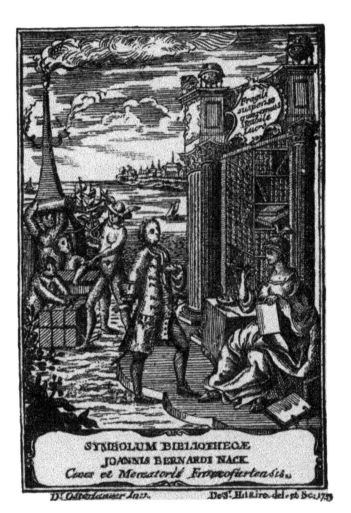

SYMBOLUM BIBLIOTHECÆ
JOANNIS BERNARDI NACK
Civis et Mercatoris Francofurtensis.

D. Osterlander Inv. De St. Hilaire del. et Sc. 1735

[No. 16.]

CONCLUSION.

WITH the series of foreign dated ex-libris we bring this essay to a conclusion. Most of the leading points connected with book-plates and their history have been touched upon. An attempt, however imperfect, has been made to show that the subject is full of interest and well worthy of fuller investigation.

Much of secondary importance still remains to be said. Indeed, since the first draft of this essay, materials have so increased upon the writer's hands, that he has been compelled to omit at least half a dozen already written chapters from his printed volume.[1] And only by these sacrifices has he been able to keep this treatise within reasonable limits.

In the foregoing pages these aspects of book-plates have been selected as of primary significance and importance—The artistic styles of ex-libris. The dates which they bear. The artists by whom they are engraved. As regards the earliest undated book-plates both in England and Germany,

[1] Some of these chapters are indicated at pp. 8 and 55.

the writer felt convinced, that the data necessary for their thorough investigation in either country were as yet but imperfectly known. The cases are quite exceptional in which internal evidence enables a book-plate to be dated with certitude. The mass of undated examples must hereafter be assigned to their appropriate periods, either by careful study of their style, or by an equally assiduous comparison with their dated analogues. In England, therefore, till these styles had been classified and these dated examples catalogued, it seemed premature to rush into giving an account of our earliest or rather of our apparently earliest book-plates. At some future day this will no doubt be done, and done exhaustively. But it is a task that is not to be attempted lightly, and which will require some rather exceptional qualifications in the investigator.

As regards the oldest German woodcut ex-libris, their ultimate successful arrangement clearly awaits a German hand. An English student could hardly embark upon an enterprise so perilous with any reasonable prospect of success. It is also much to be wished that some French ex-librist would endeavour to classify the various artistic styles of their national series.

The *Rococo* book-plate is fairly analogous to our Chippendale, with which it also tolerably synchronises. The old and purely heraldic style fades out in each country about the same time. But the greater variety of subject and treatment in France will be at once conspicuous.

In conclusion, the writer ventures to crave the indulgence of his readers for the numerous shortcomings of the present attempt. He is well aware that in a few years, much that he has now written will be superseded by ampler information and materials more complete. The lists in the present volume of engravers and dated examples will be hereafter

trebled and more than trebled. The novelties of this work will soon become the commonplaces of the science of book-plates. Still, a beginning will have been made. And should this essay stimulate elsewhere the publication of a treatise at once abler and more exhaustive, the present writer will not have laboured wholly in vain.

FINIS.

P

A GUIDE TO THE STUDY OF BOOK-PLATES

BY

JOHN BYRNE LEICESTER WARREN
(LORD DE TABLEY).

9 780266 593997